D0078988

John Crome

the

Elder

Publication of this book
has been aided by a grant
from The Millard Meiss
Publication Fund of the
College Art Association
of America

The publication of this
book has been aided by
a grant from the Andrew
W. Mellon Foundation.

NORMAN L. GOLDBERG

JOHN CROME
the
ELDER

II · ILLUSTRATIONS

NEW YORK · NEW YORK UNIVERSITY PRESS · 1978

Library of Congress Catalog Card Number: 75–27046
ISBN: 0–8147–2957–6

Manufactured in the United States of America

Contents

VOLUME II

LIST OF ILLUSTRATIONS

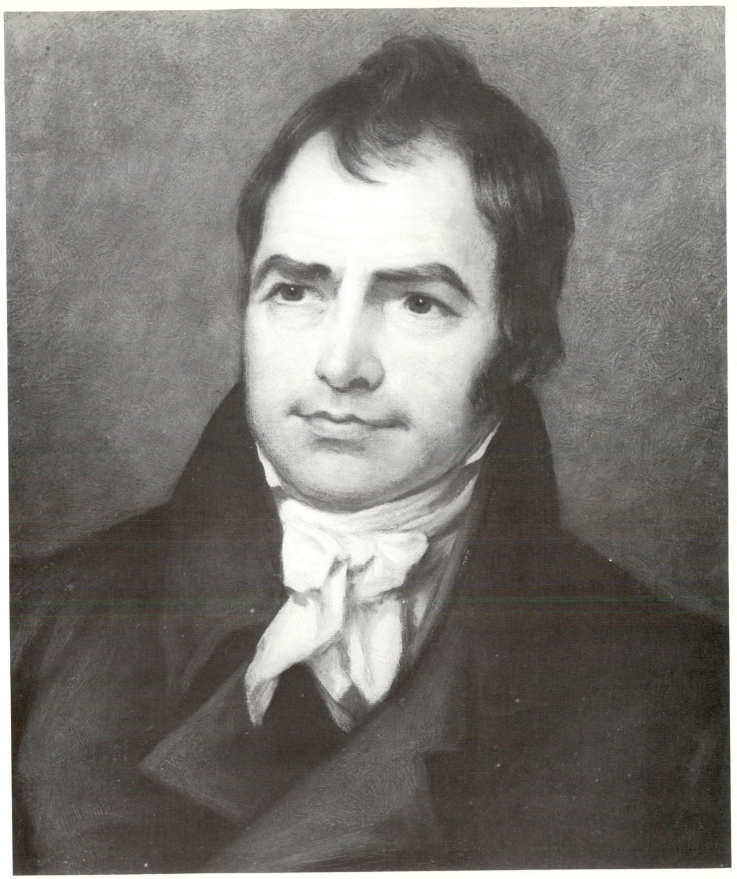

Frontispiece. *Portrait of John Crome*. Denis Brownell Murphy. Collection the right Honorable Viscount Mackintosh of Halifax, Barford, Norfolk.

THE LANDSCAPES

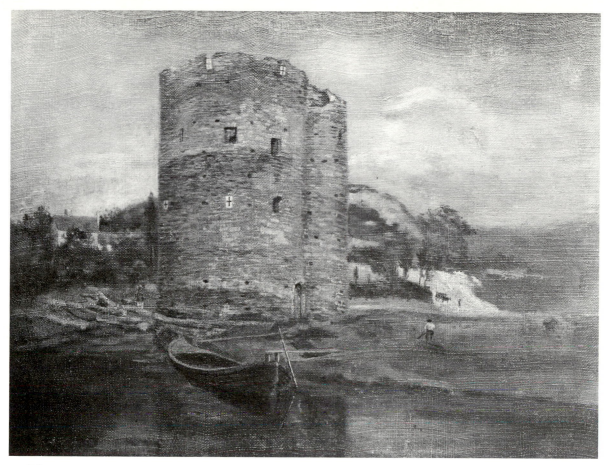

1. *The Cow Tower on the Swannery Meadow, Norwich.* City of Norwich Museums, Norwich.

2. *View on the Coast of Baiae.* City of Norwich Museums, Norwich.

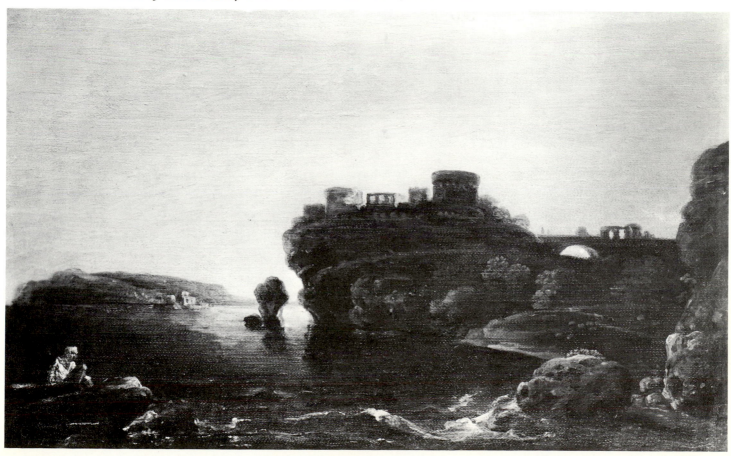

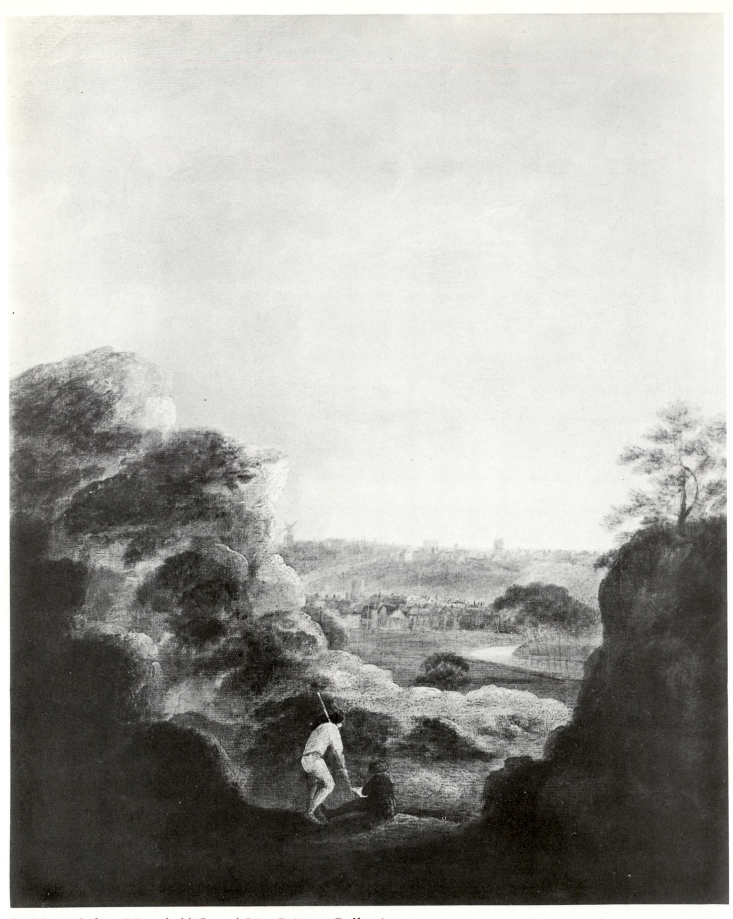

3. *Norwich from Mousehold Gravel Pits.* Private Collection.

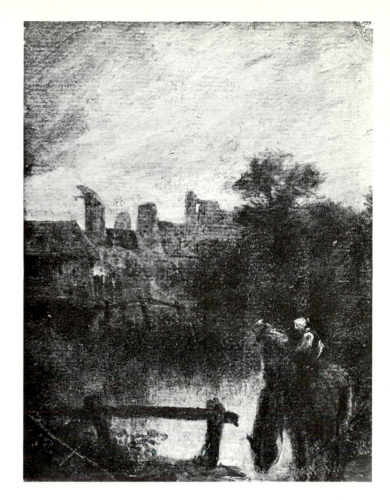

4. (top) *Horse Watering*. City of Norwich Museums, Norwich.
5. (bottom) *Farmyard*. Collection the Right Honorable Viscount Mackintosh of Halifax, Barford, Norfolk.

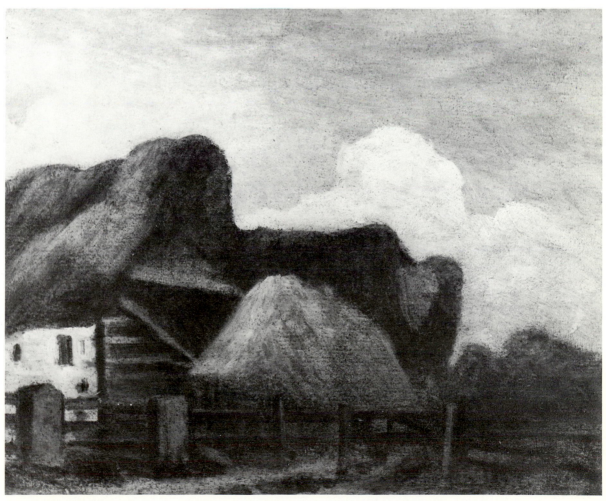

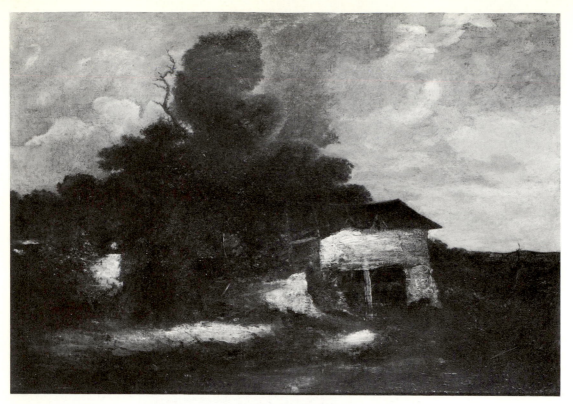

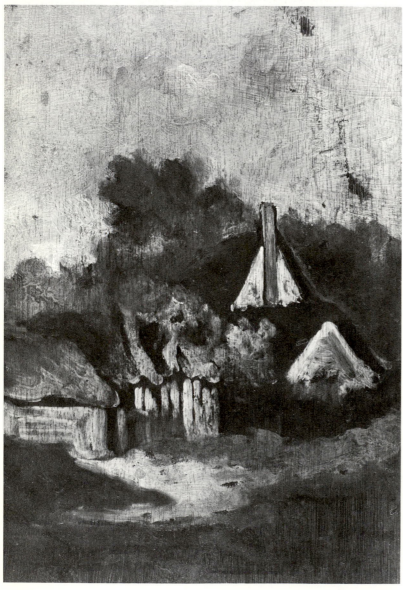

6. (top) *A Cart Shed, at Melton, Norfolk*. Collection Dr. Arnold Renshaw, Manchester.
7. (bottom) *Cottage and Pigsty*. Collection Mrs. R. F. Colman, Brundall, Norfolk.

following page:
8. (top left) *Storm, Mousehold Heath*. Whereabouts unknown.
9. (top right) *Back of the New Mills, looking North*. Collection Dr. Norman J. Townsley, Norwich.
10. (bottom) *Sheds and Old Houses on the Yare*. Collection the Right Honorable Viscount Mackintosh of Halifax, Barford, Norfolk.

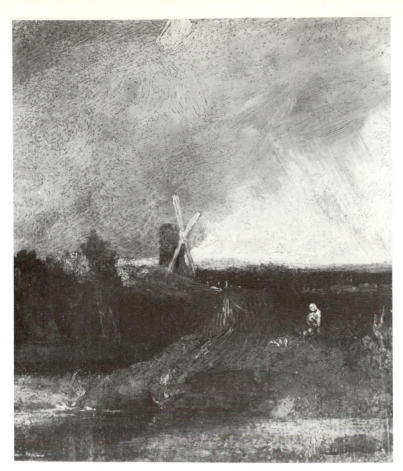

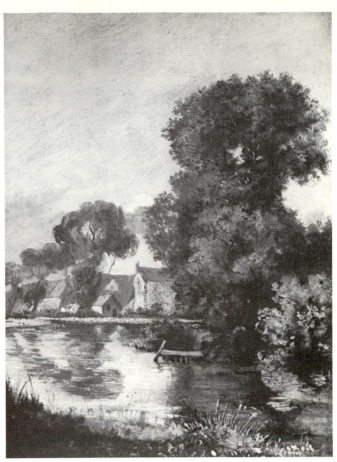

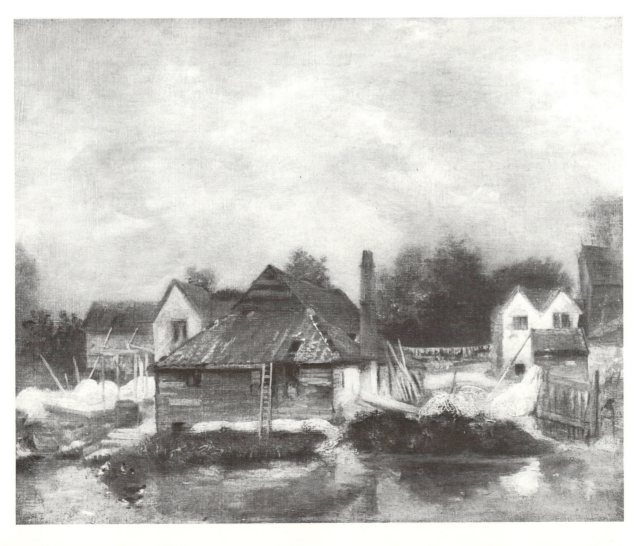

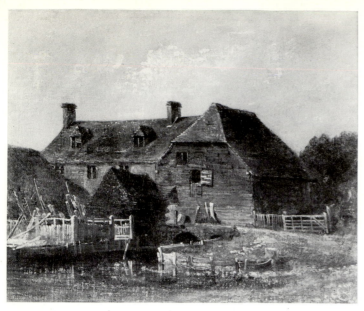

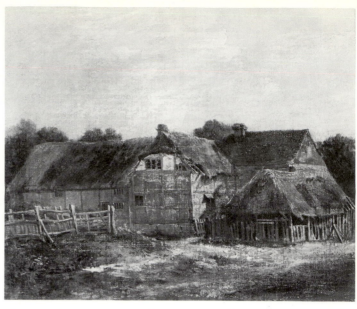

11. *A Mill near Lakenham*. Collection the Right Honorable Lord Mancroft, London.

12. *A Cottage near Lakenham*. Collection the Right Honorable Lord Mancroft, London.

13. *Composition in the Style of Wilson*. Collection the Right Honorable Viscount Mackintosh of Halifax, Barford, Norfolk.

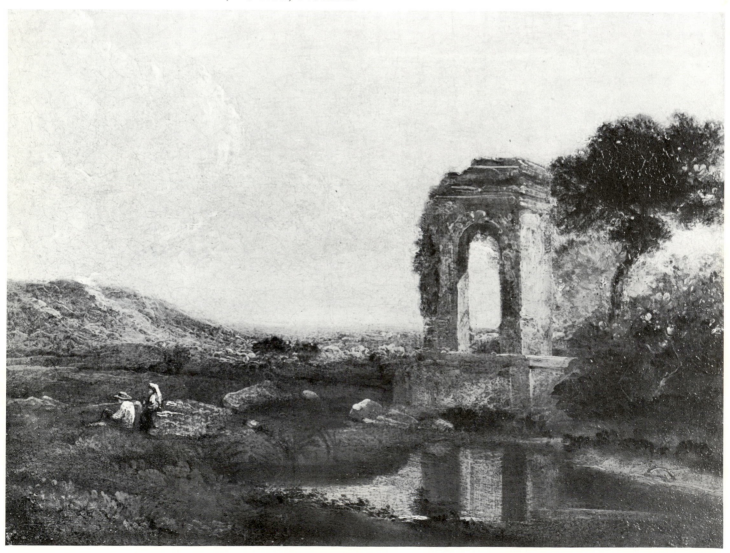

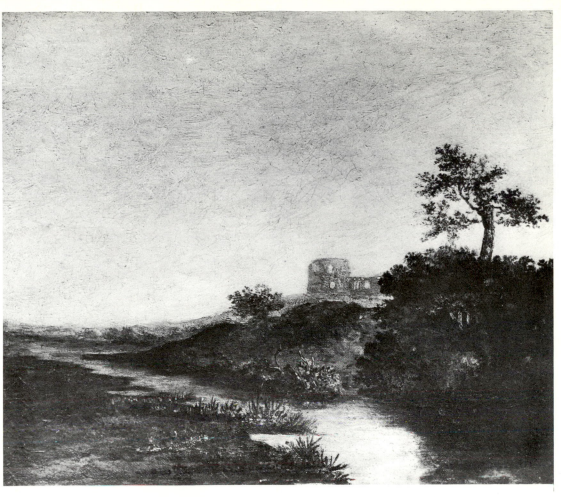

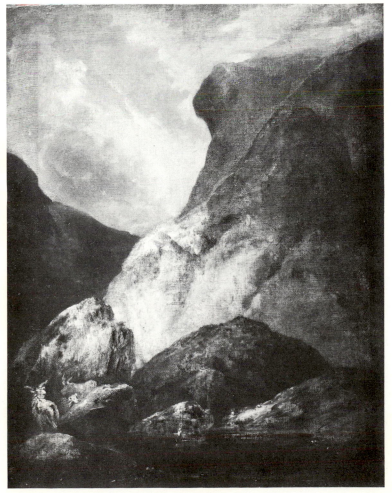

14. (top) *A Castle in Ruins, Morning.* City of Norwich Museums, Norwich.
15. (bottom) *Scene in Cumberland.* National Gallery of Scotland, Edinburgh.

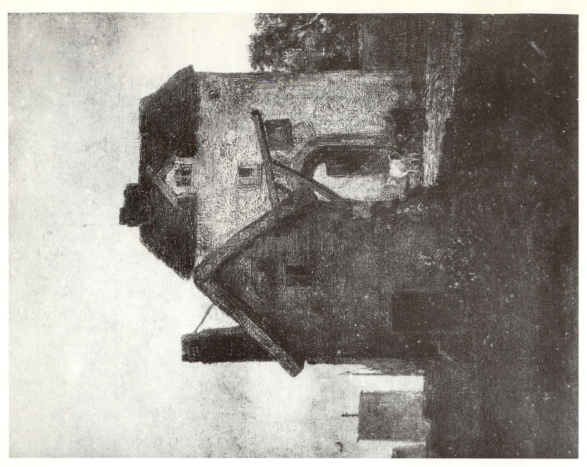

17. *The Bell Inn.* Private Collection.

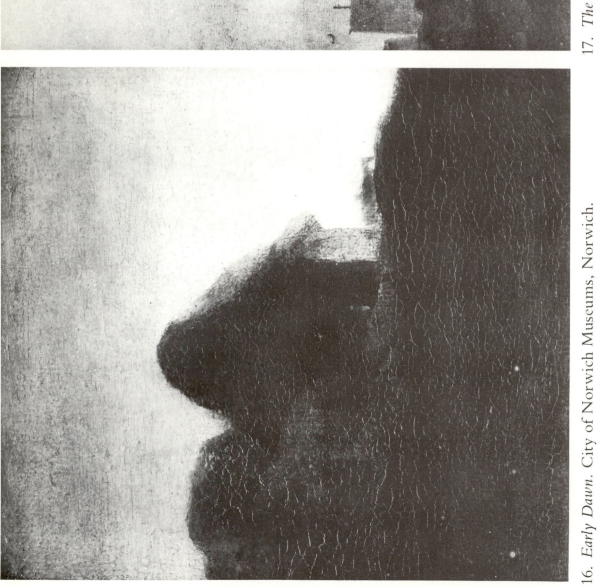

16. *Early Dawn.* City of Norwich Museums, Norwich.

8

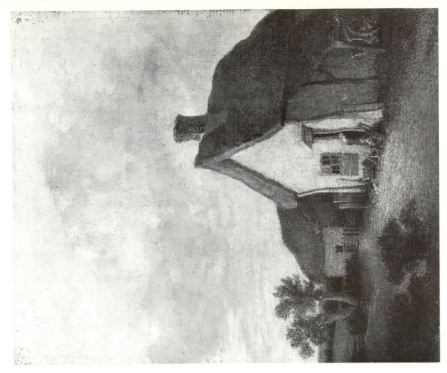

18. (left) *A Cottage on the Yare*. Collection Her
Majesty Queen Elizabeth, the Queen Mother,
London.
19. (right) *A Norfolk Cottage*. With M. Bernard,
London.

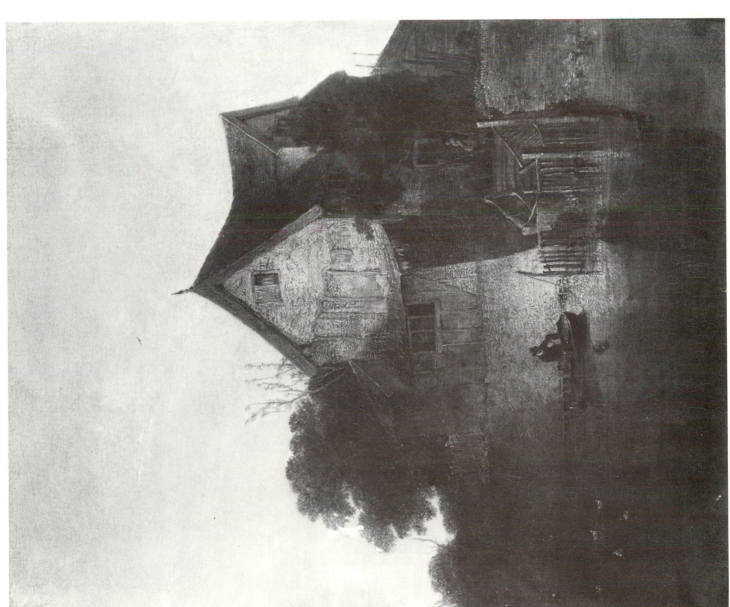

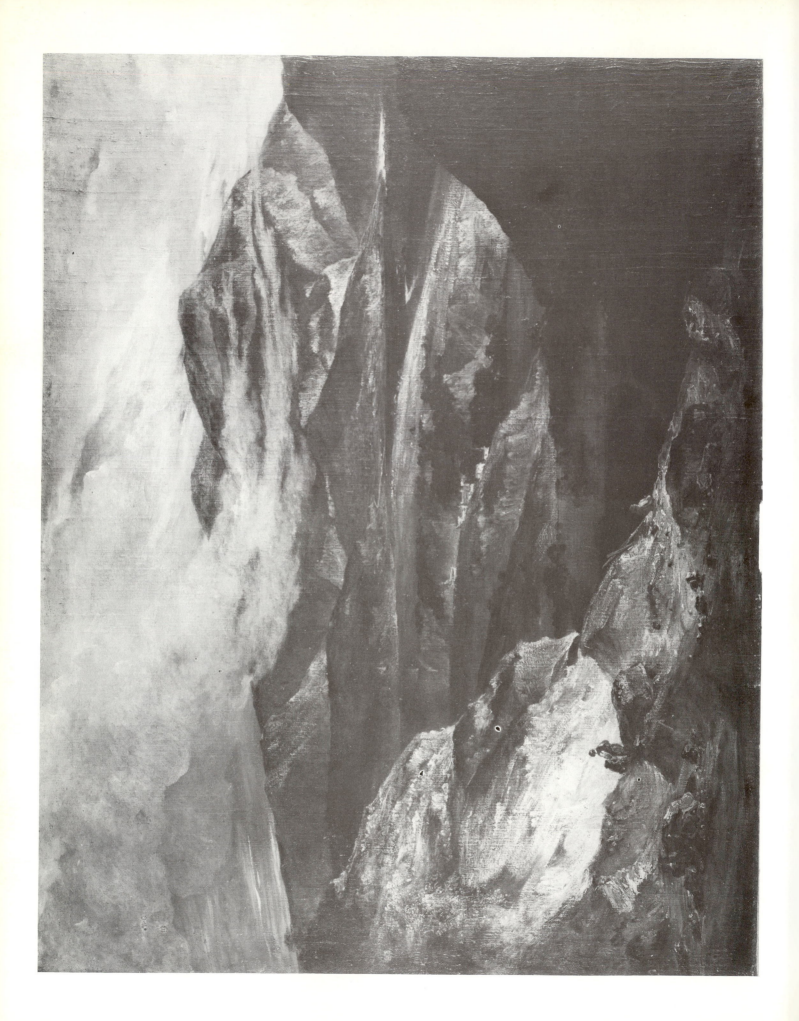

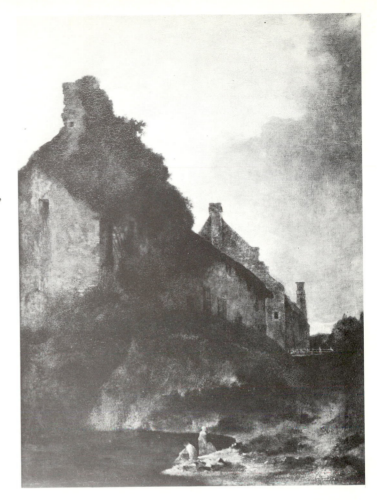

preceding page:
20. *Slate Quarries.* Tate Gallery, London.

21. (top) *Carrow Abbey.* City of Norwich Museums, Norwich.
22. (bottom) *The Limekiln.* Collection the Honorable Lady Courtauld, Umtali, Rhodesia.

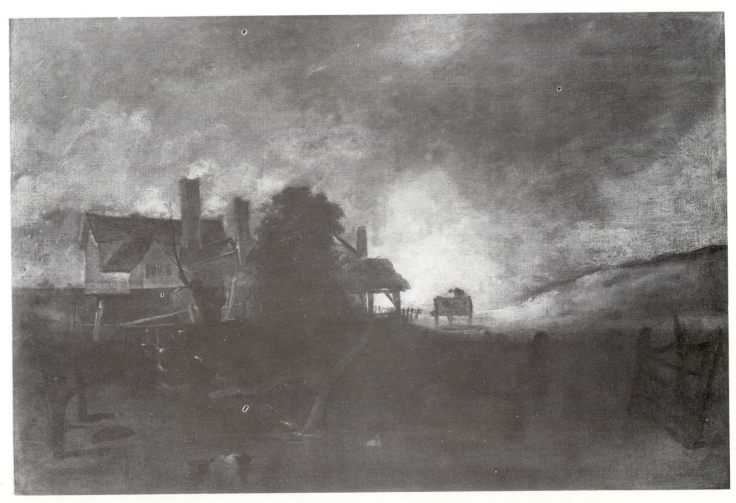

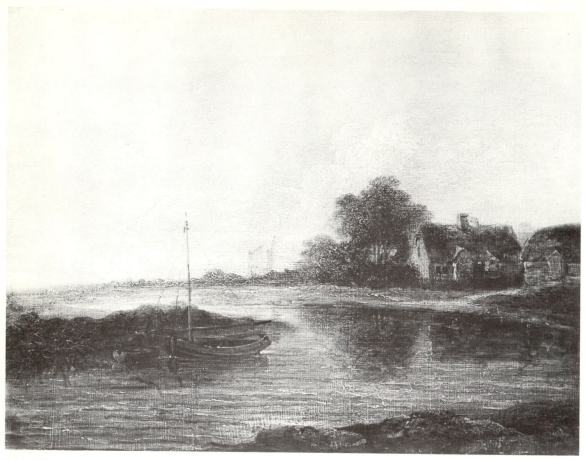

23. *The River Yare.* Collection Mrs. W. W. Spooner. Lullington, Somerset.

24. *Old Mill on the Yare.* Museum of Art (George W. Elkins Collection), Philadelphia.

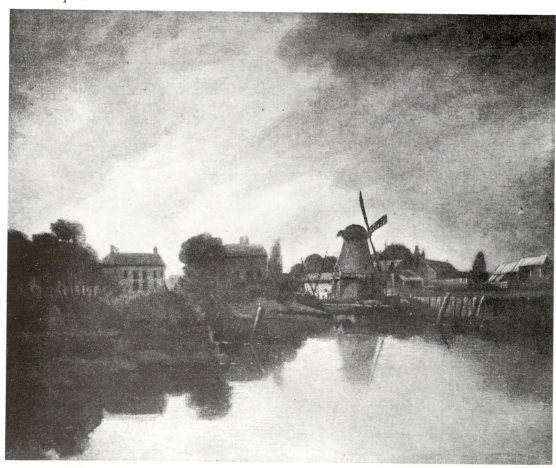

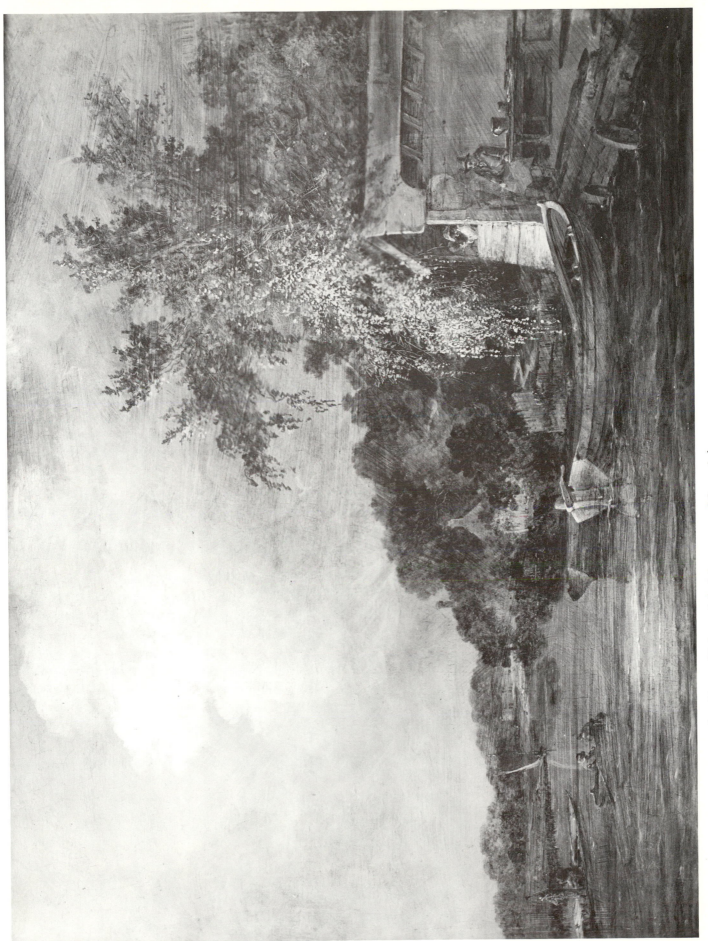

25. *The Yare at Thorpe, Norwich.* City of Norwich Museums, Norwich.

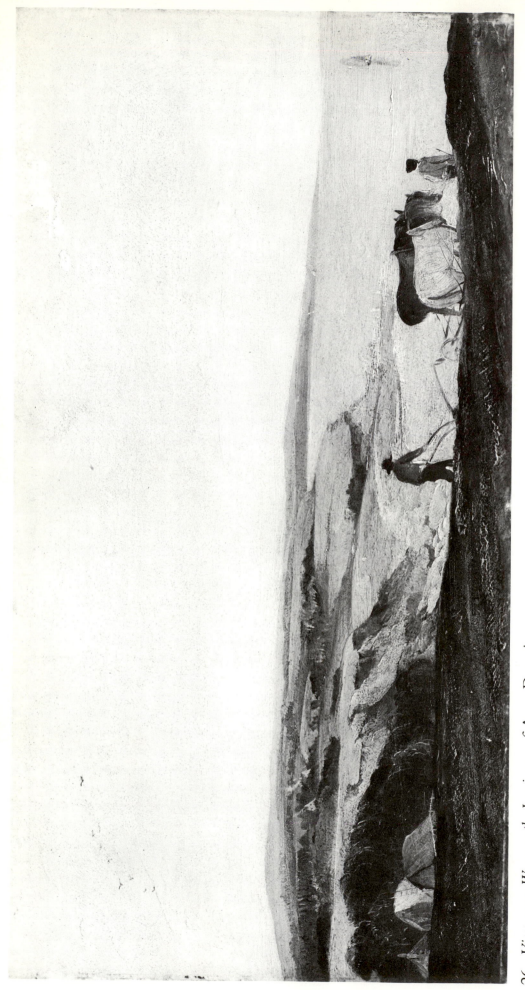

26. *View near Weymouth*. Institute of Arts, Detroit.

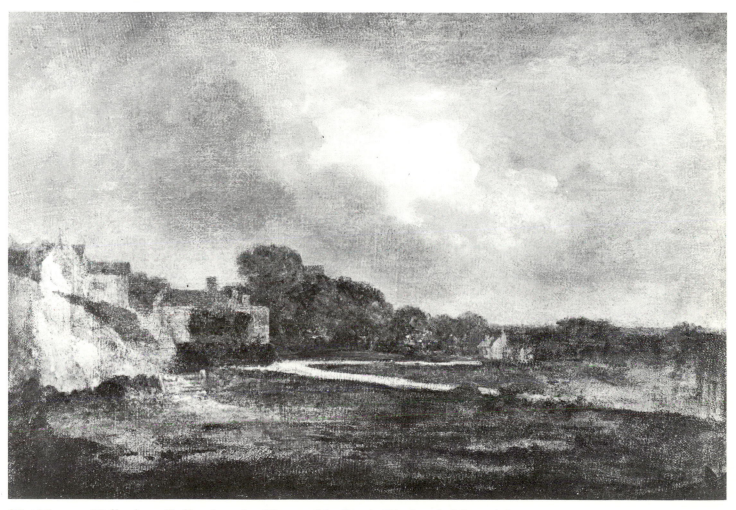

27. *View at Hellesdon*. Collection the Honorable Doris Harbord, Norwich.

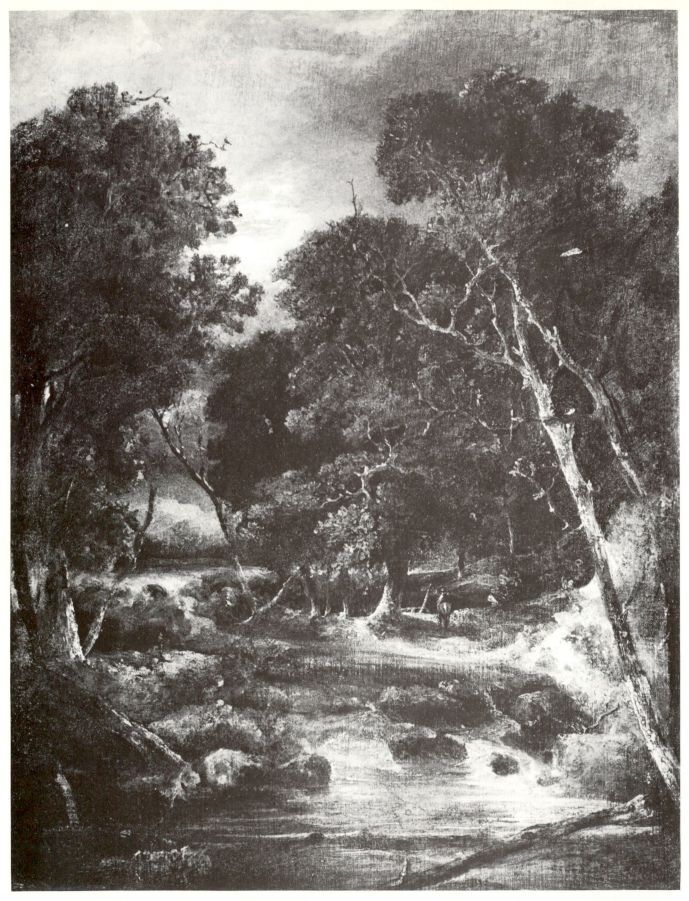

28. *View near Thorpe*. Collection Dr. and Mrs. Norman L. Goldberg, St. Petersburg, Florida.

following page:
29. *Yarmouth Jetty*. City of Norwich Museums, Norwich.

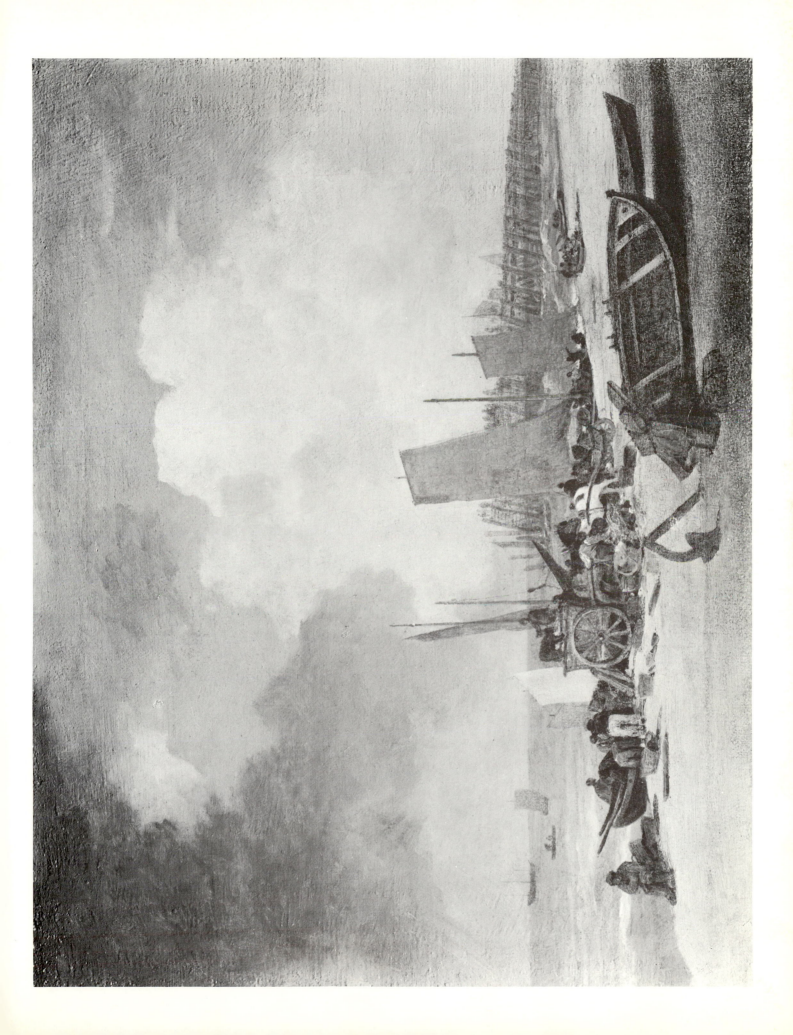

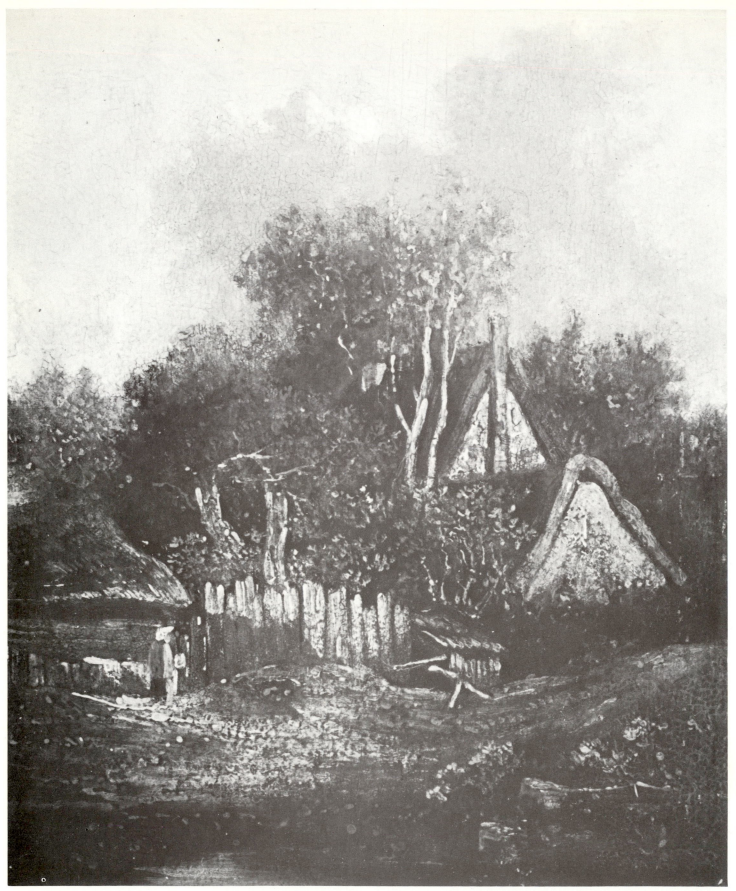

30. *Cottage near Yarmouth.* Collection Mr. Frederick L. Wilder, Woodford Green, Essex.

following page:
31. *Gibraltar Watering Place, Heigham.* With Marshall Spink, London.

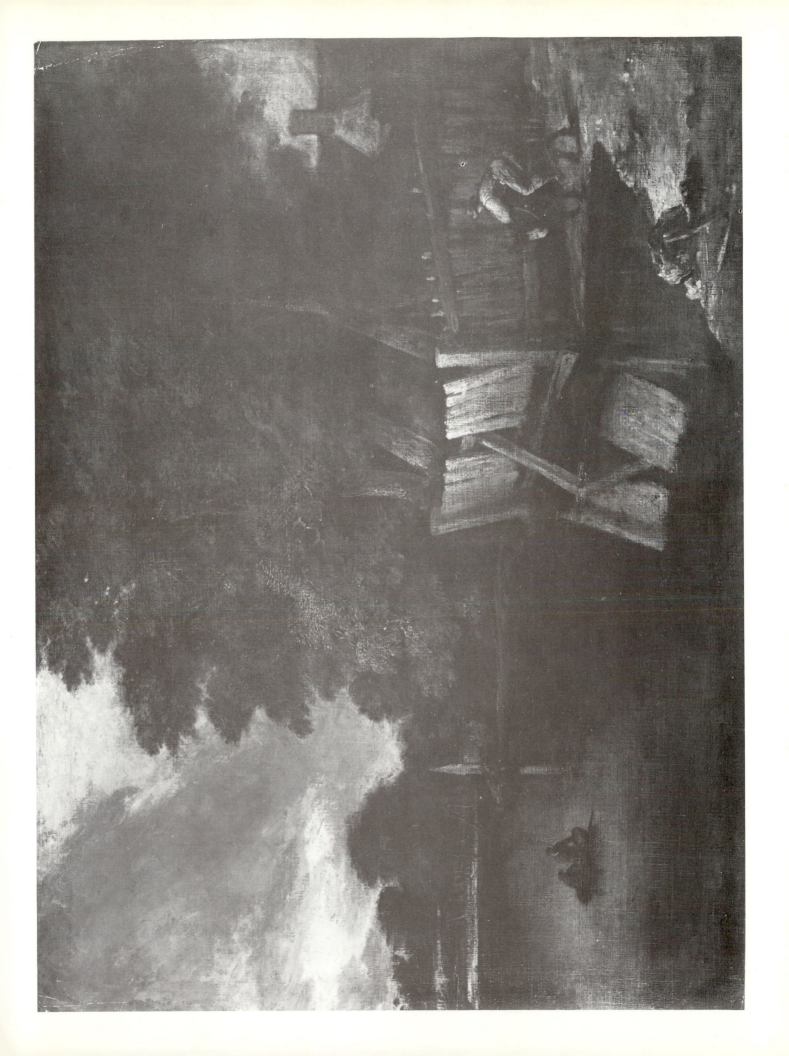

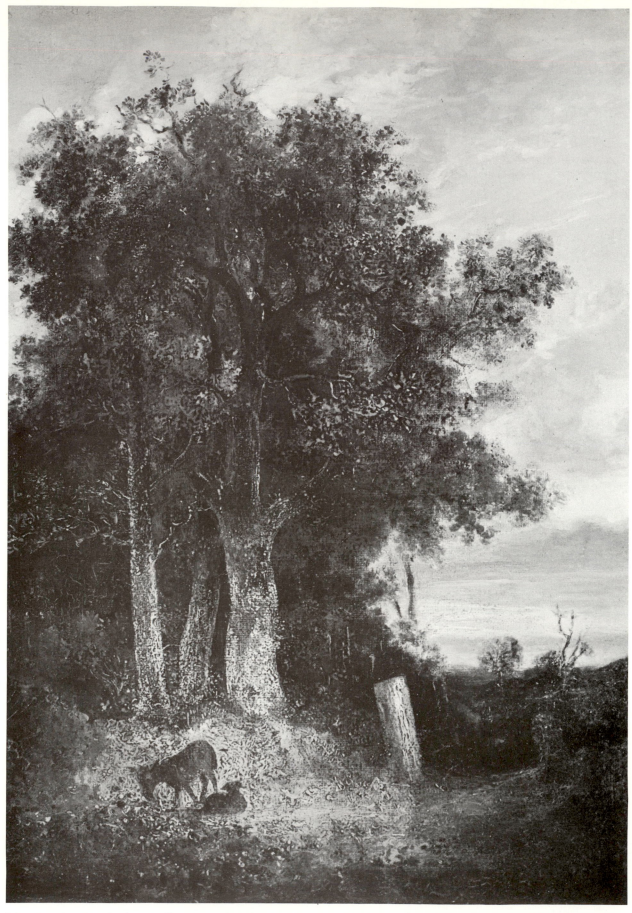

32. *By the Roadside*. Collection the Right Honorable Viscount Mackintosh of Halifax, Barford, Norfolk.

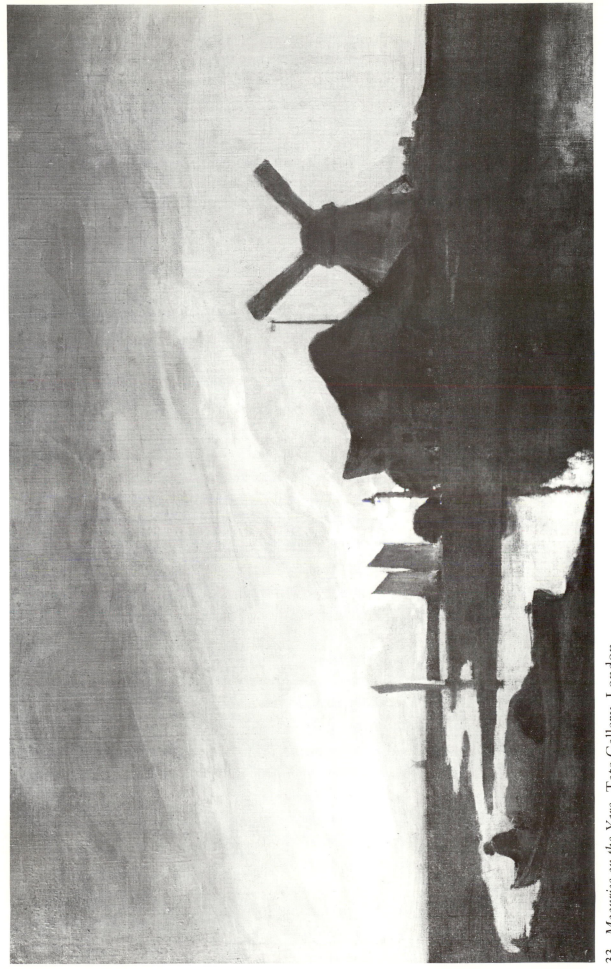

33. *Moonrise on the Yare.* Tate Gallery, London.

21

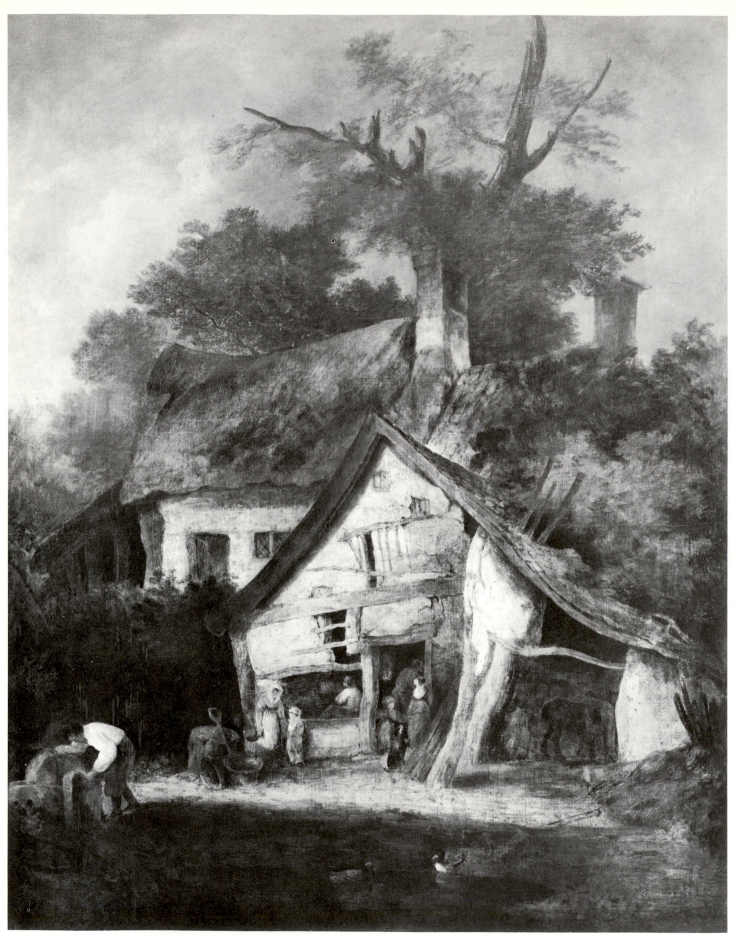

34. *The Blacksmith's Shop, Hingham*. Museum of Art (John M. McFadden Collection), Philadelphia.

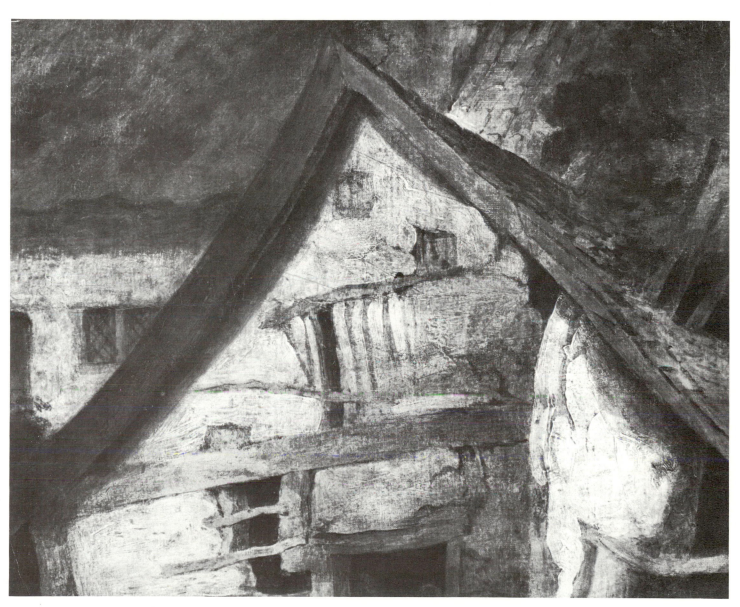

35. Detail of Figure 34.

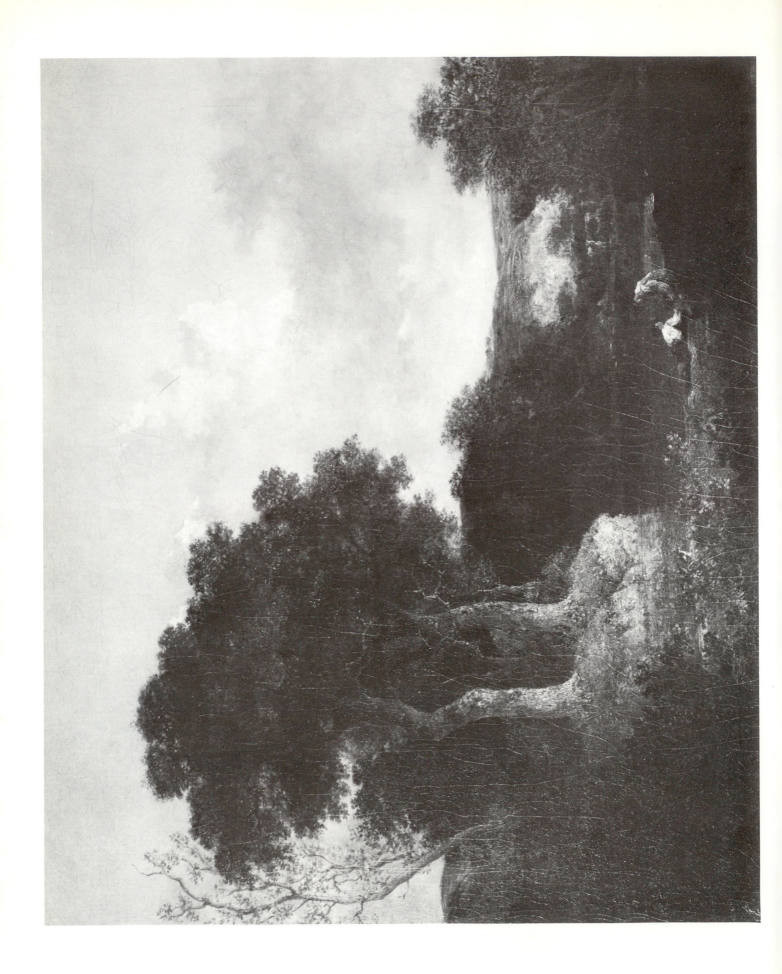

24

preceding page:
36. *Landscape*. Washington University Art Gallery, St. Louis.

37. (top) *A View on the Wensum*. City of Norwich Museums, Norwich.
38. (bottom) *View on the Yare*. Collection the Right Honorable Malcolm Macdonald, London.

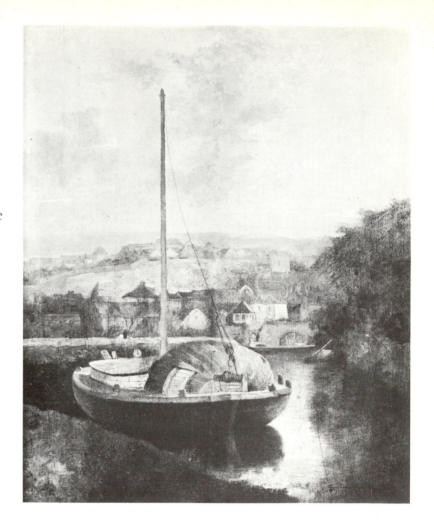

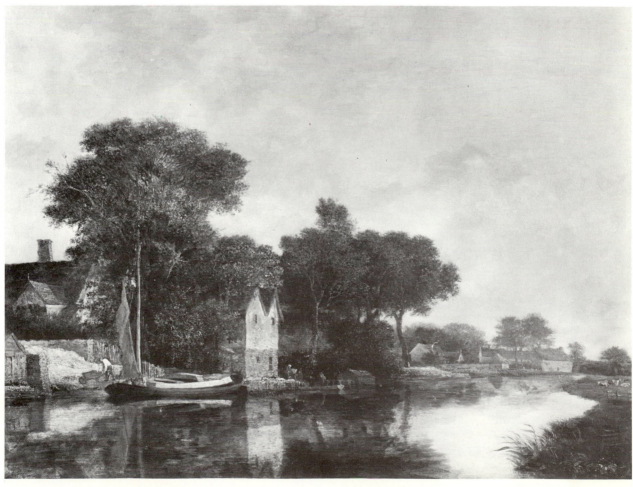

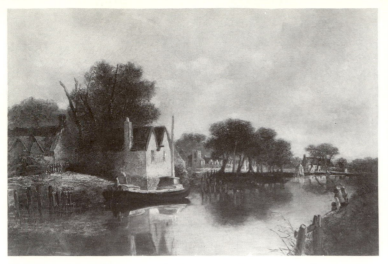

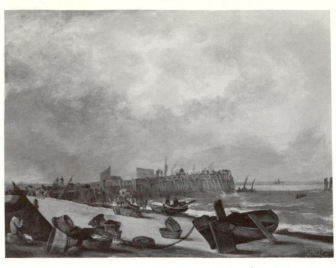

39. *River Landscape with Barge.* Yale Center for British Art, Paul Mellon Collection, New Haven, Connecticut.

40. *Yarmouth Jetty.* Yale Center for British Art, Paul Mellon Collection, New Haven, Connecticut.

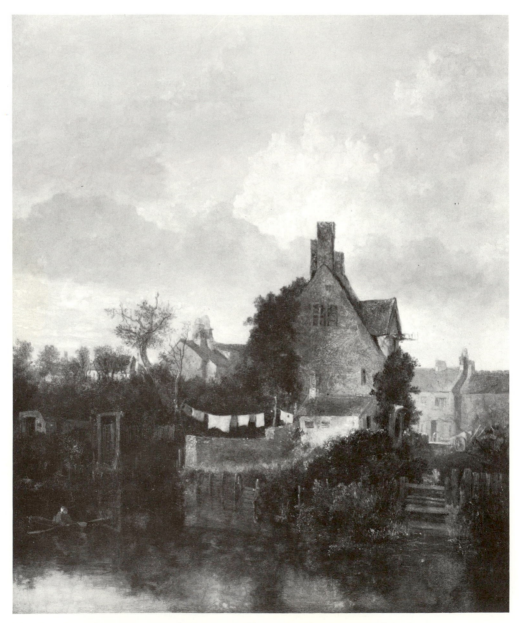

41. *St. Martin's River and Gate.* Collection the Honorable James Bruce, Balmano Castle, Scotland.

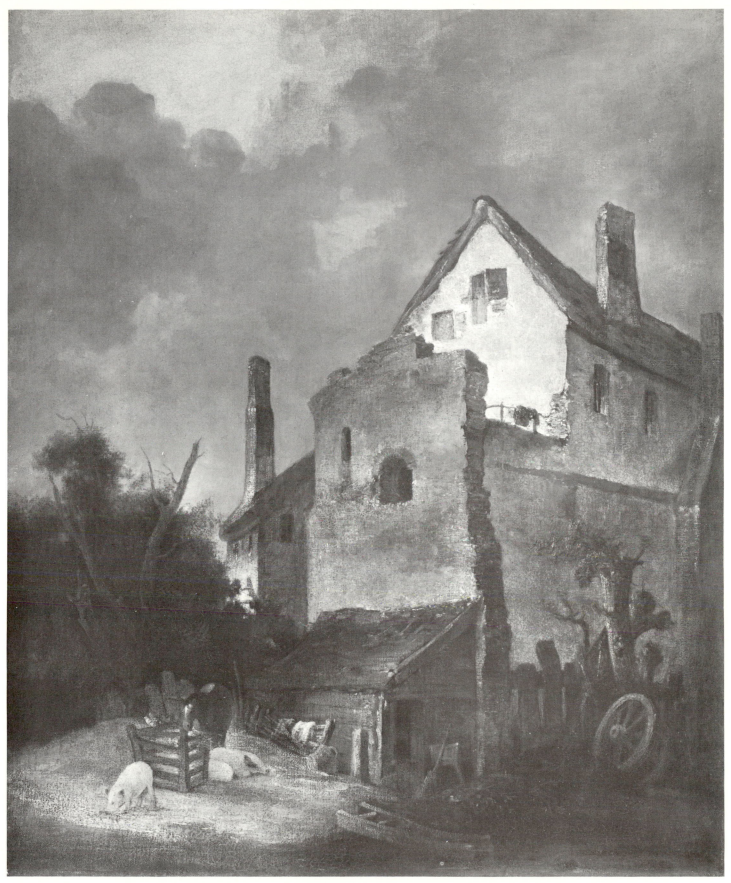

42. *Ruins, Evening.* National Gallery of Canada, Ottawa.

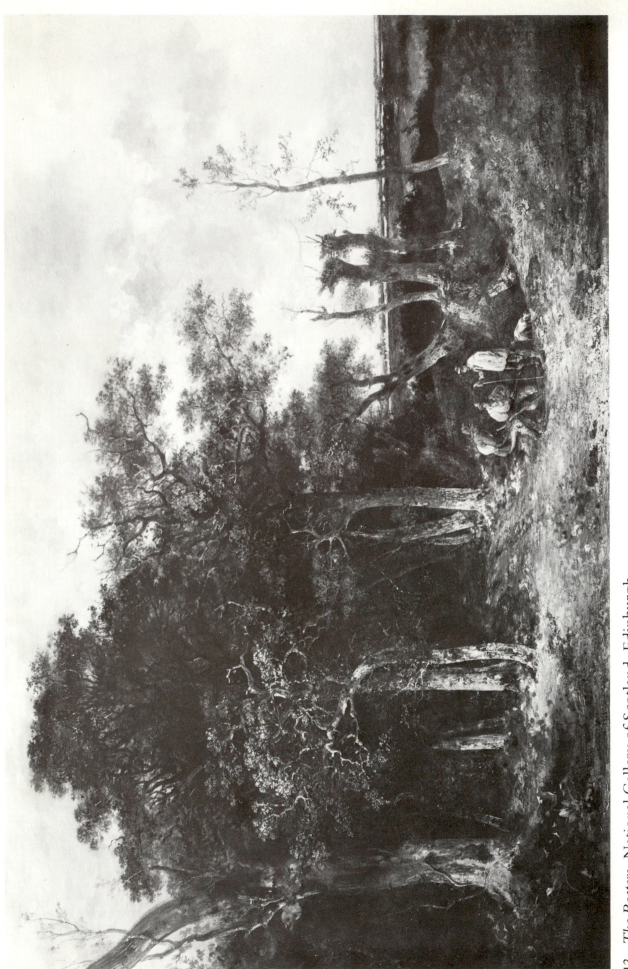

43. *The Beaters*. National Gallery of Scotland, Edinburgh.

following page:
44. Detail of Figure 43.

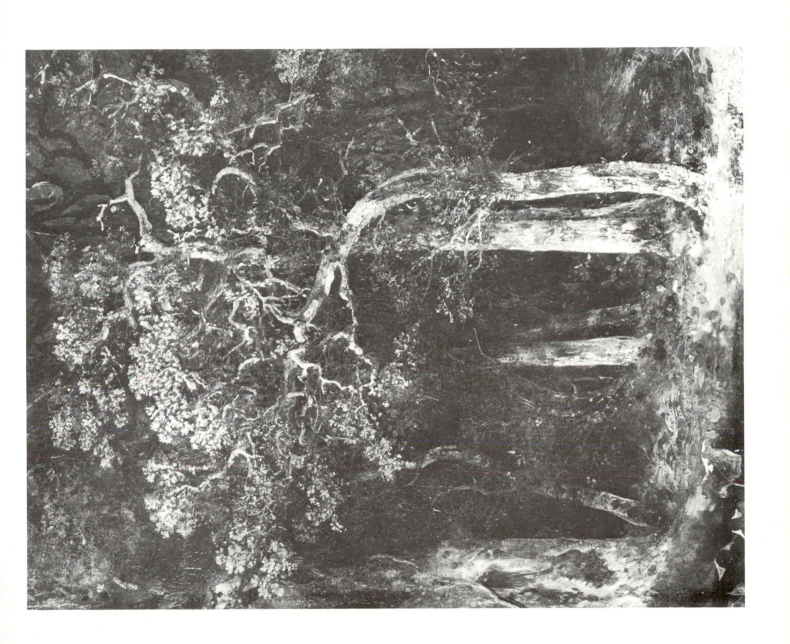

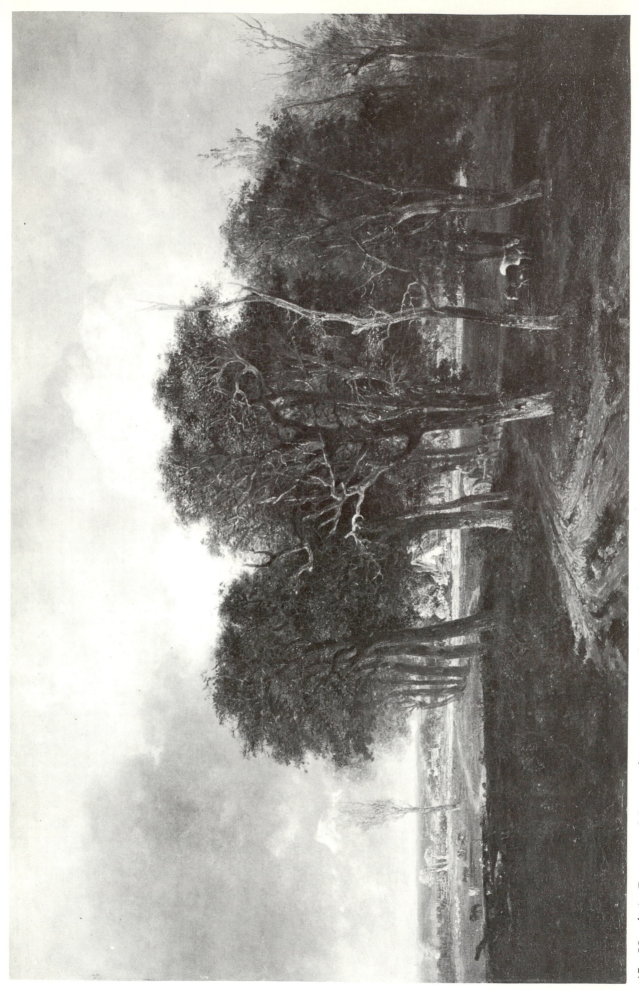

45. *Hautbois Common.* Metropolitan Museum of Art (Gift of Henry G. Marquand, 1889), New York.

following page:
46. *Back of the New Mills, Norwich,* Norwich. City of Norwich Museums, Norwich.

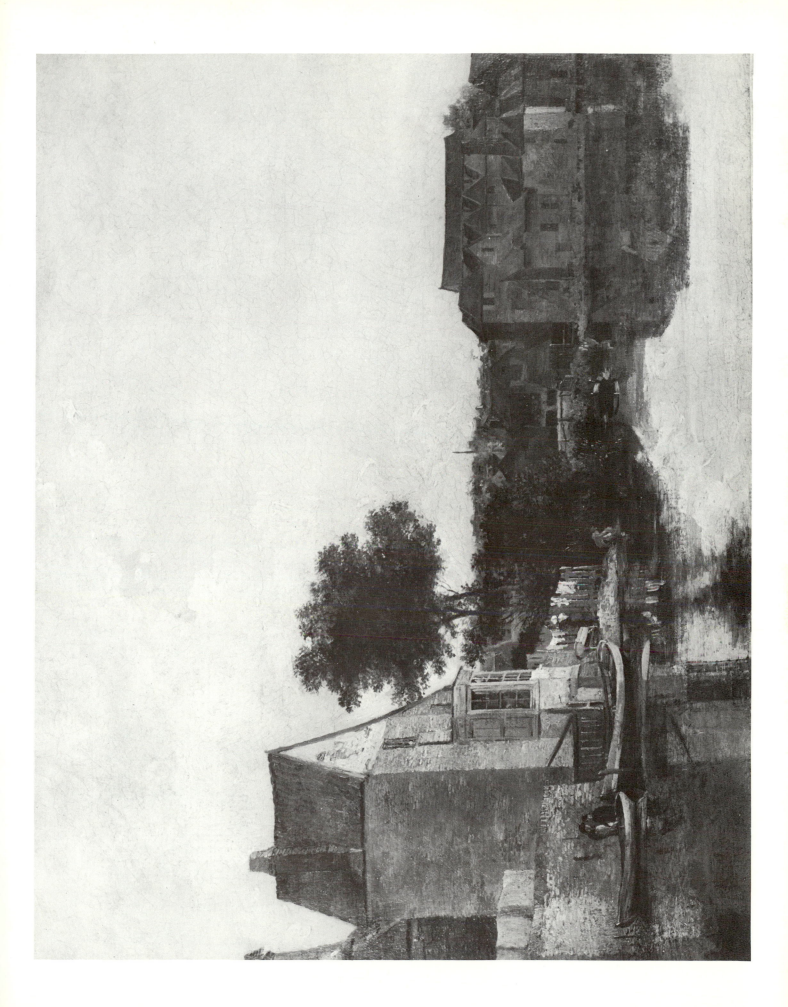

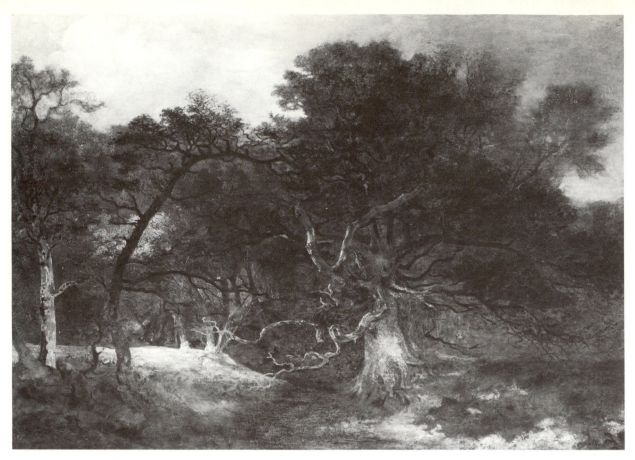

47. *A Woodland Scene near Norwich.* Yale Center for British Art, Paul Mellon Collection, New Haven, Connecticut.

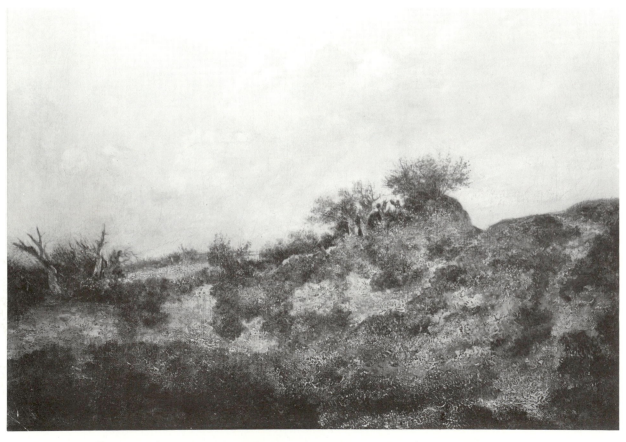

48. *A Sandy Bank.* Collection Mr. Christopher Norris, Dorking, Sussex.

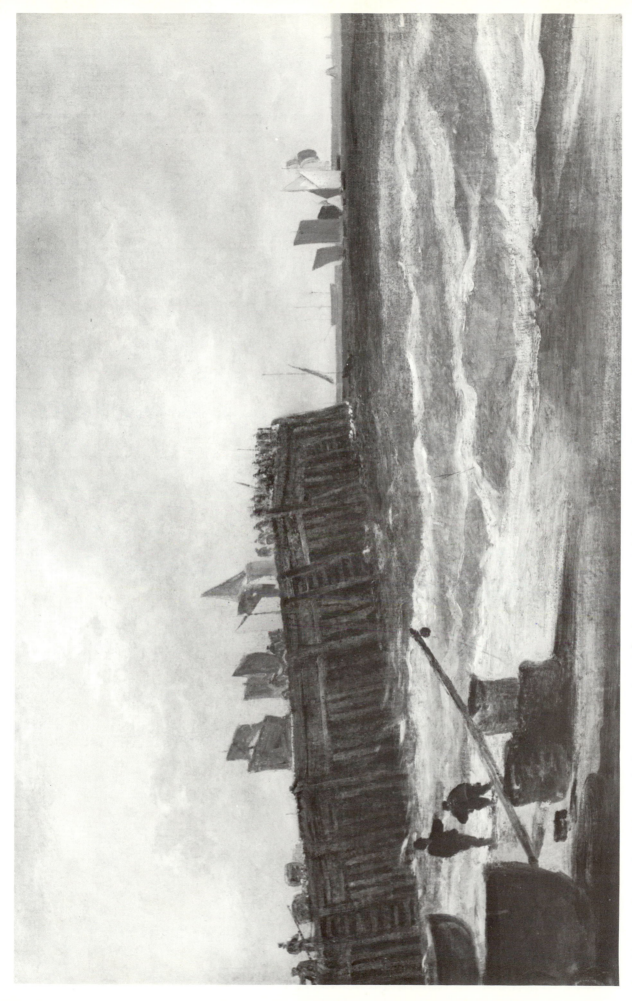

49. *Yarmouth Beach and Yetty.* Yale Center for British Art, Paul Mellon Collection, New Haven, Connecticut.

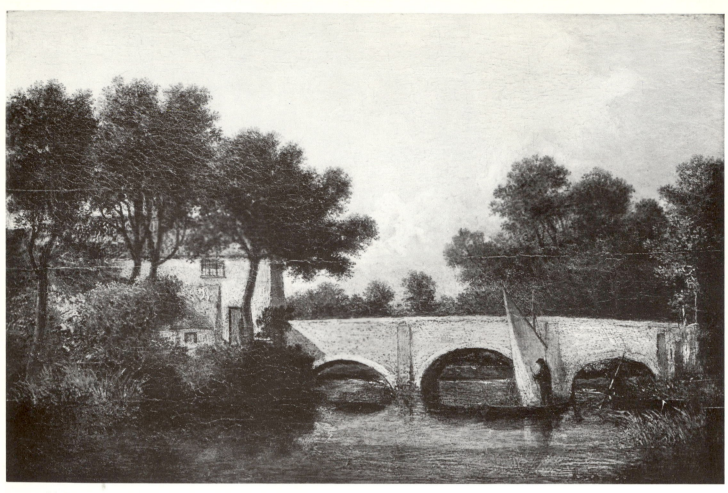

50. *Old Trowse Bridge*. City of Norwich Museums, Norwich.

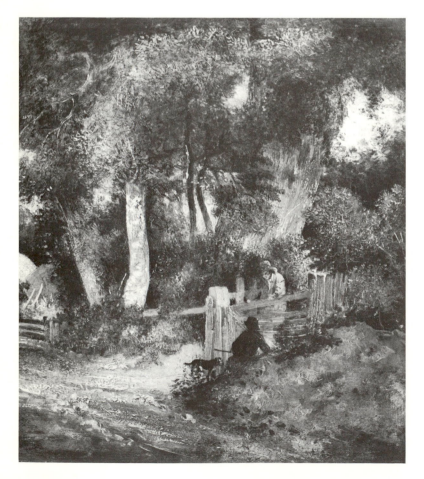

51. *Landscape at Blofield*. Collection the Right Honorable Viscount Mackintosh of Halifax, Barford, Norfolk.

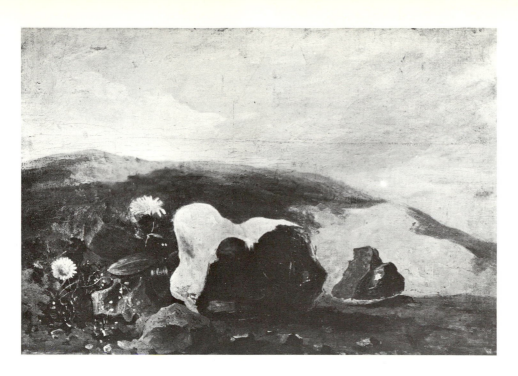

52. (top) *Study of Flints*. City of
Norwich Museums, Norwich.
53. (bottom) *The Skirts of the Forest*.
Victoria and Albert Museum
(Crown copyright), London.

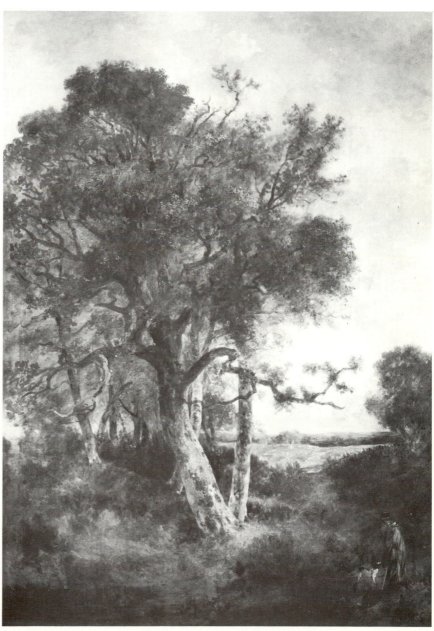

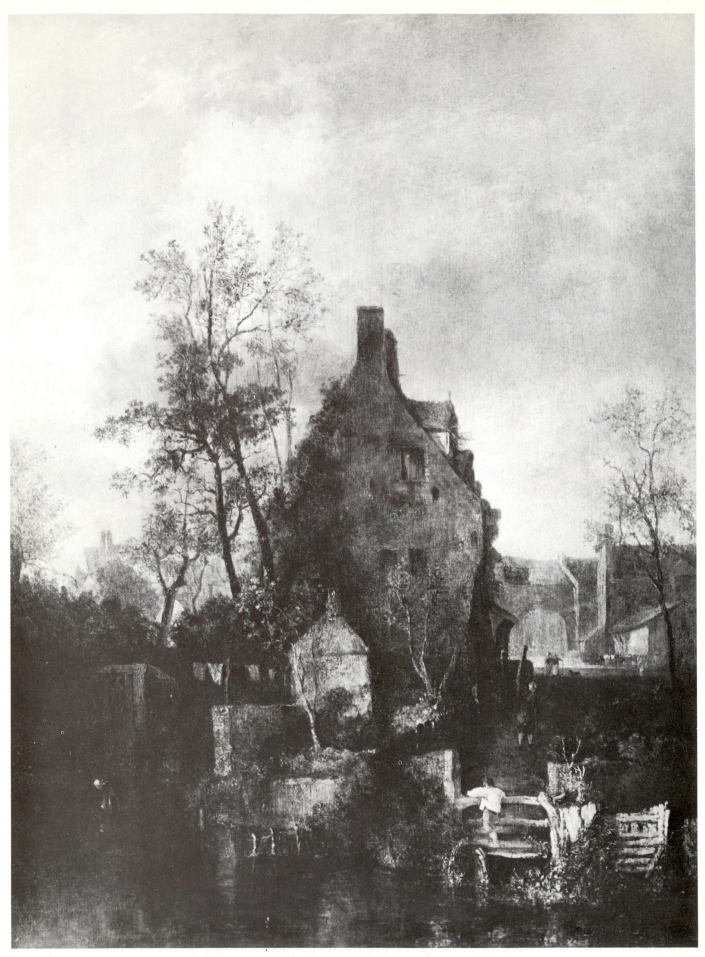

54. *St. Martin's Gate, Norwich.* City of Norwich Museums, Norwich.

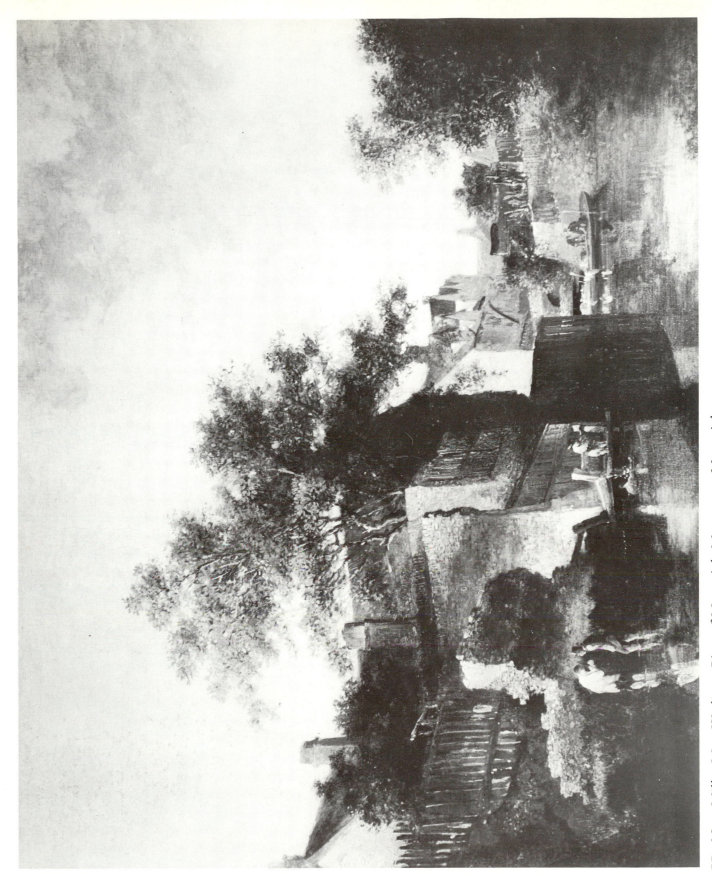

55. *New Mills: Men Wading*. City of Norwich Museums, Norwich.

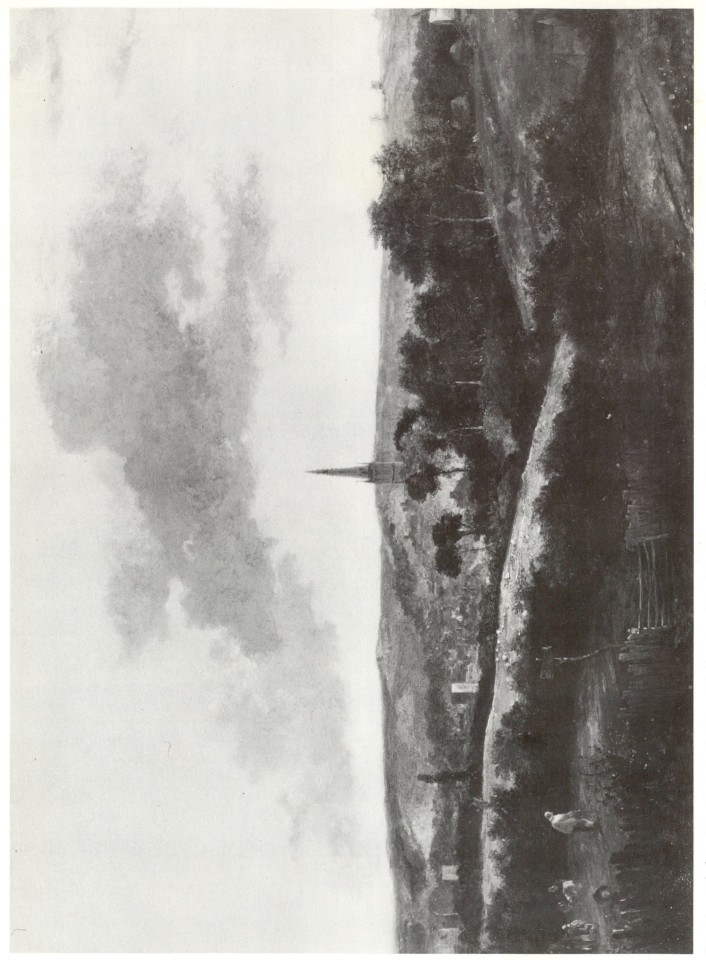

56. *Norwich from St. Augustine's Gate.* Collection Mr. John Gurney, Walsingham Abbey, Norfolk.

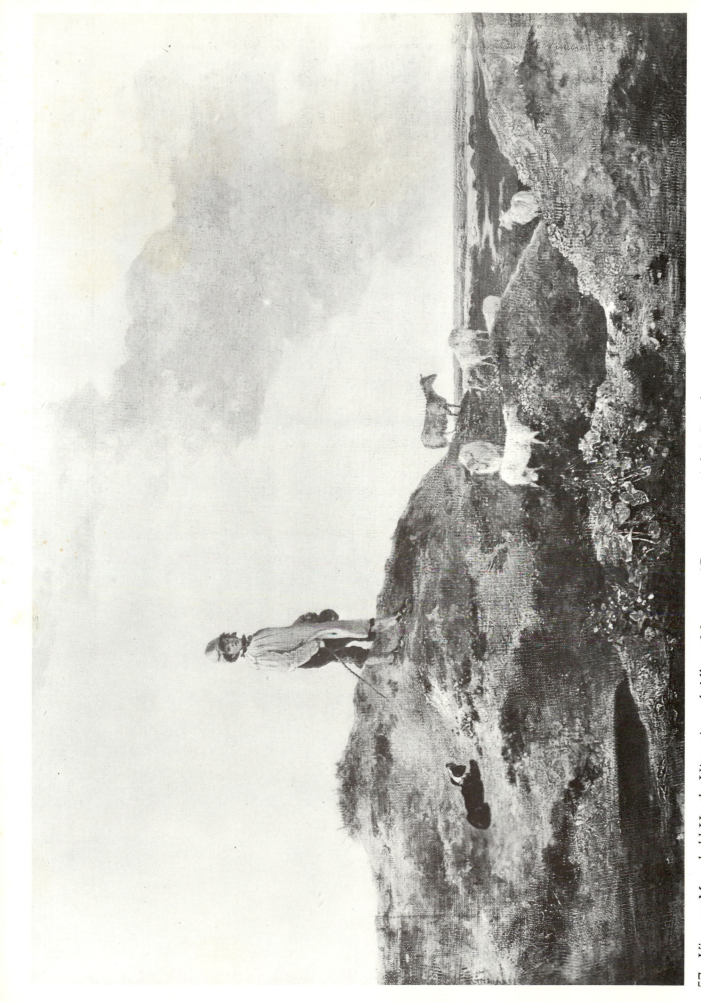

57. *View on Mousehold Heath.* Victoria and Albert Museum (Crown copyright), London.

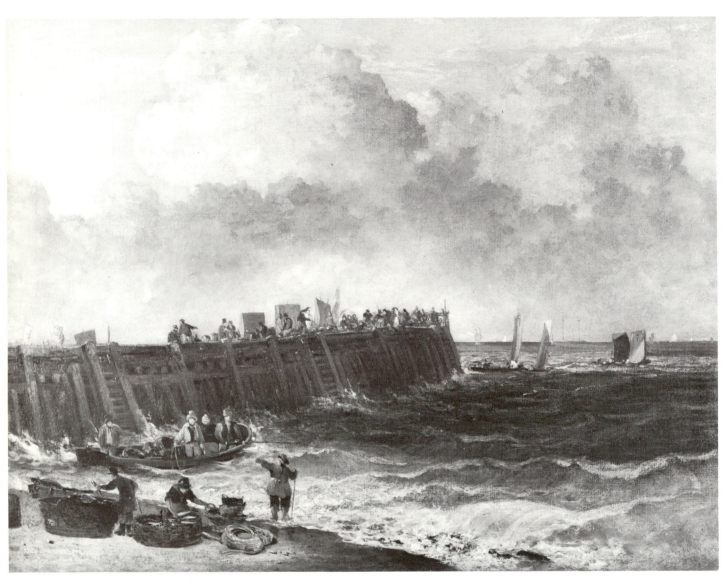

58. *Yarmouth Jetty*. City of Norwich Museums, Norwich.

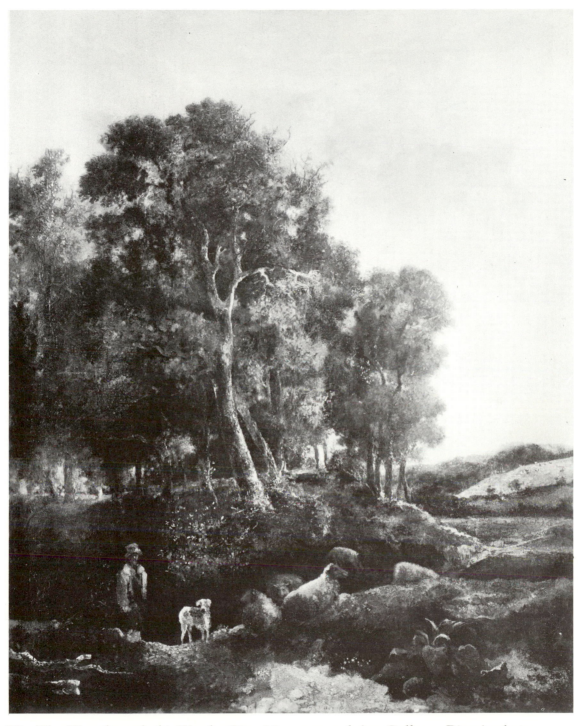

59. *The Way through the Woods.* City Museum and Art Gallery, Birmingham.

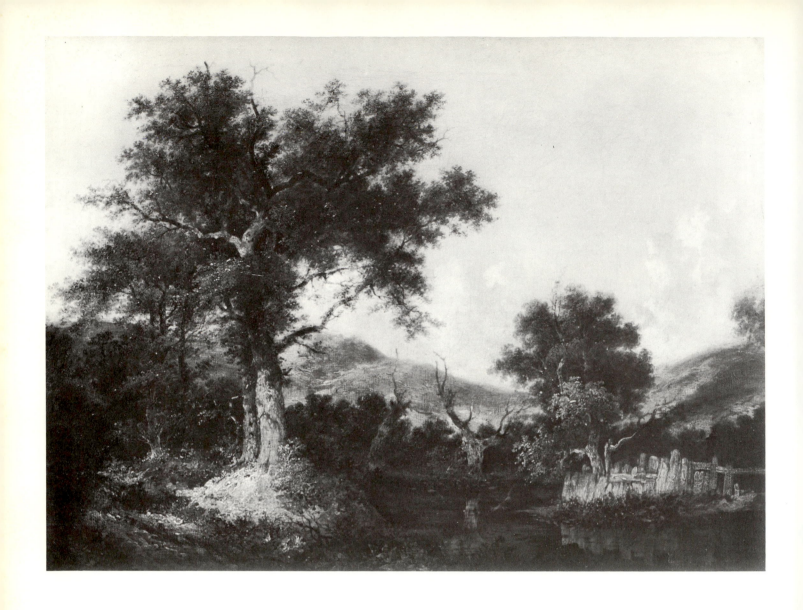

60. *Hingham Lane Scene, Norfolk.* Tate Gallery,
London.
following page:
61. (top) (Copy), *Hingham Lane Scene, Norfolk.*
Collection Mrs. Leonard A. Toone, Greenwich,
Connecticut.
62. (bottom) Detail of Figure 61.

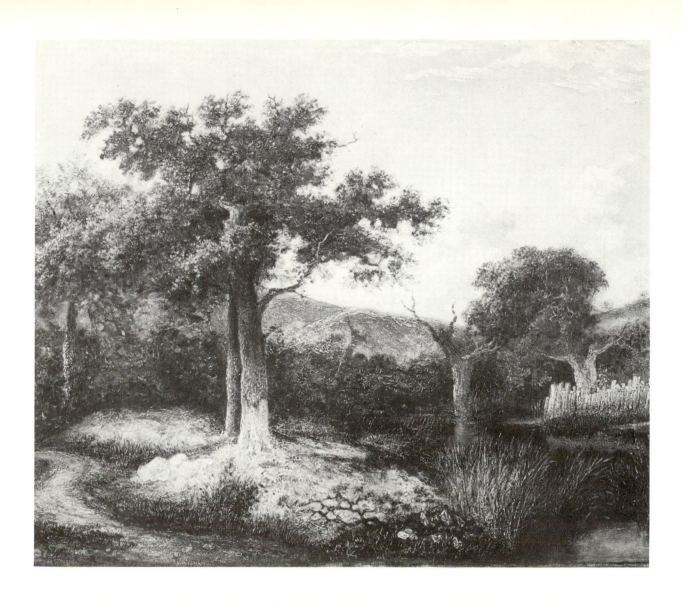

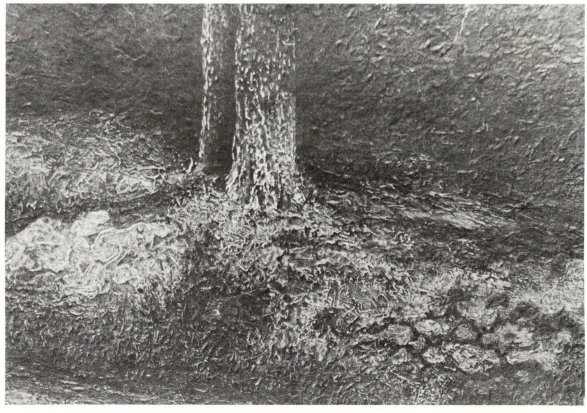

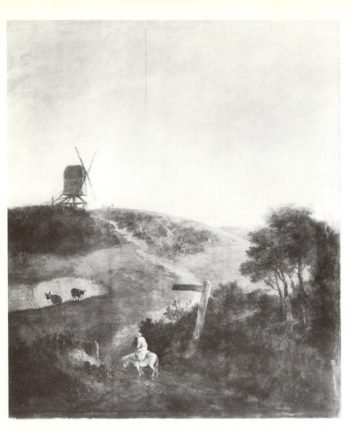

following page:
65. *Study of a Burdock*. City of Norwich Museums, Norwich.

63. (top) *A Windmill near Norwich*. Tate Gallery, London.
64. (bottom) *View of Kirstead Church*. City of Norwich Museums, Norwich.

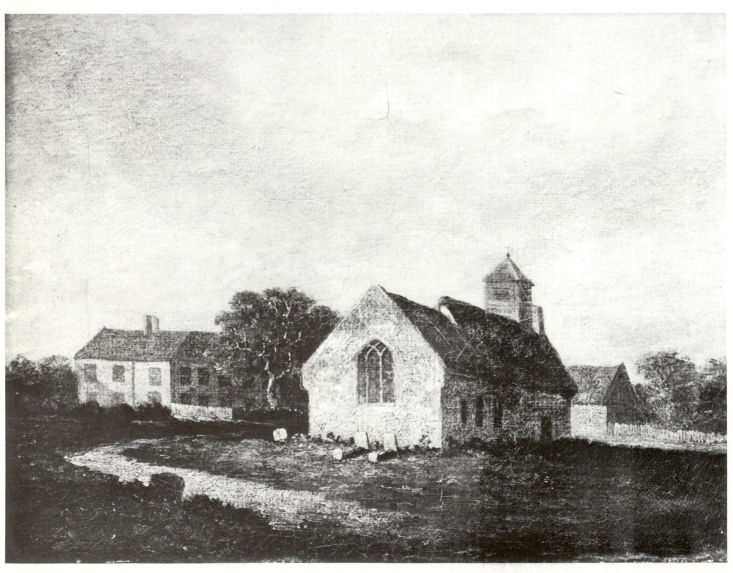

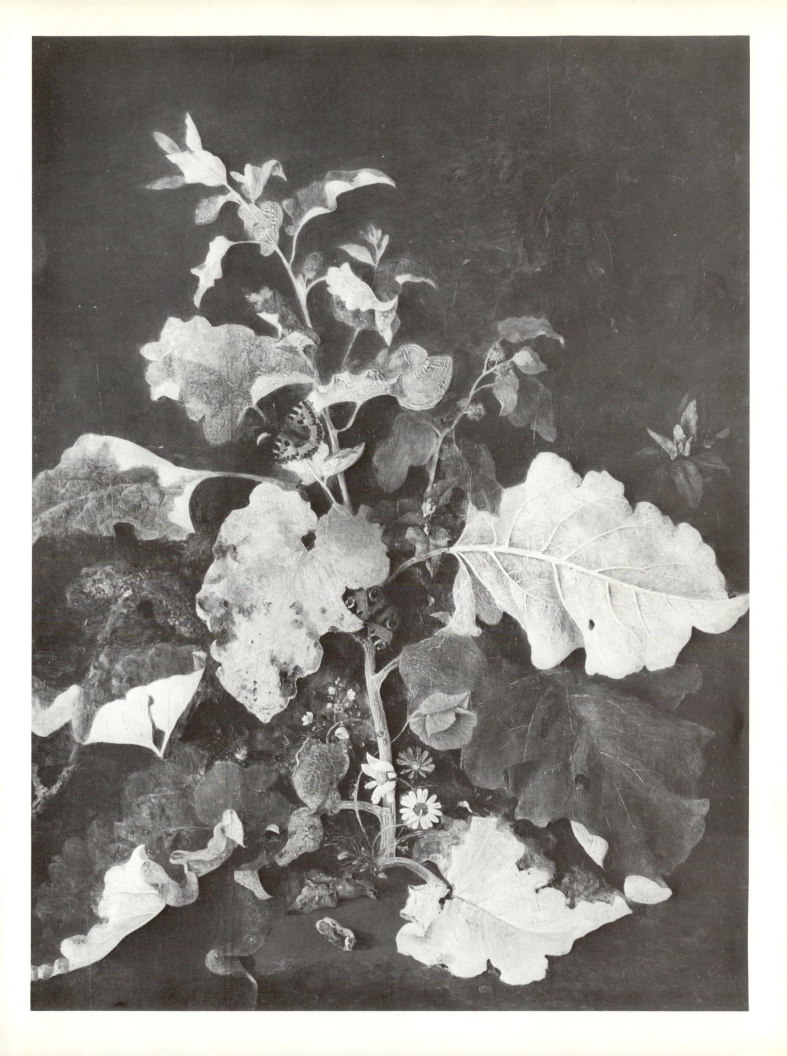

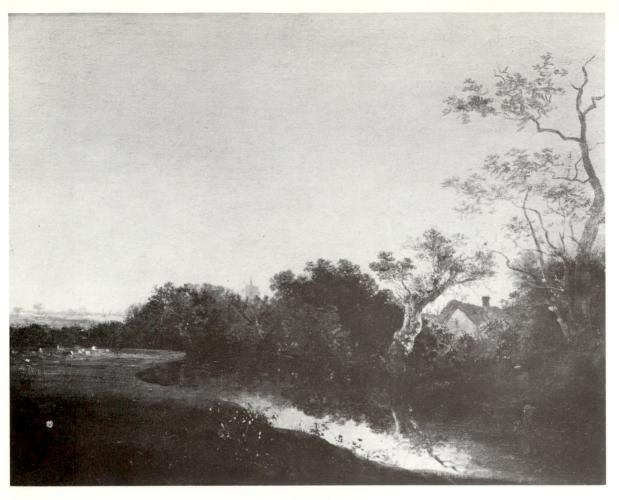

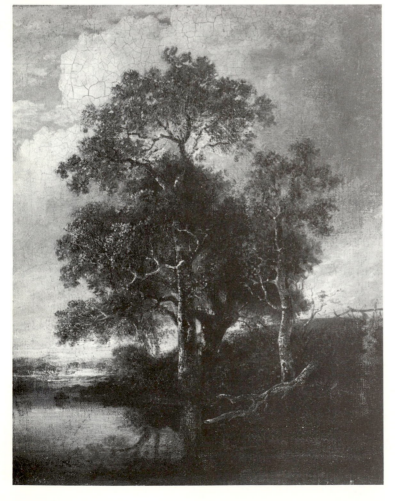

66. (top) *At Honingham.* City of Norwich
Museums, Norwich.
67. (bottom) *Clump of Trees, near Salhouse.*
Corcoran Gallery of Art, Washington, D. C.

following page:
68. (top) *The Old Oak.* National Gallery of
Canada, Ottawa.
69. (bottom) (Copy), *The Old Oak.*
Collection Mr. and Mrs. M. Walker, New
York.

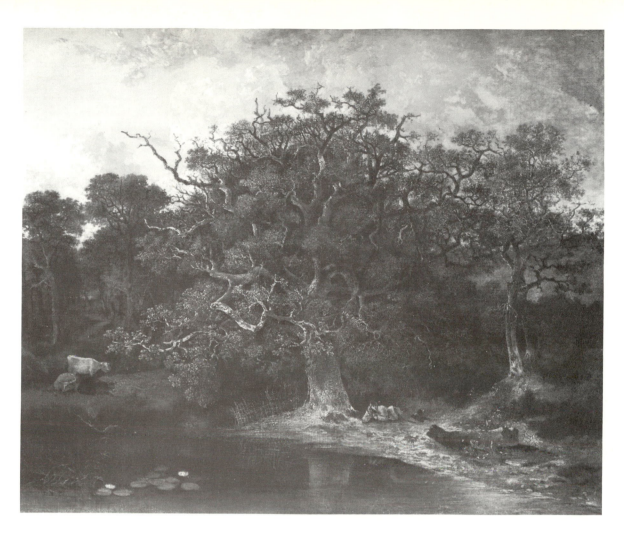

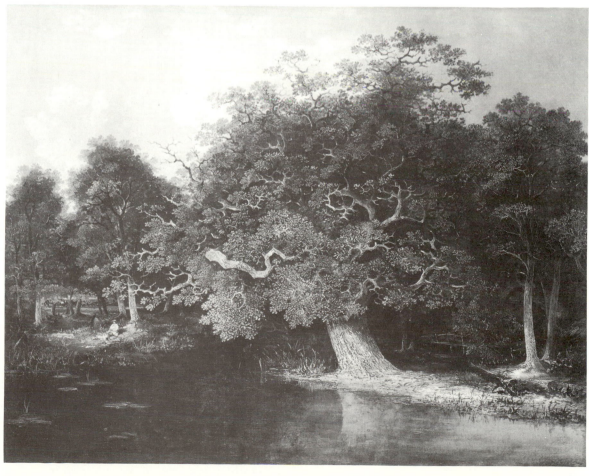

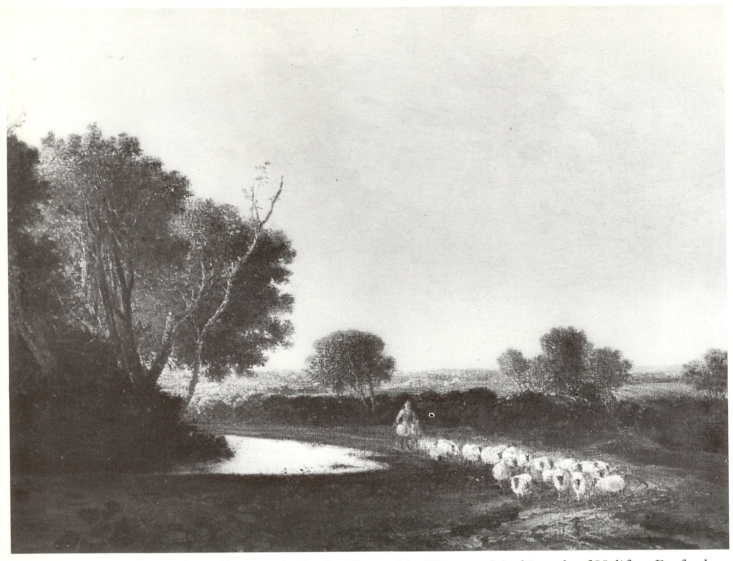

70. *The Return of the Flock*. Collection the Right Honorable Viscount Mackintosh of Halifax, Barford, Norfolk.

71. *Study of Dock Leaves*. City of Norwich Museums, Norwich.

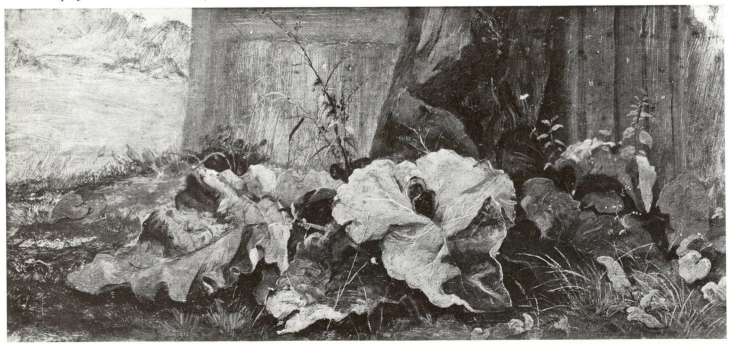

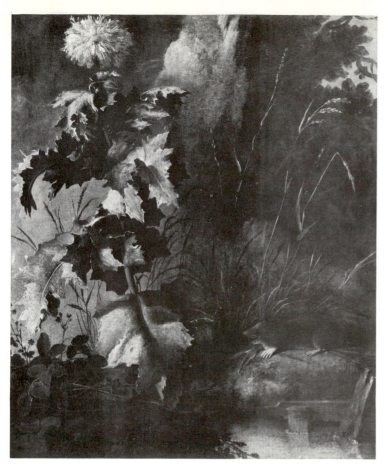

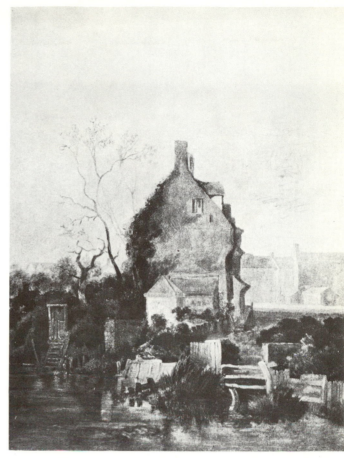

72. (top left) *Thistle and Water Vole*. Yale
Center for British Art, Paul Mellon
Collection, New Haven, Connecticut.
73. (top right) *St. Martin's Gate*.
Museum of Art (William L. Elkins
Collection), Philadelphia.
74. (bottom) *The Edge of a Common*.
Henry E. Huntington Library and Art
Gallery, San Marino, California.

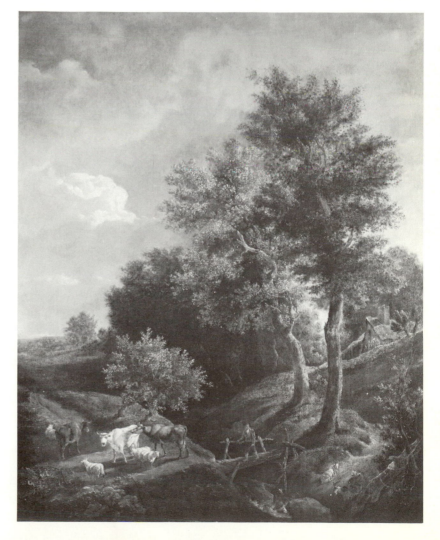

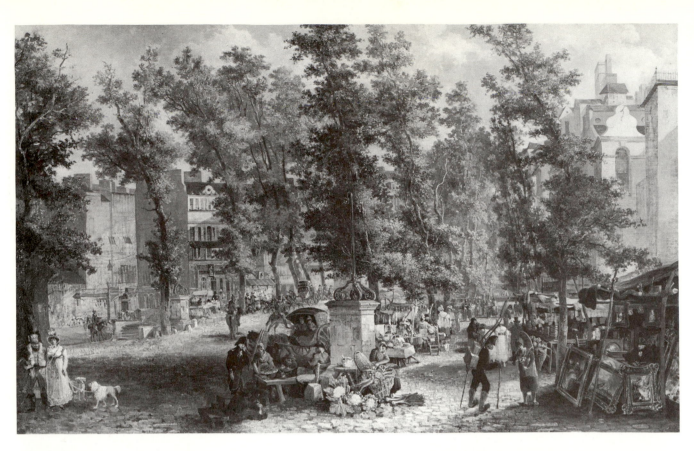

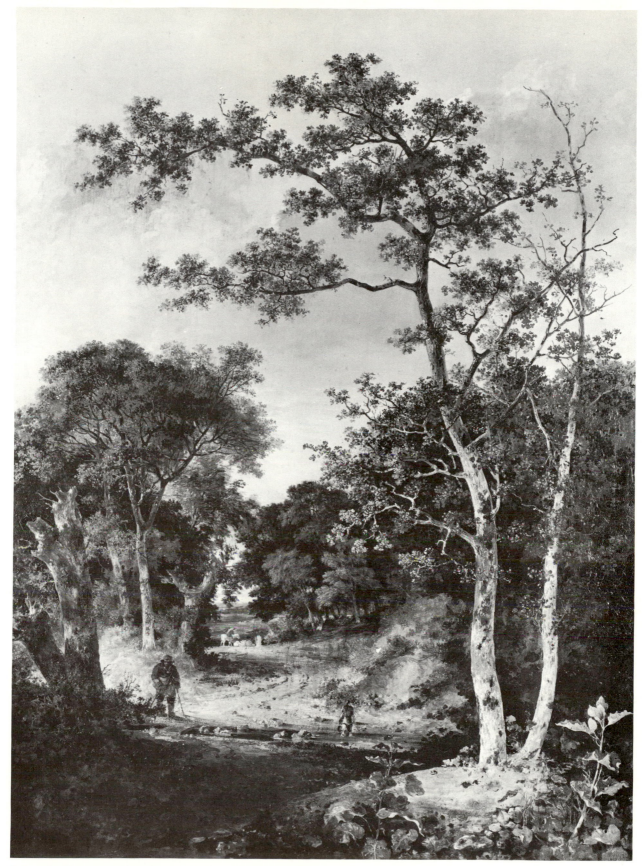

77. *Marlingford Grove.* Lady Lever Art Gallery, Port Sunlight.

preceding page:
75. (top) *Boulevard des Italiens, Paris.* Collection Mr. R. Q. Gurney, Bawdeswell Hall, Norfolk.
76. (bottom) Detail of Figure 75.

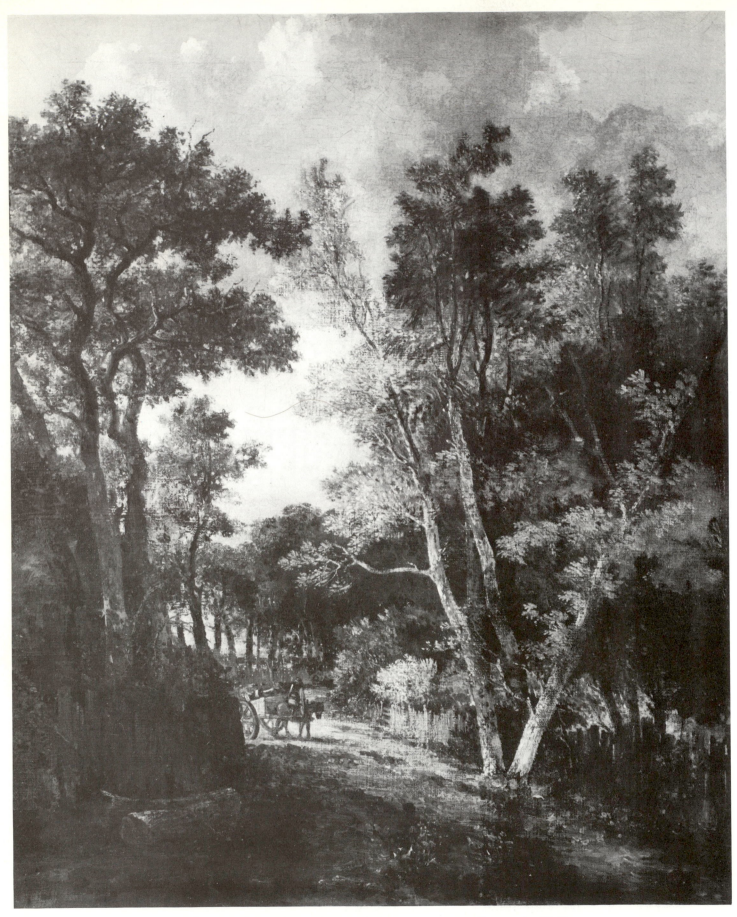

78. *Catton Lane Scene*. Collection Mr. Humphrey A. Day, Saxmundham, Suffolk.

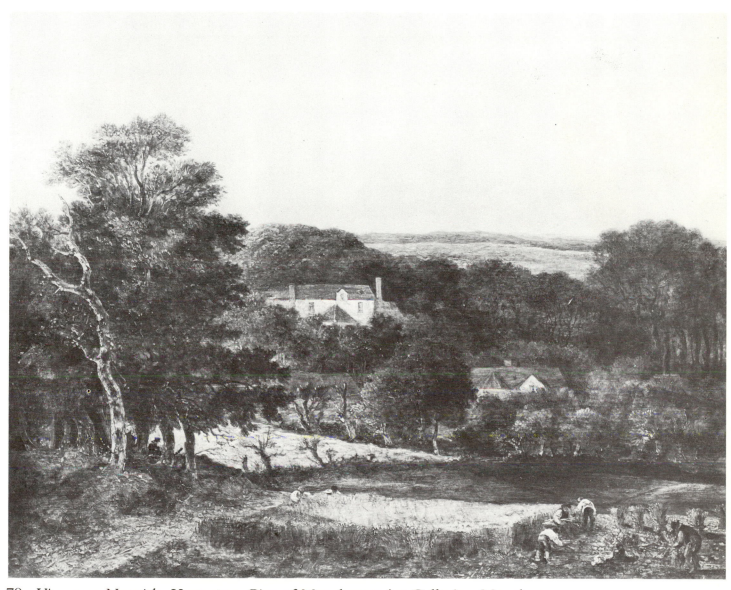

79. *View near Norwich, Harvesters*. City of Manchester Art Galleries, Manchester.

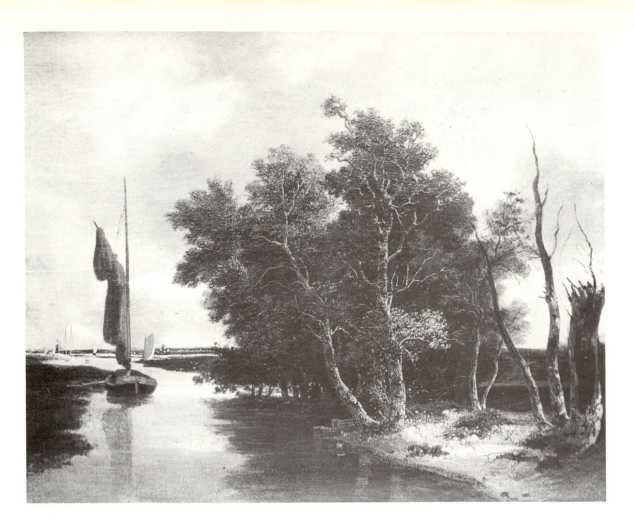

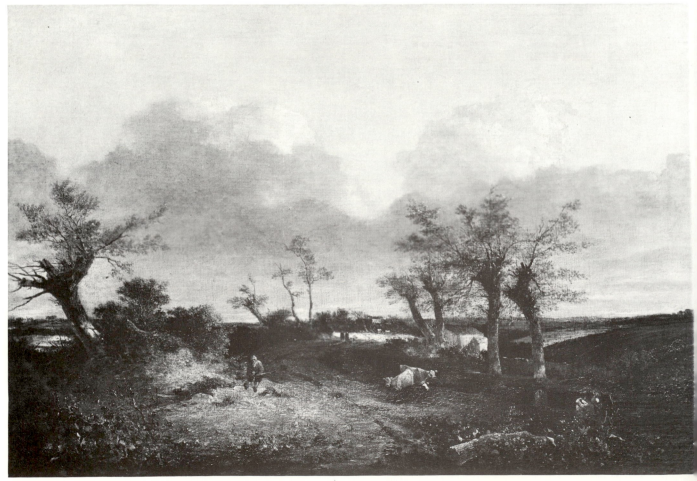

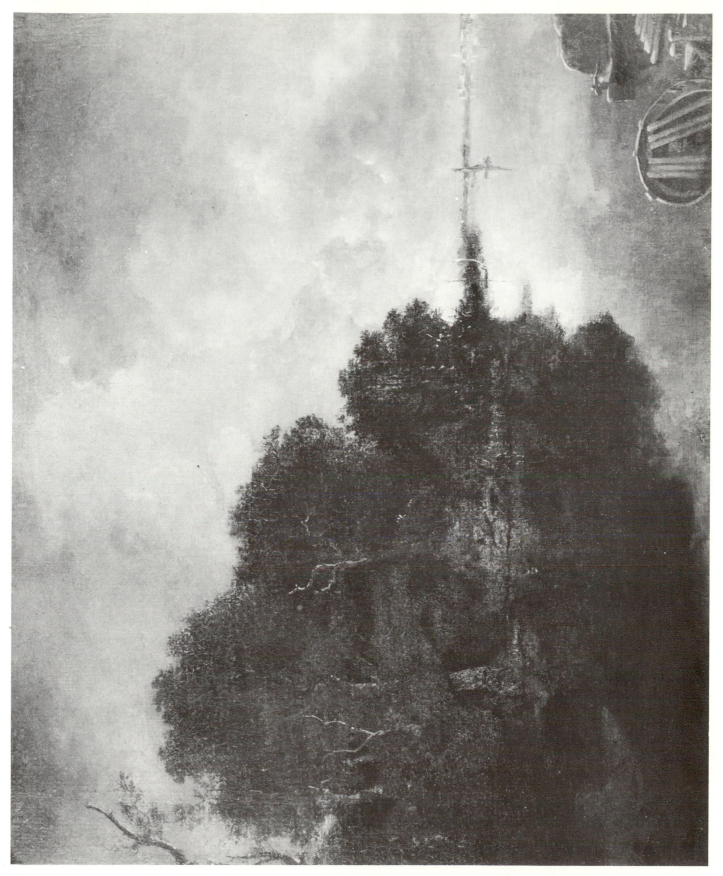

82. *Bruges River—Ostend in the Distance—Moonlight*. City of Norwich Museums, Norwich.

preceding page:
80. *Wherries on the Yare*. City Art Galleries, Leeds.
81. *Road with Pollards*. City of Norwich Museums, Norwich.

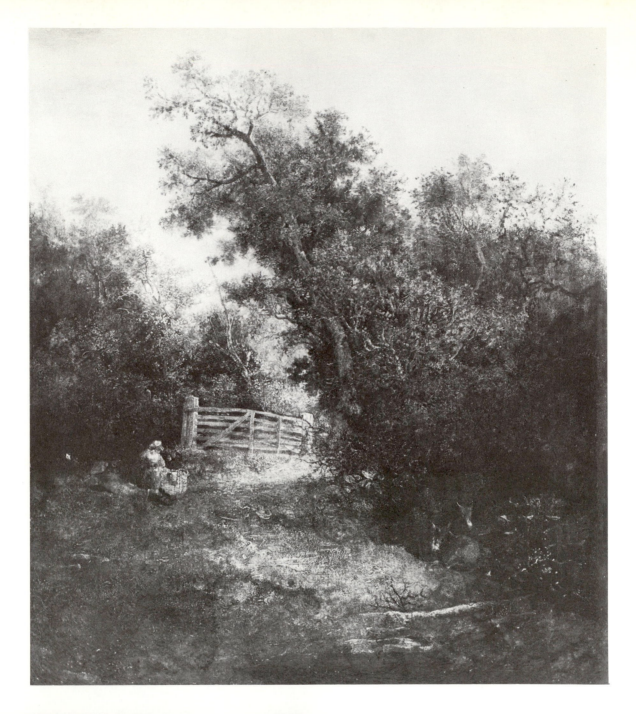

83. (top) *The Gate*. Private Collection.
84. (bottom) Detail of Figure 83.

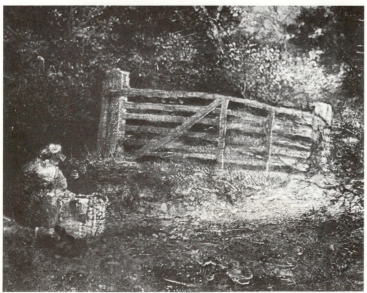

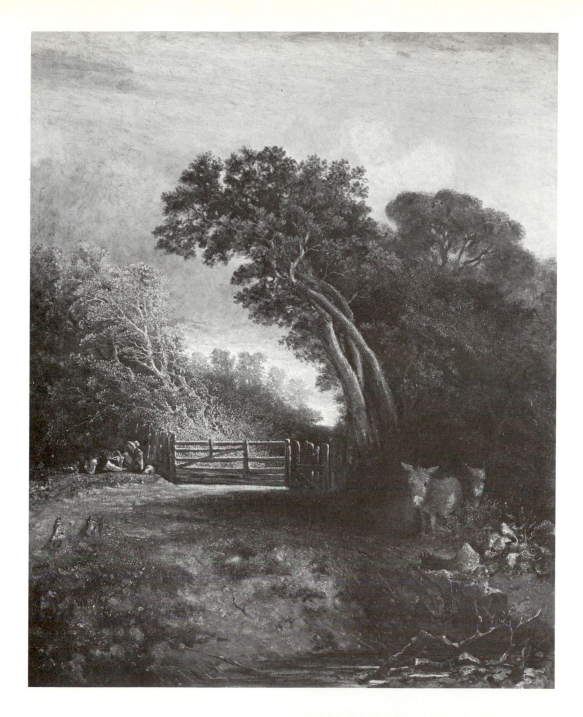

85. (top) (Copy), *The Harling Gate, near Norwich*. National Gallery of Art (Widener Collection), Washington, D. C.
86. (bottom) Detail of Figure 85.

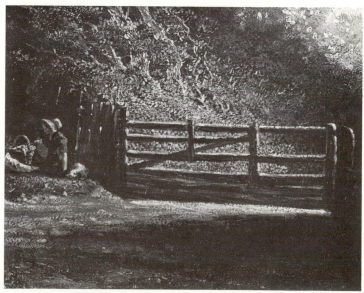

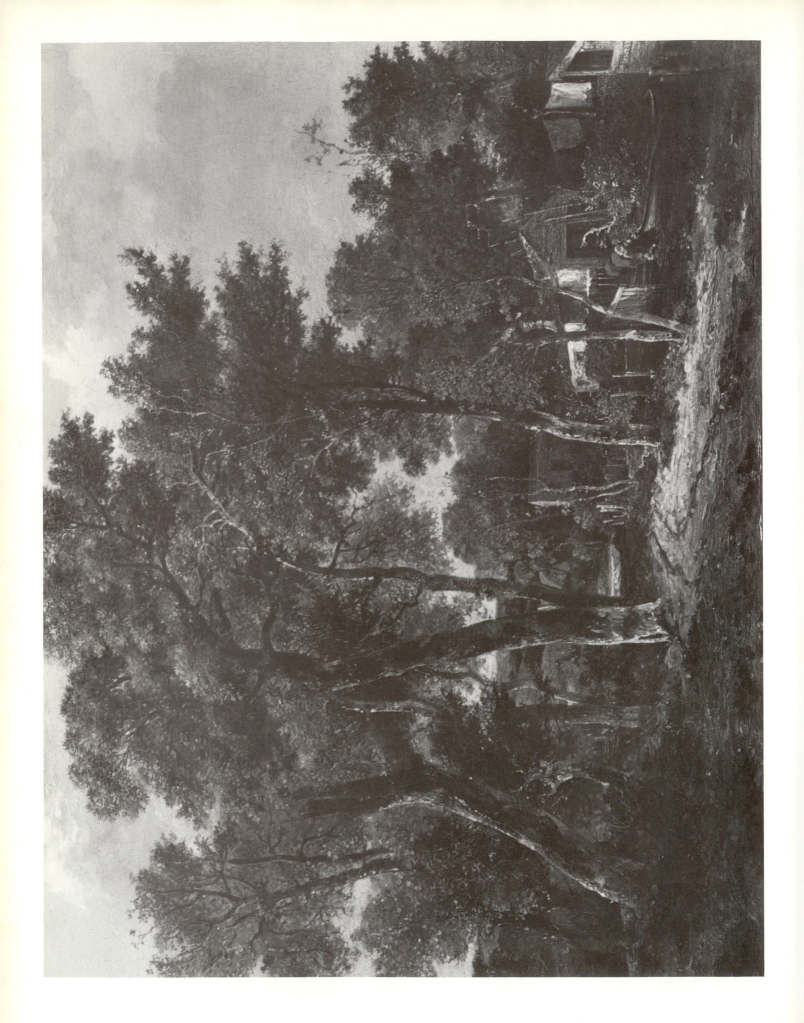

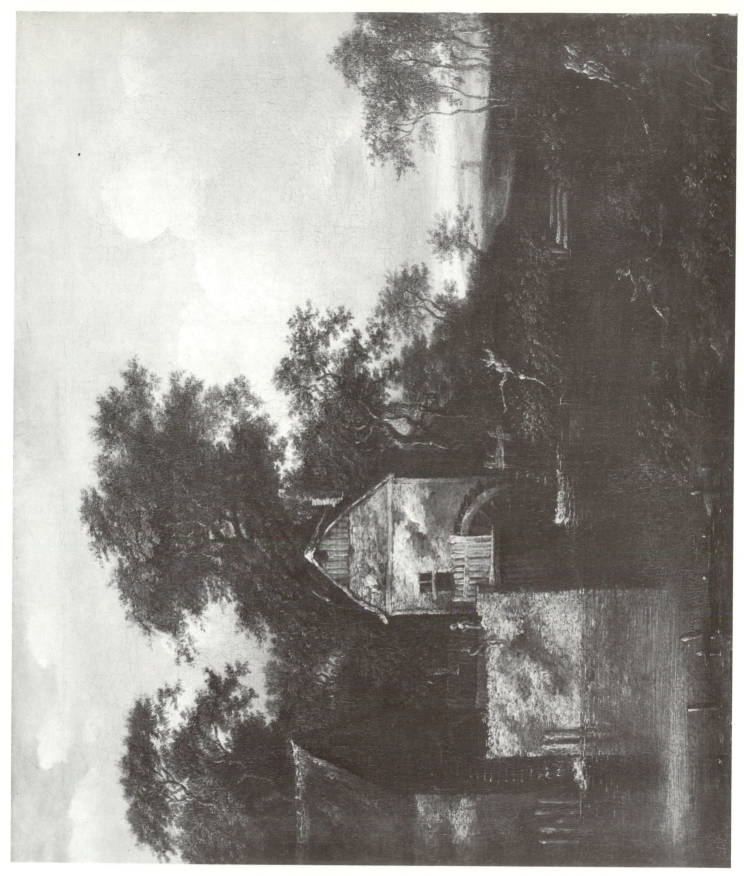

88. *An Old Watermill*. Collection Dr. and Mrs. Norman L. Goldberg, St. Petersburg, Florida.

preceding page:
87. *A Road near Bury St. Edmunds*. Collection Mrs. Oscar Ashcroft, Eastbourne, Sussex.

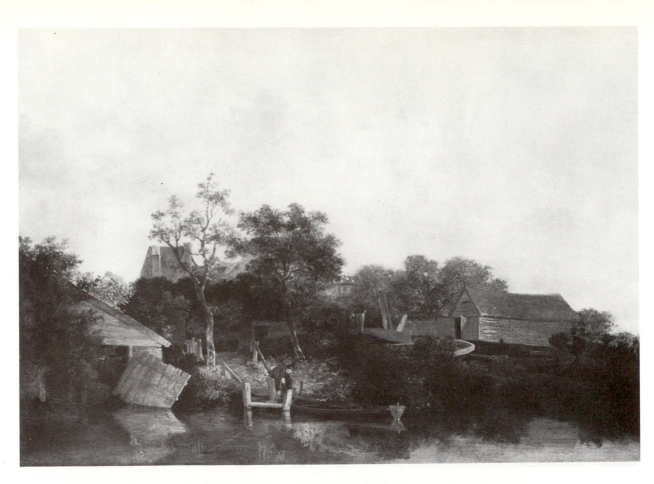

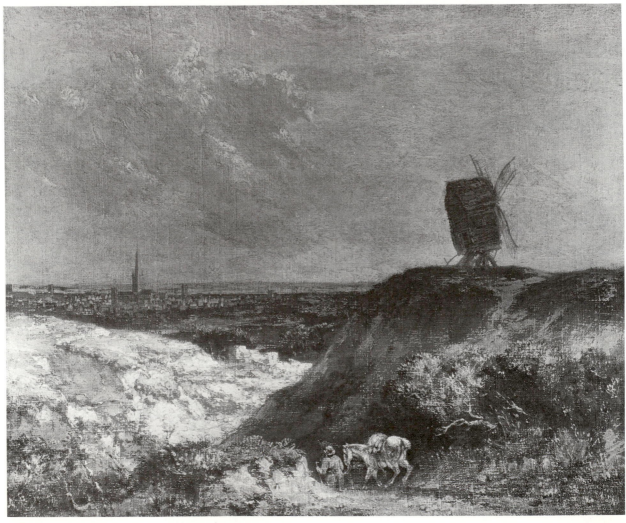

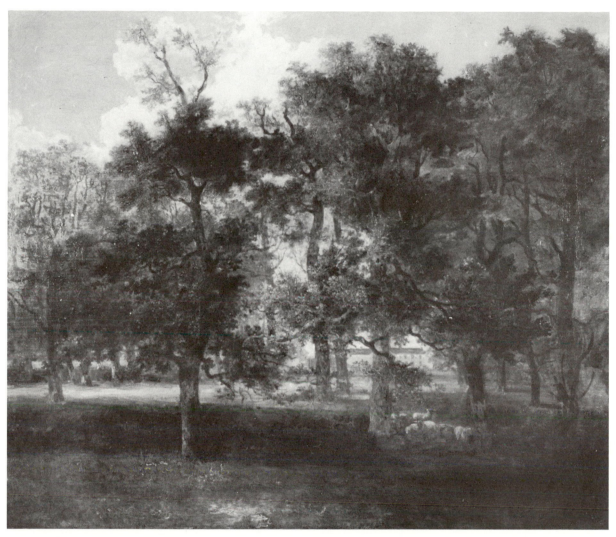

91. *Woodland Scene with Sheep*. Collection the Right Honorable Viscount Mackintosh of Halifax, Barford, Norfolk.

preceding page:
89. *Pockthorpe: Boat and Boathouse*. Private Collection.
90. *The Windmill near Norwich*. Museum of Fine Arts, Boston.

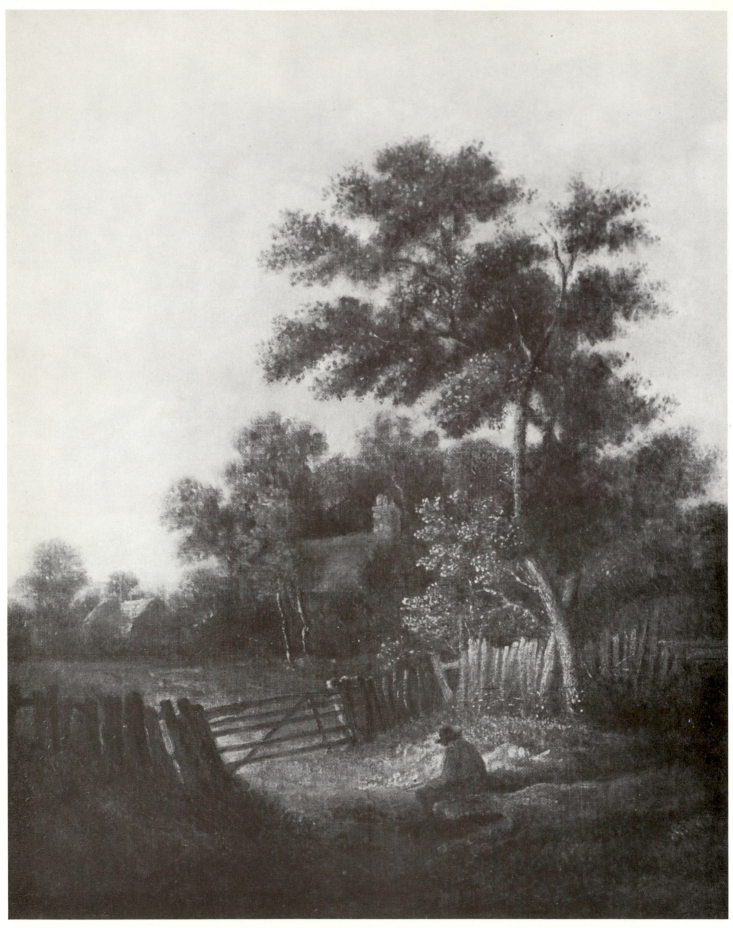

92. *The Harling Gate.* Collection Dr. and Mrs. Norman L. Goldberg, St. Petersburg, Florida.

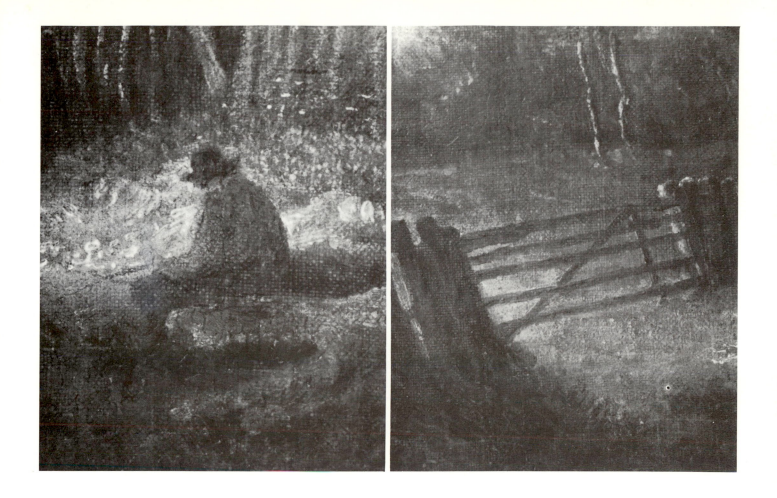

93. (top left) Detail of Figure 92 (scated man).
94. (top right) Detail of Figure 92 (country road).
95. (bottom) Detail of Figure 92 (twin oak trees).

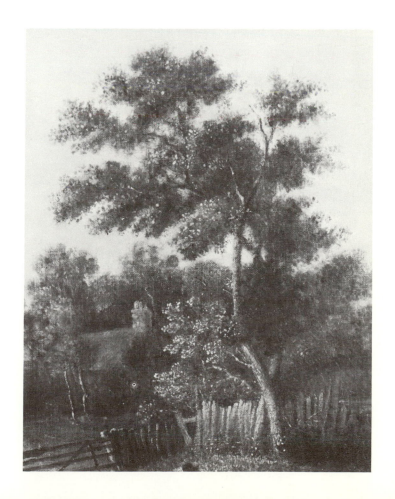

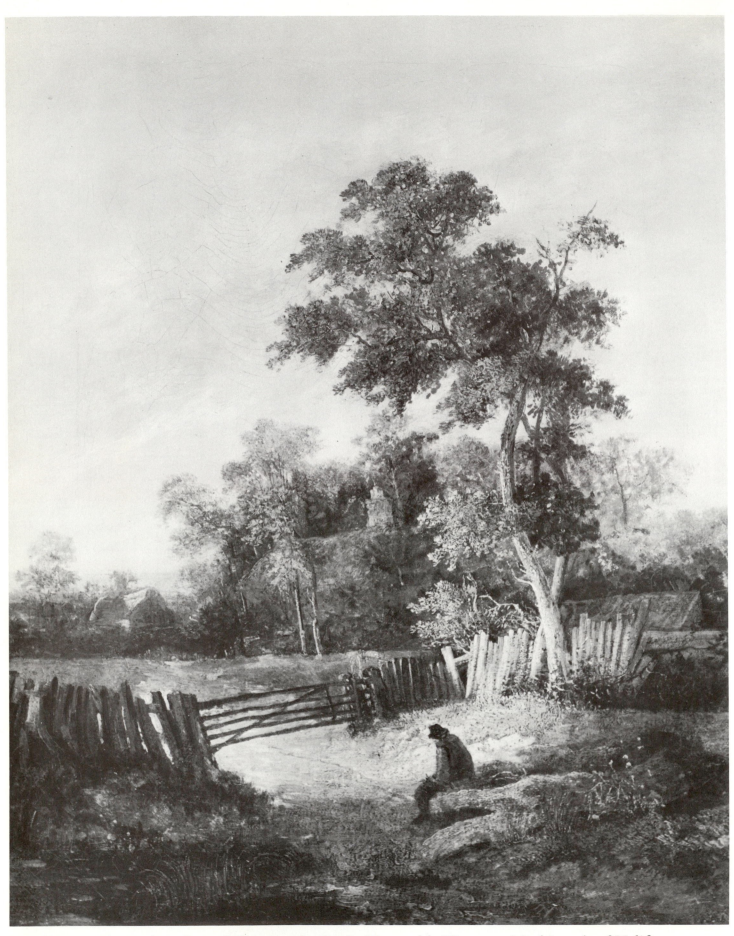

96. (Copy), *The Harling Gate*. Collection the Right Honorable Viscount Mackintosh of Halifax, Barford, Norfolk.

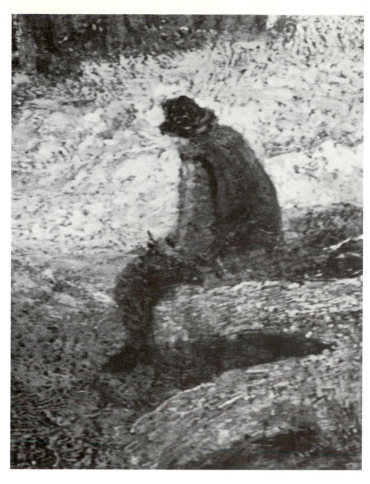

97. (top) Detail of Figure 96 (seated man).
98. (bottom) *Yarmouth Harbour*. Tate Gallery,

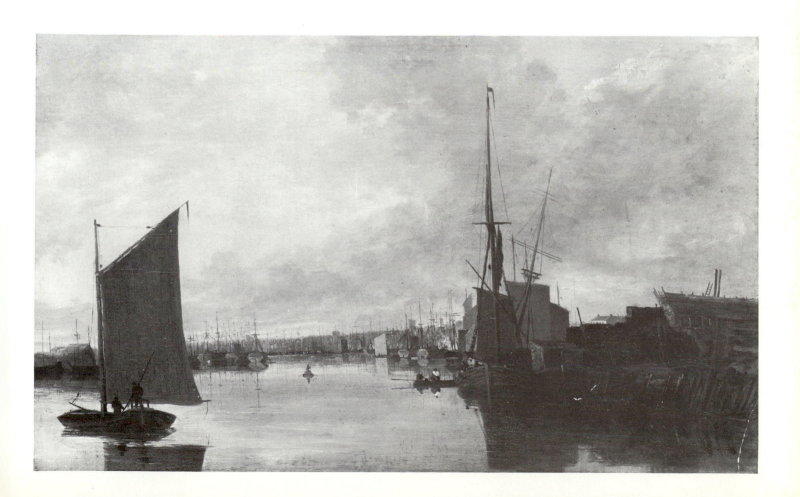

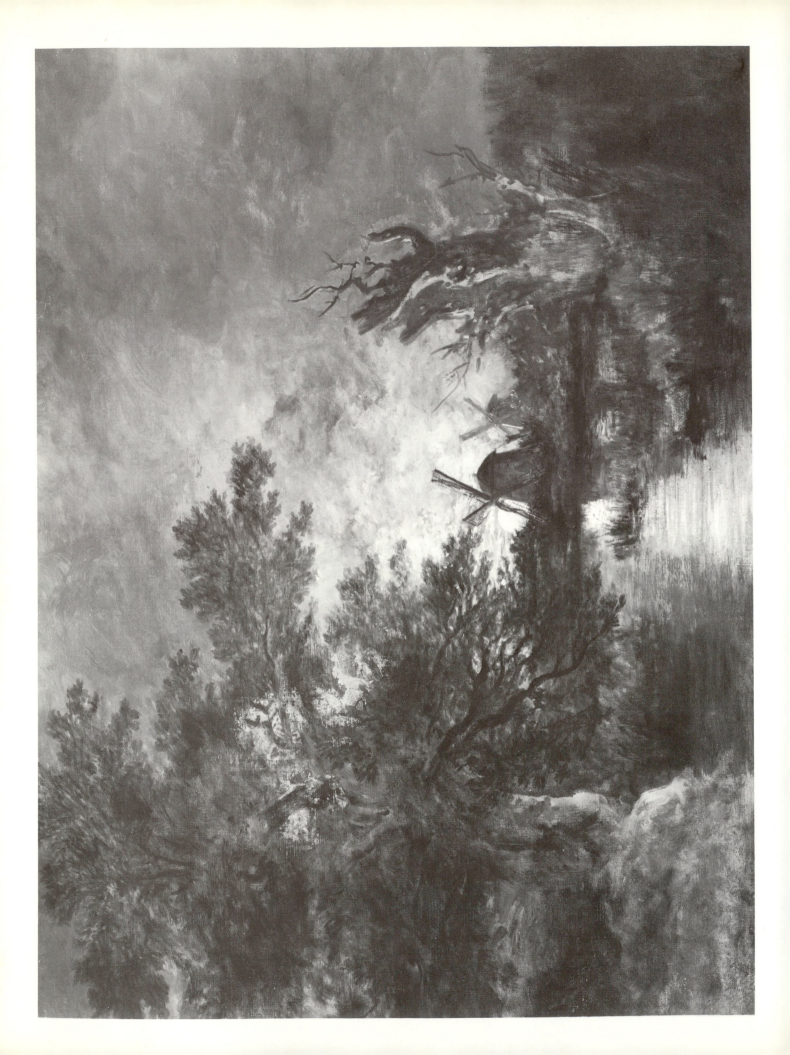

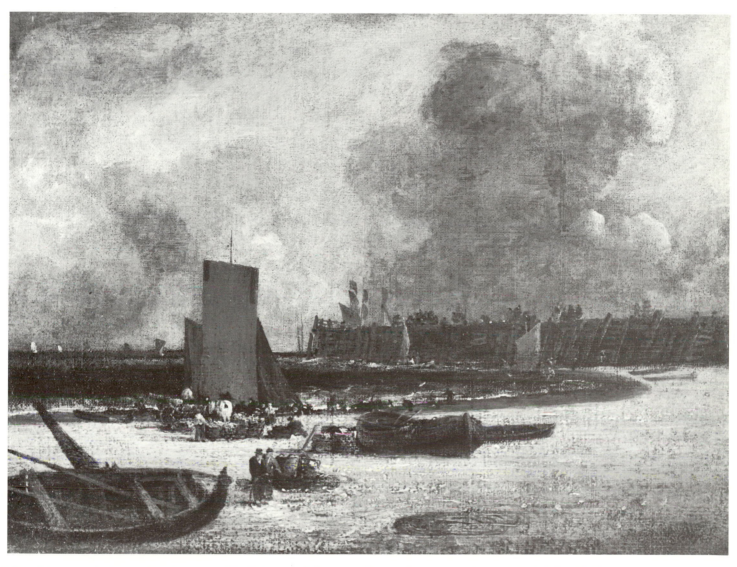

100. *Yarmouth Jetty*. Collection Sir Edmund Bacon, Bart., Raveningham Hall, Norfolk.

preceding page:
99. *Moonlight on the Yare*. National Gallery of Art, Paul Mellon Collection, Washington, D. C.

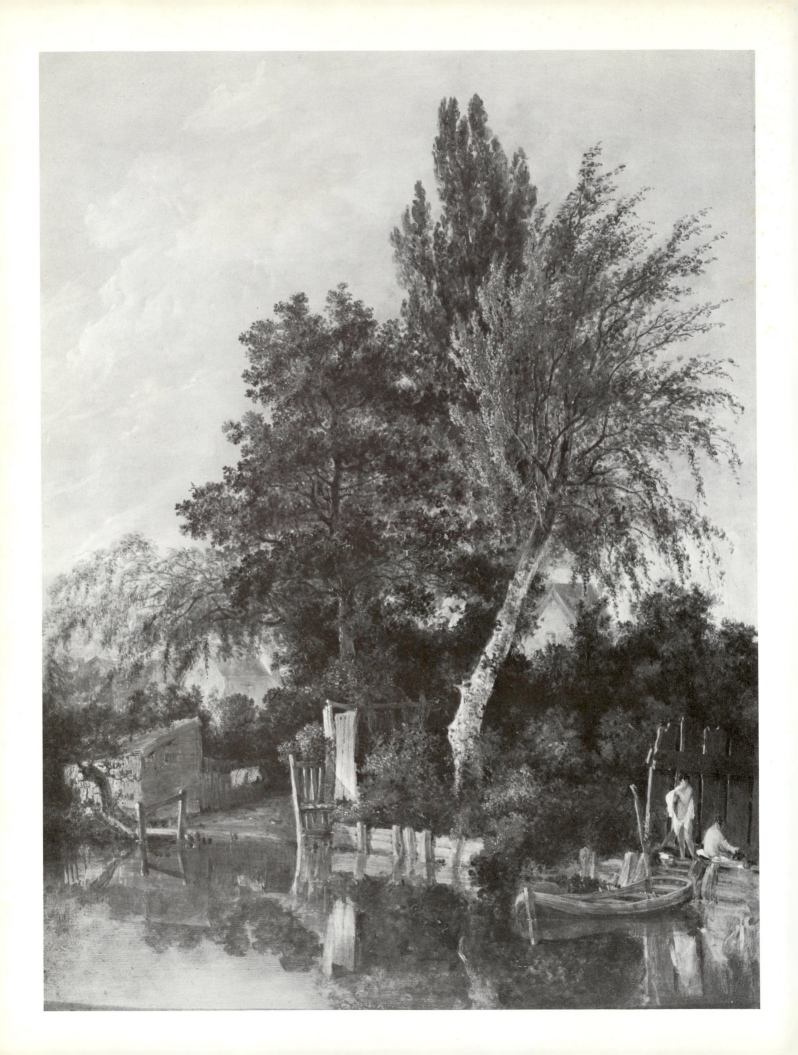

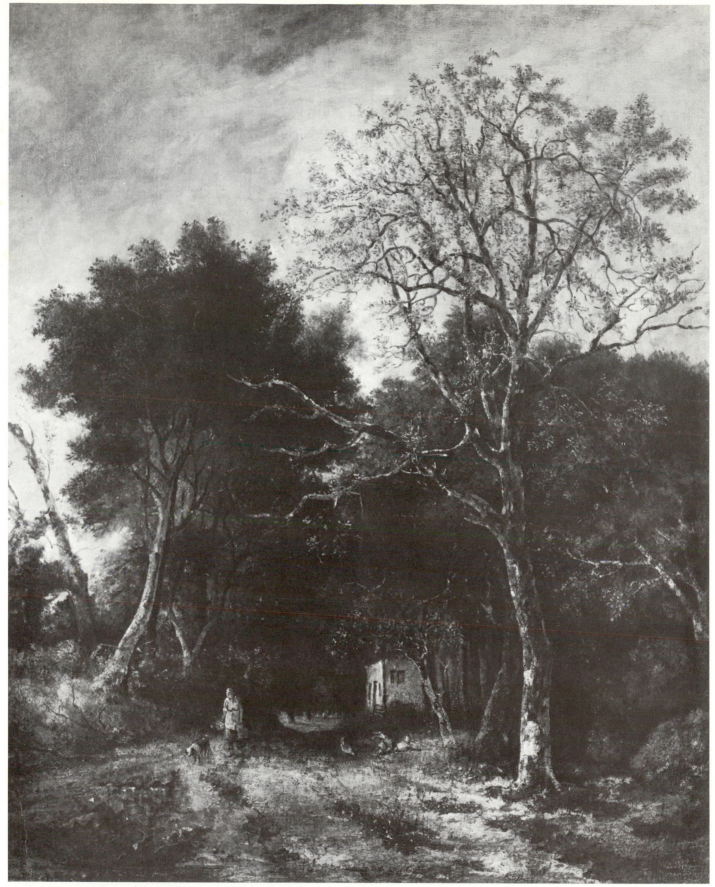

102. *The Glade Cottage*. Collection Mr. Ronald A. Vestey, Great Thurlow Hall, Suffolk.

preceding page:
101. *The Wensum at Thorpe: Boys Bathing.* Yale Center for British Art, Paul Mellon Collection, New Haven, Connecticut.

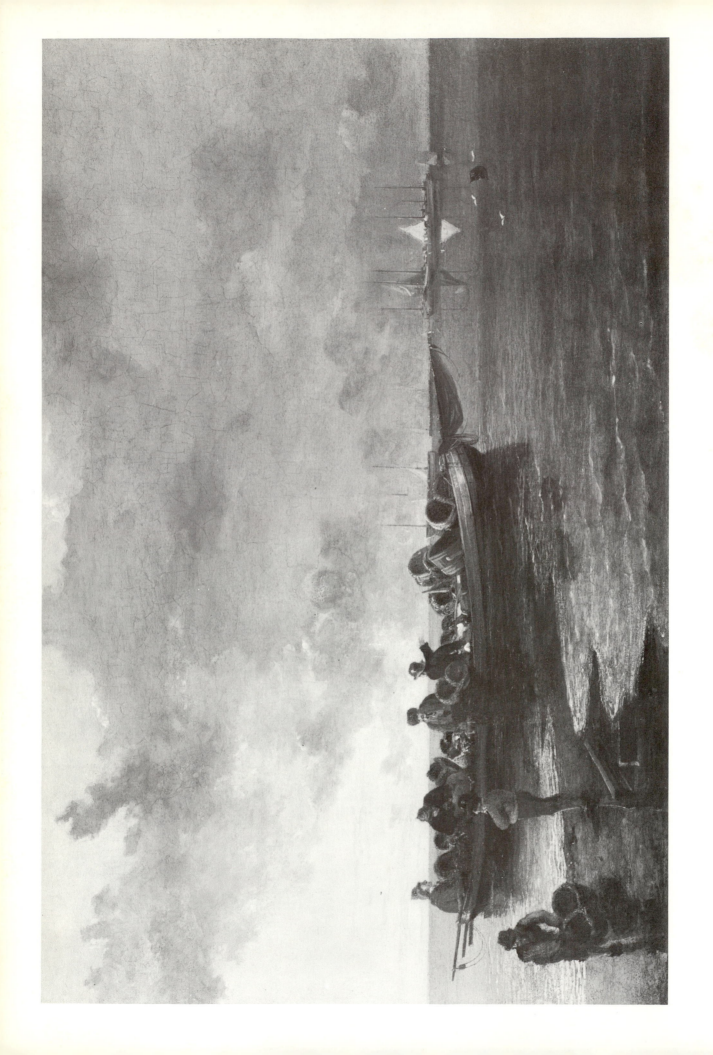

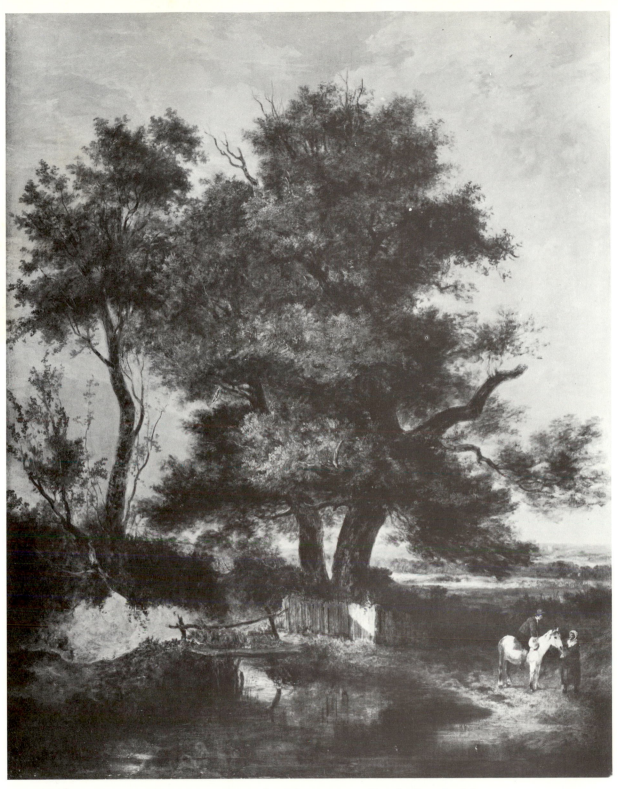

104. *Willow Tree, with a Horseman and a Woman on a Road.* Castle Museum, Nottingham.

preceding page:
103. *A Barge with a Wounded Soldier.* Paul Mellon Collection, Upperville, Virginia.

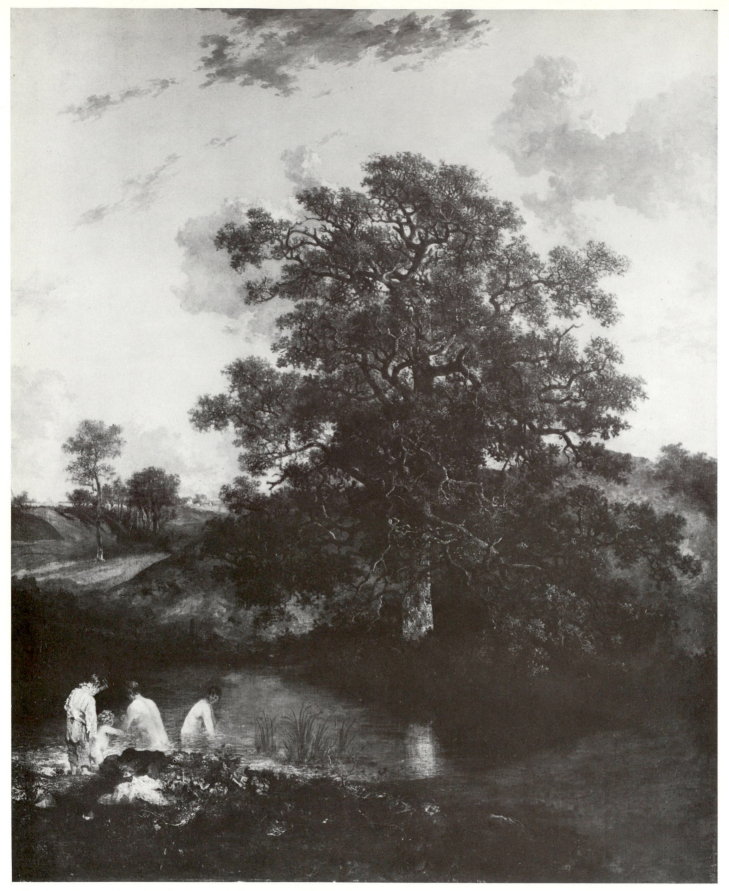

105. *The Poringland Oak.* Tate Gallery, London.

following page:
106. *Squall off Yarmouth.* Collection Mr. Hereward T. Watlington, Bermuda.
107. *Yarmouth Beach and Mill, looking North.* Collection Mr. David Dugdale, Crathorne Hall, Yorkshire.

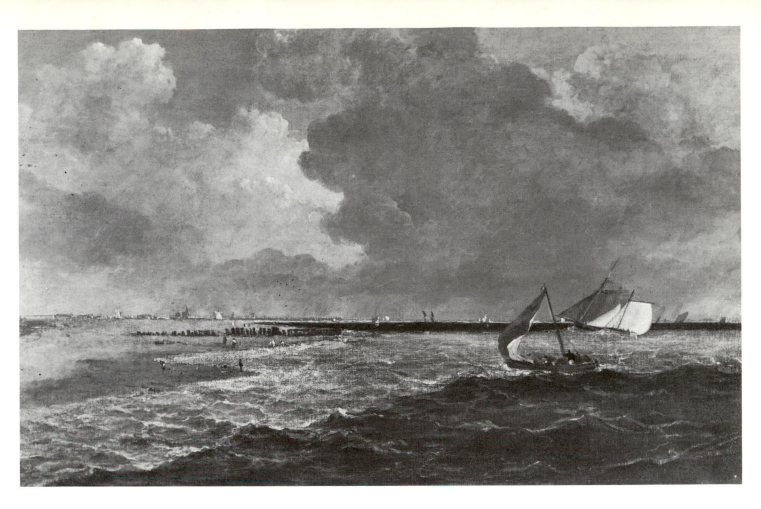

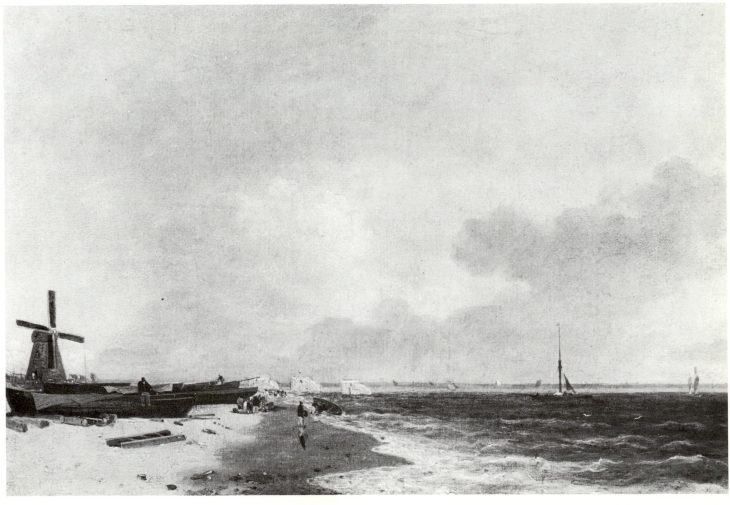

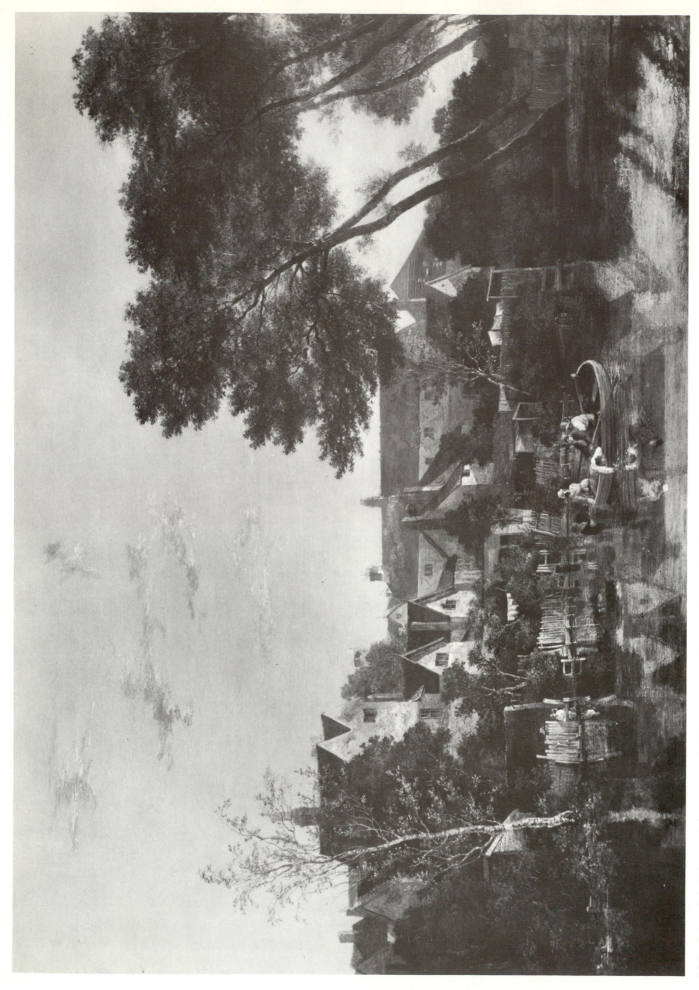

108. *Norwich River: Afternoon.* Collection Mr. Max Michaelis, Rycote Park, Oxfordshire.

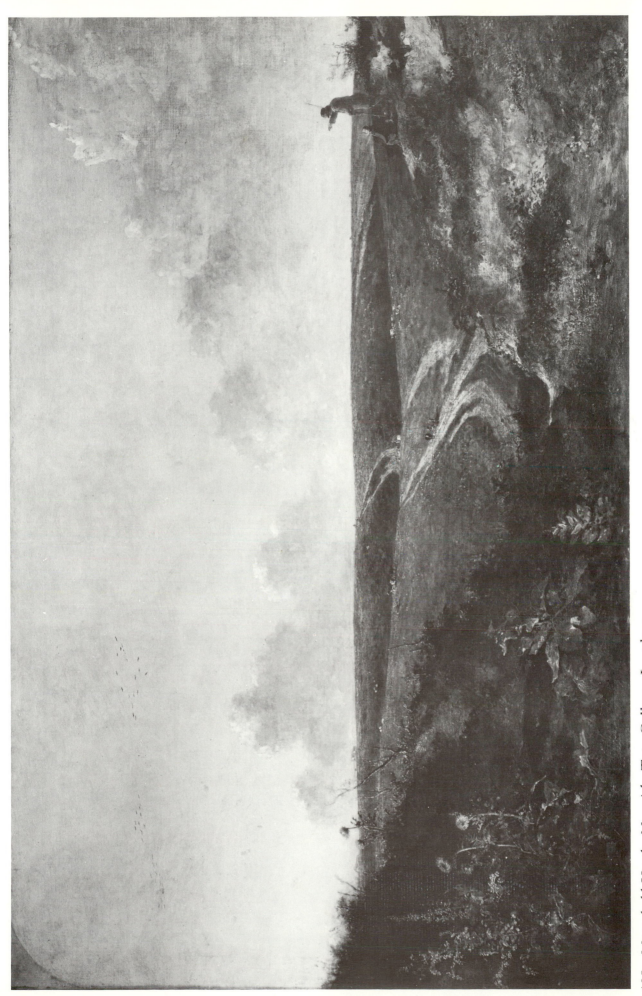

109. *Mousehold Heath, Norwich*. Tate Gallery, London.

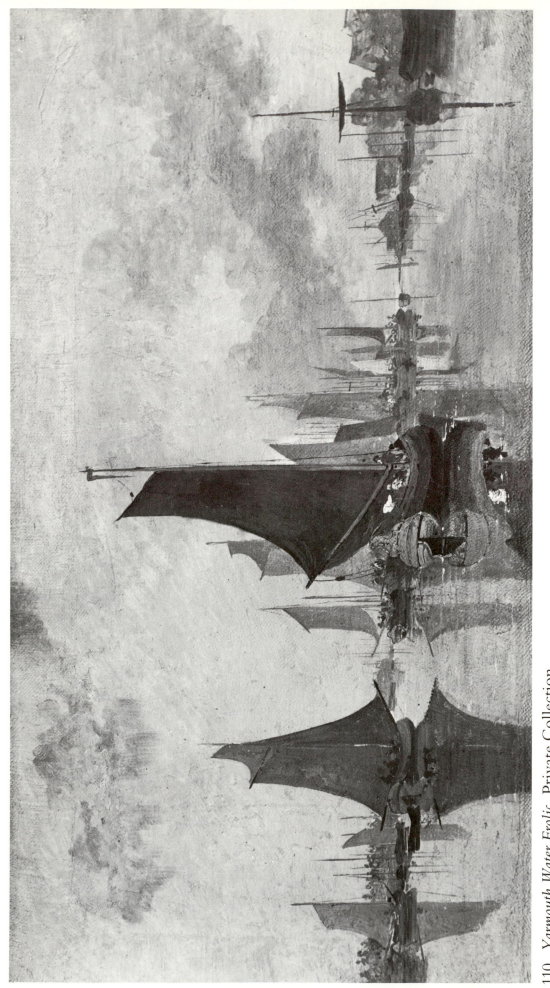

110. *Yarmouth Water Frolic. Private Collection.*

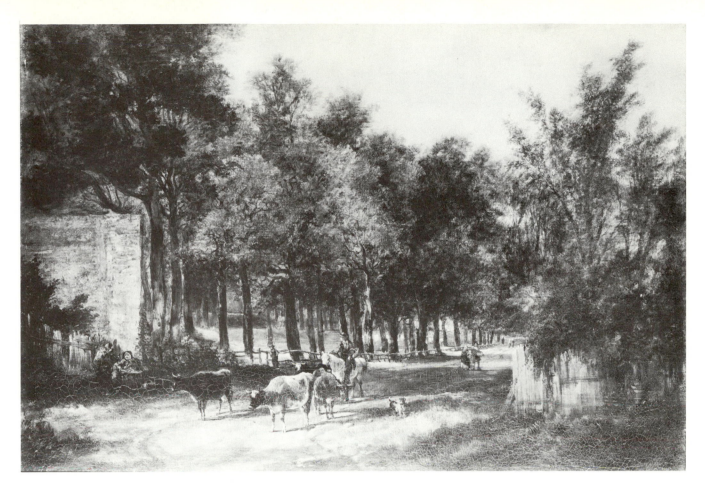

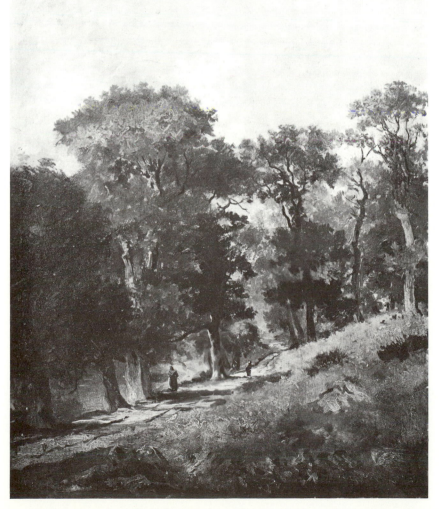

111. (top) *A View of Chapel Fields, Norwich.* Tate Gallery, London.
112. (bottom) *Postwick Grove.* City of Norwich Museums, Norwich.

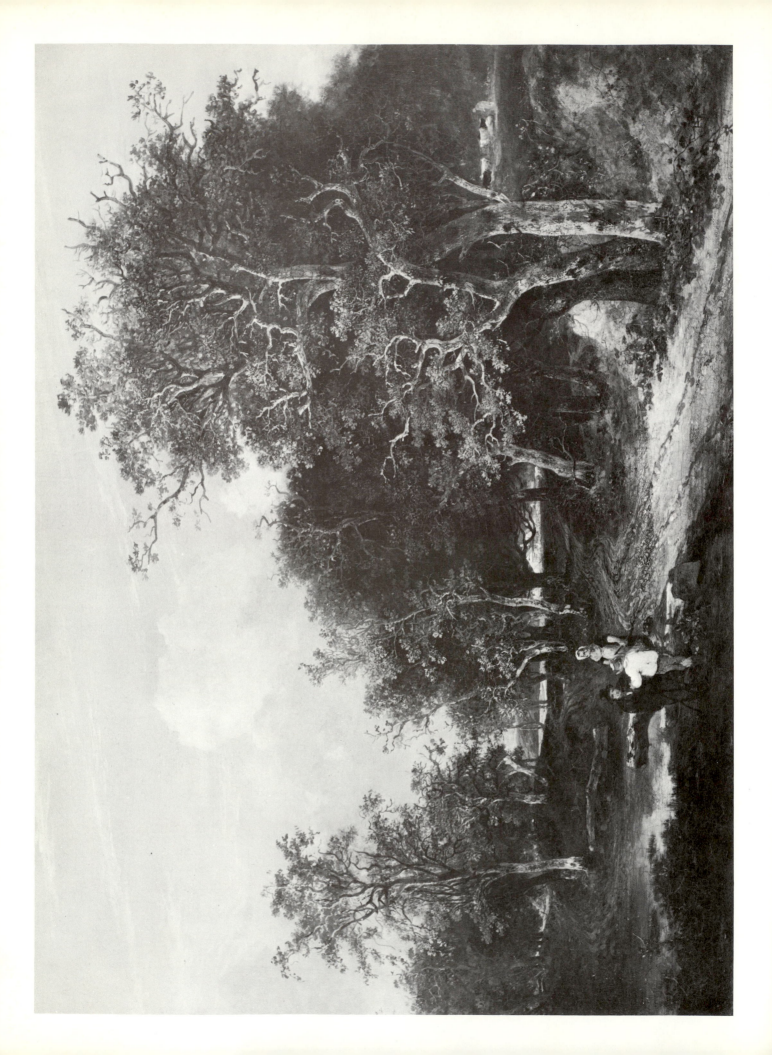

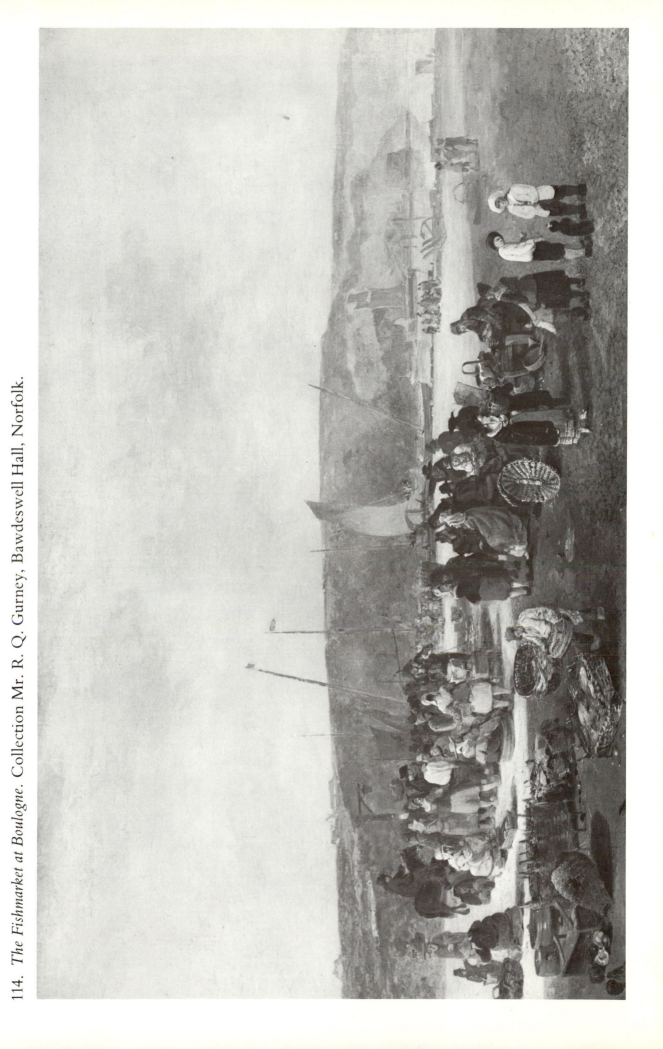

preceding page:
113. *Grove Scene.* City of Norwich Museums, Norwich.

114. *The Fishmarket at Boulogne.* Collection Mr. R. Q. Gurney, Bawdeswell Hall, Norfolk.

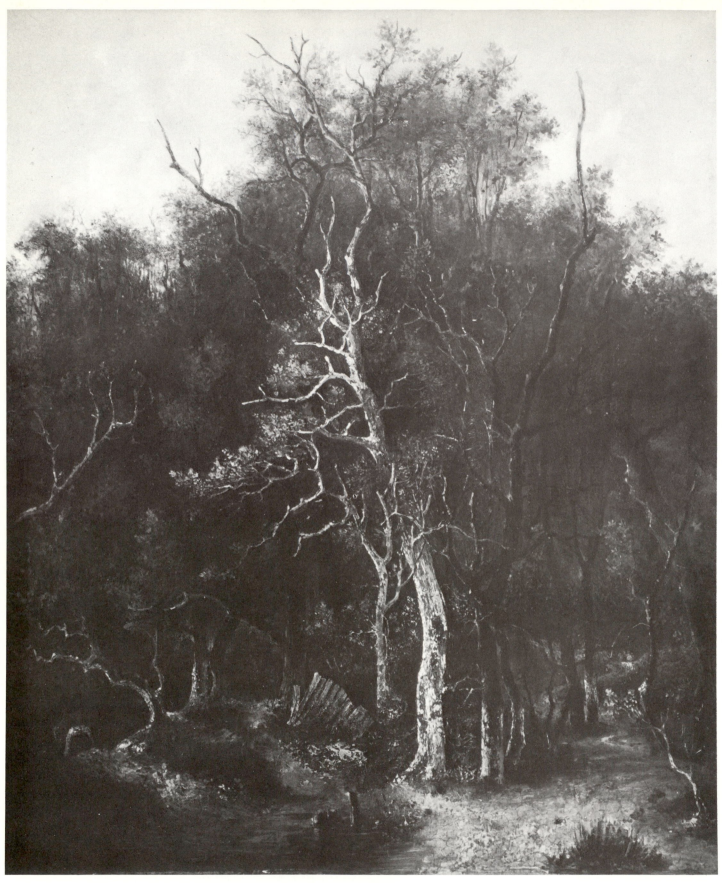

115. *Woodland Path*. National Gallery of Victoria, Melbourne, Australia.

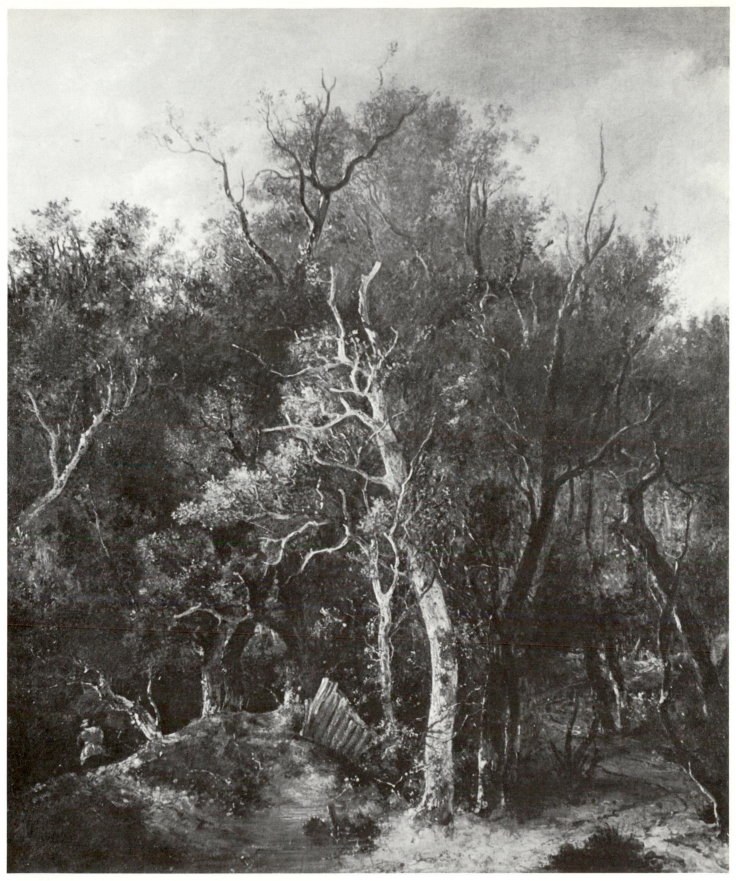

116. *Wood Scene with Pool in Front.* Collection Dr. and Mrs. Norman L. Goldberg, St. Petersburg, Florida.

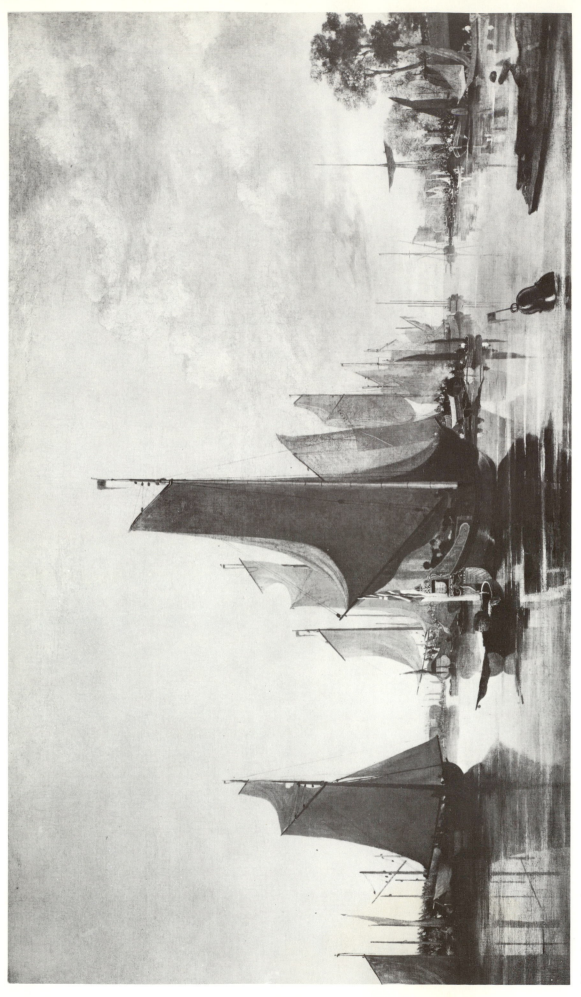

117. *Yarmouth Water Frolic.* Iveagh Bequest, Kenwood, London.

COPIES, IMITATIONS
AND FORGERIES

following page:
118. (top) [Copy], *On the Wensum, above New Mills.*
City of Norwich Museums, Norwich.
119. (bottom) [Copy], *The Wensum, Norwich.* Yale
Center for British Art, Paul Mellon Collection, New
Haven, Connecticut.

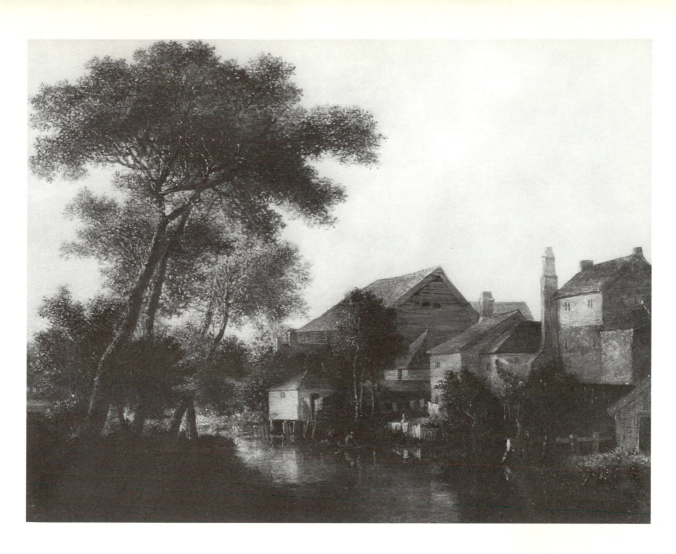

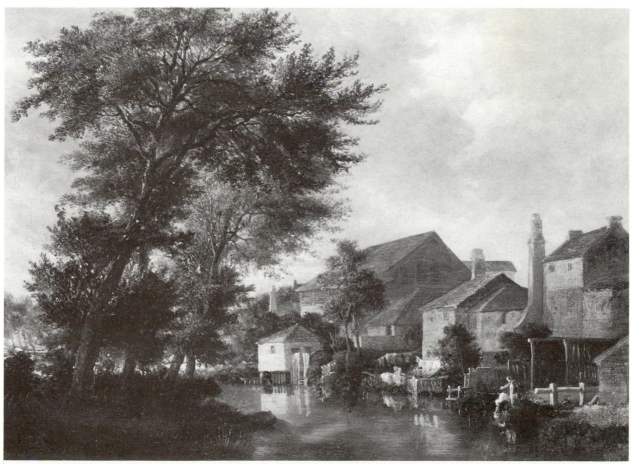

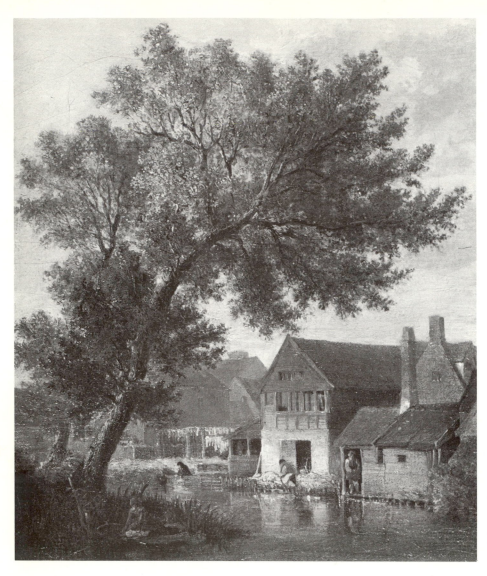

120. (Copy), *The Tannery Yard.*
Collection the John S. Phipps
Foundation, Old Westbury House,
Old Westbury, Long Island.

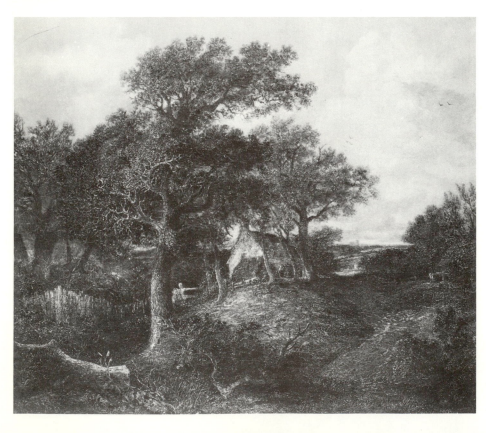

121. (Forgery), *Norfolk Homestead.*
Art Gallery of Ontario, Toronto.

THE PORTRAITS

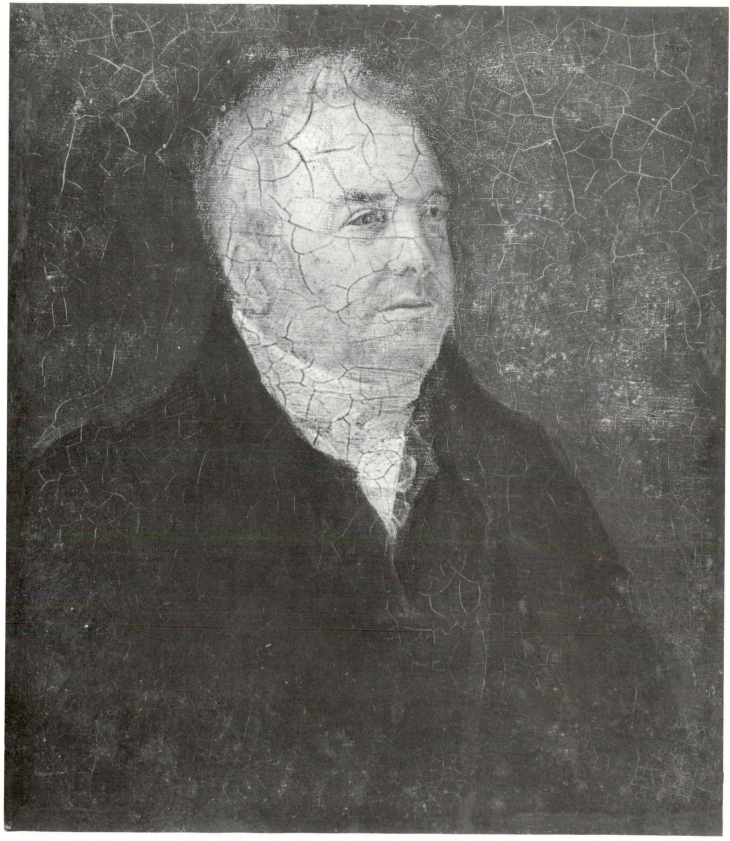

122. *Portrait of Stephen Crome.* Collection Mr. Derek G. Turner, Worton, Wilshire.

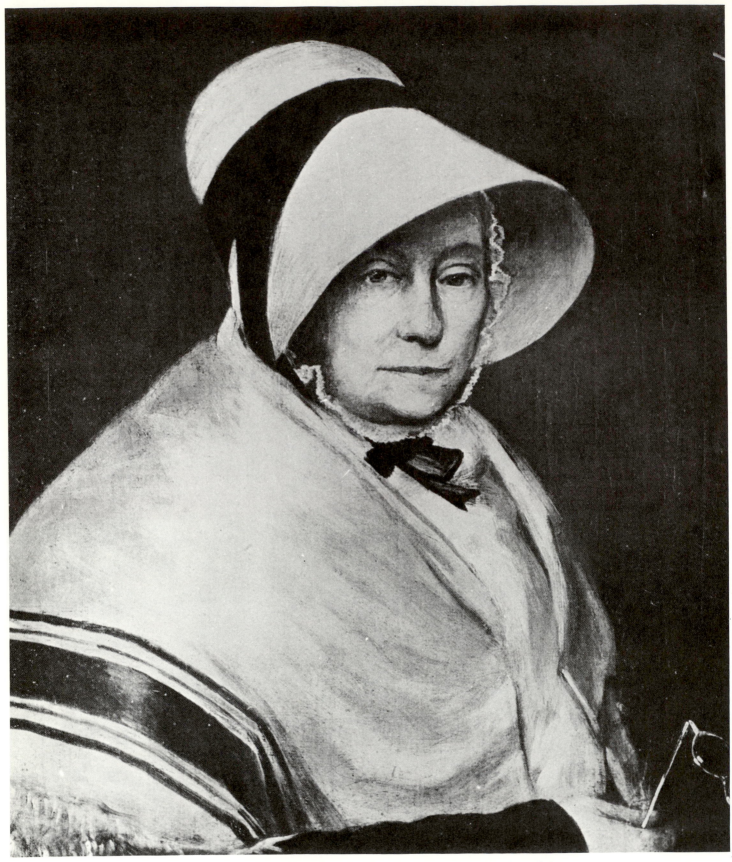

123. *Portrait of Mrs. Gurney*. Collection Mr. Simon Houfe, Ampthill, Bedfordshire.

THE INN SIGNS

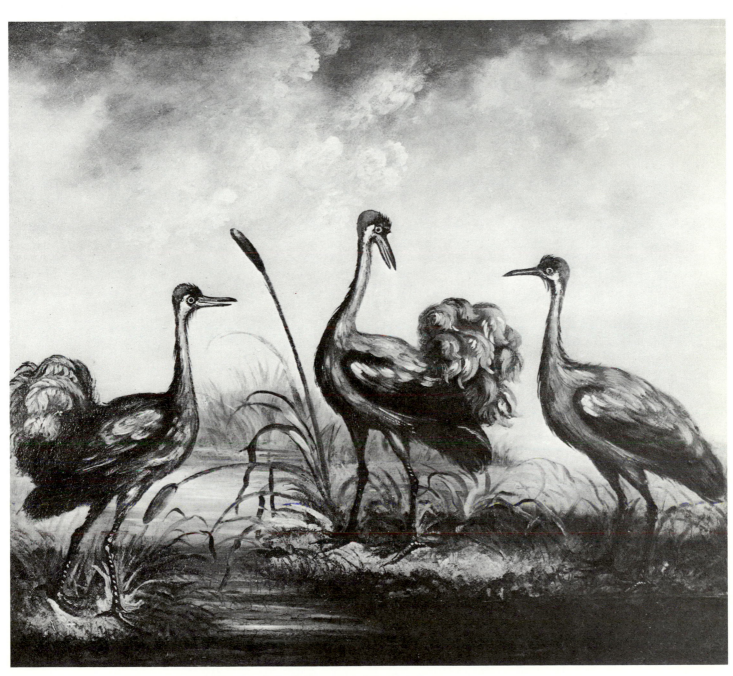

124. *The Three Cranes*. City of Norwich Museums, Norwich.

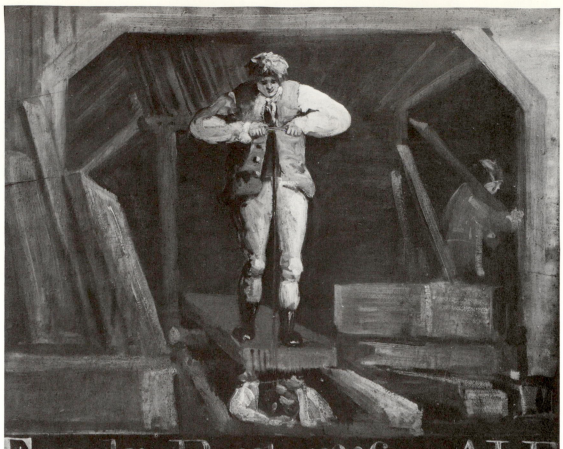

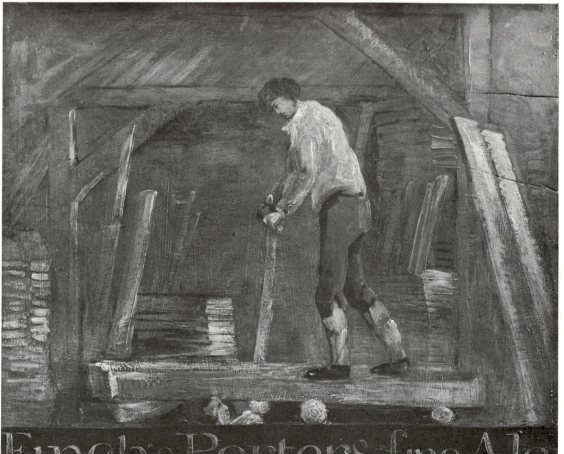

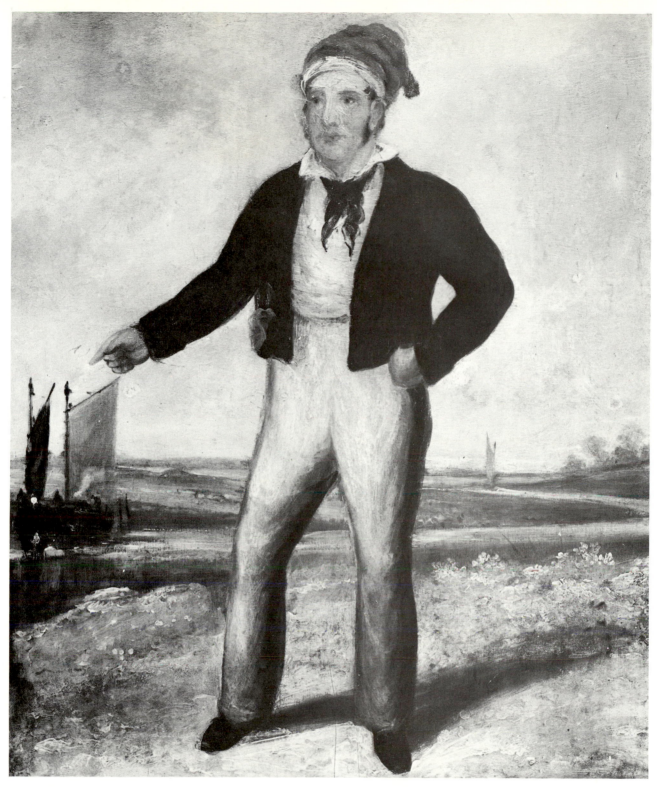

126. *The Wherryman*. Victoria and Albert Museum (Crown Copyright), London.

preceding page:
125. (top) *The Top Sawyer*. Watney Mann (East Anglia), Limited, Norwich.
125a. (bottom) Reverse of Figure 125.

THE DRAWINGS
AND WATERCOLORS

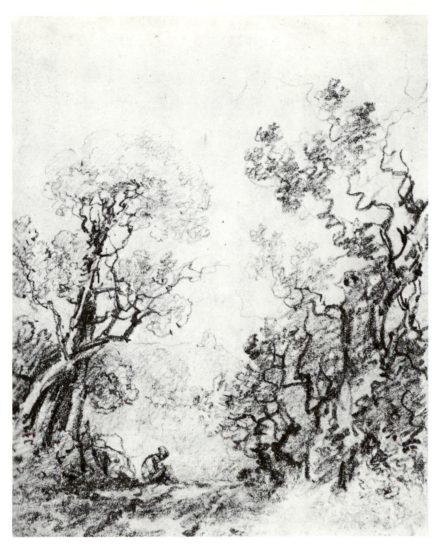

127. (top) *Sketch of Trees*. Henry E. Huntington Library and Art Gallery, San Marino, California.

128. (bottom left) Gainsborough, *Wooded Landscape*. British Museum, London. Reproduced by kind permission of Trustees of the British Museum.

129. (bottom right) *Wooded Landscape with Lane*. Simon Carter Gallery, Woodbridge, Suffolk.

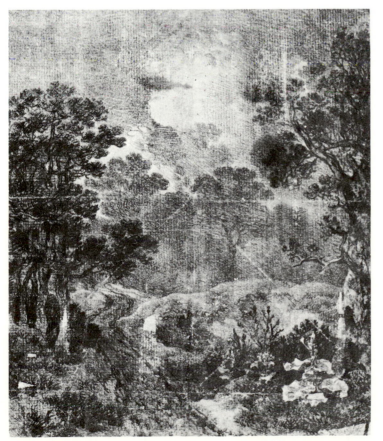

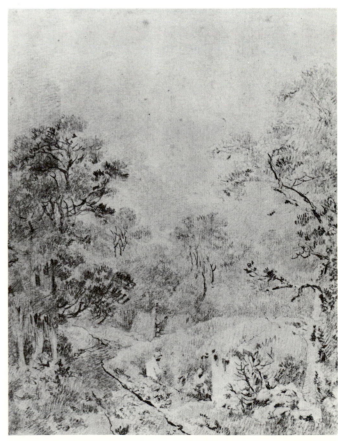

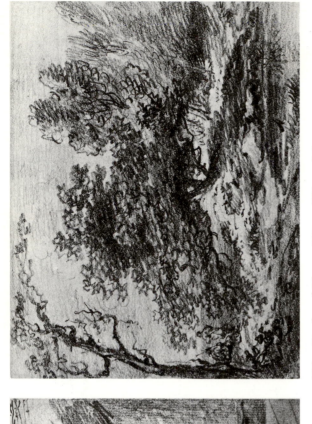

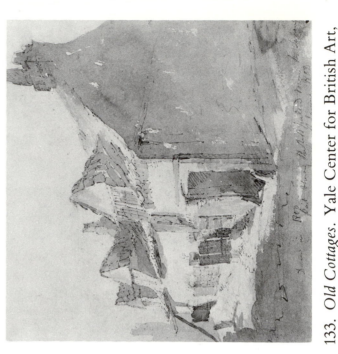

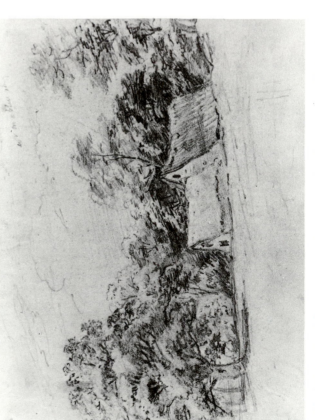

130. *Cottage and Sheds.* British Museum, London. Reproduced by kind permission of Trustees of the British Museum.

131. *Study of Trees.* Fitzwilliam Museum, Cambridge.

132. *Two Buildings among Trees.* Yale Center for British Art, Paul Mellon Collection, New Haven, Connecticut.

133. *Old Cottages.* Yale Center for British Art, Paul Mellon Collection, New Haven, Connecticut.

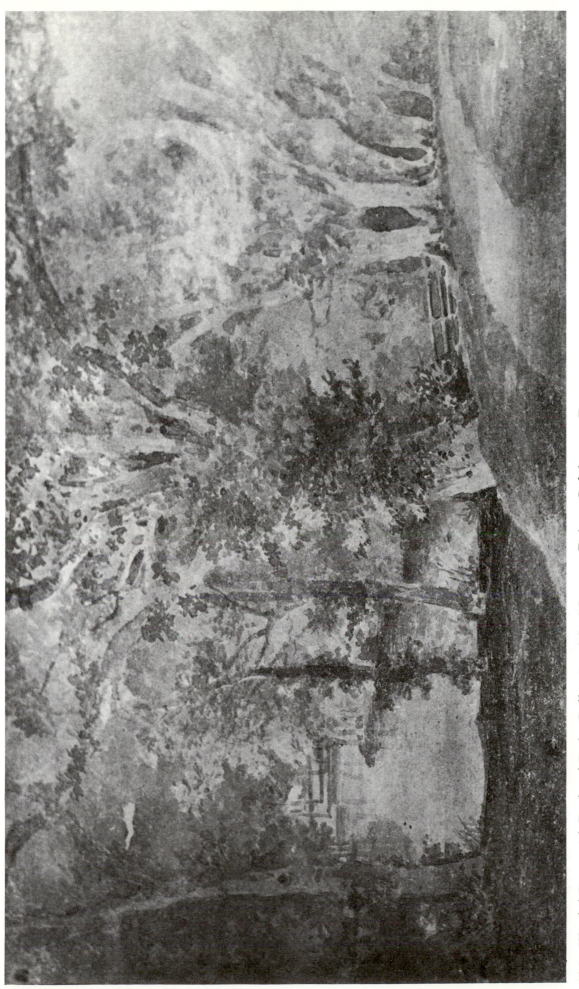

134. *Wooded Scene with Pool and Path.* Collection Mr. Norman Baker, Colchester, Essex.

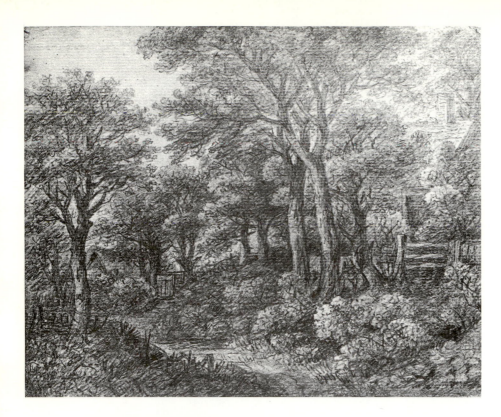

135. *Cottage in a Wood*. Whitworth Art Gallery, University of Manchester, Manchester.

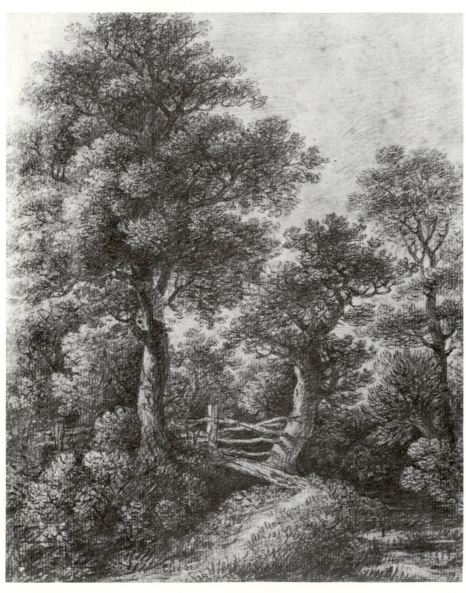

136. *Old Trees and a Stile*. Collection the Right Honorable Lord Mancroft, London.

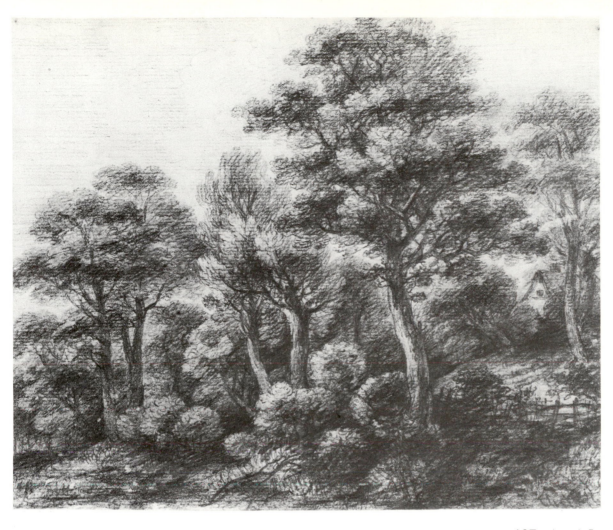

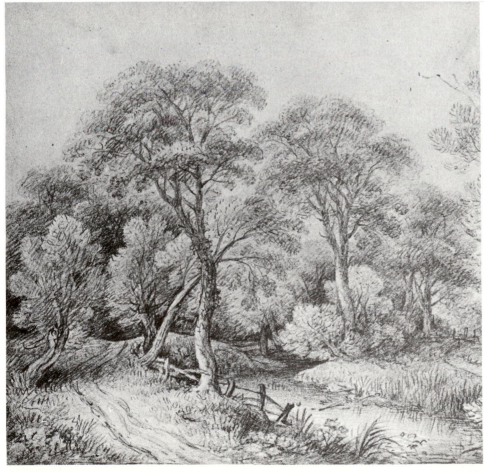

137. (top) *Landscape with House and Trees.* Collection the Right Honorable Viscount Mackintosh of Halifax, Barford, Norfolk.

138. (bottom) *The Edge of a Stream.* Whitworth Art Gallery, University of Manchester, Manchester.

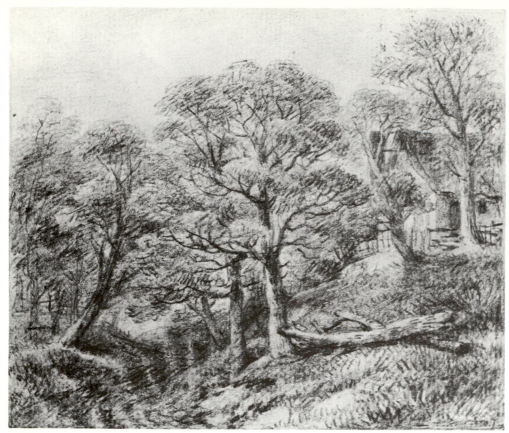

139. *Landscape with House and Trees.* Courtauld Institute of Art, Witt Collection, London.

140. *Wooded Landscape with Cottage.* Henry E. Huntington Library and Art Gallery, San Marino, California.

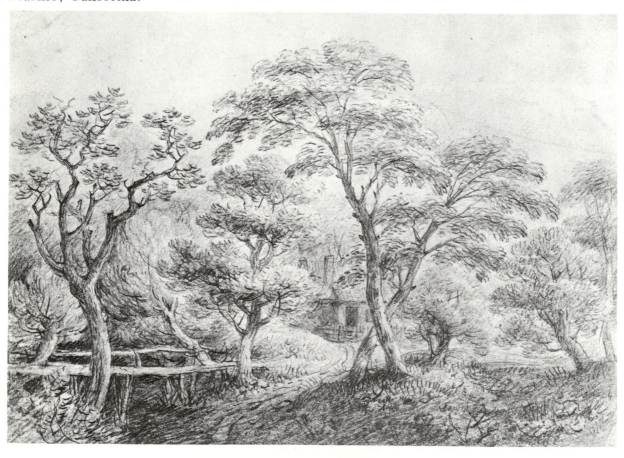

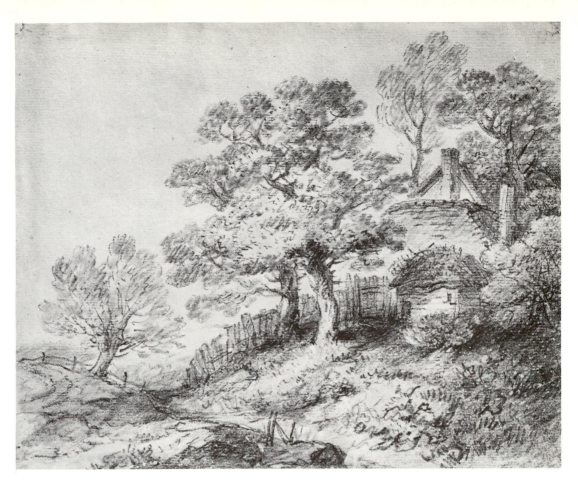

141. (top) *Landscape*. City Art Galleries, Leeds.
142. (bottom) *Sketch of Trees*. Henry E. Huntington Library and Art Gallery, San Marino, California.

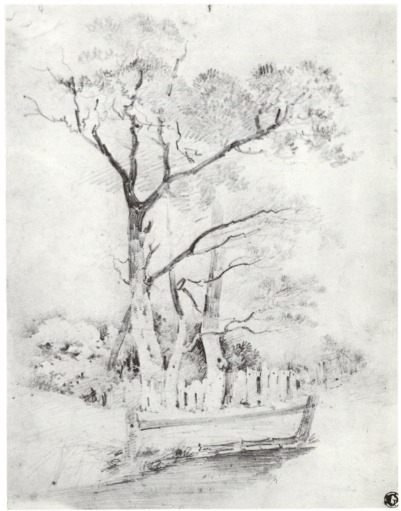

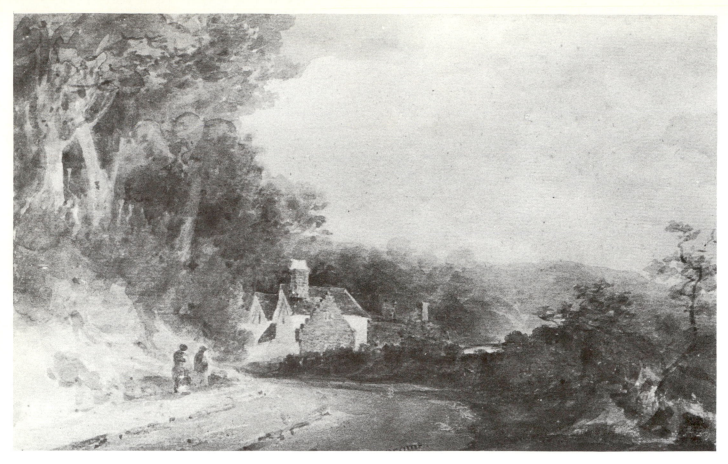

143. *Scene in Patterdale, Cumberland.* Collection the Right Honorable Viscount Mackintosh of Halifax, Barford, Norfolk.

144. *Cottage and Bridge.* British Museum, London. Reproduced by kind permission of Trustees of the British Museum.

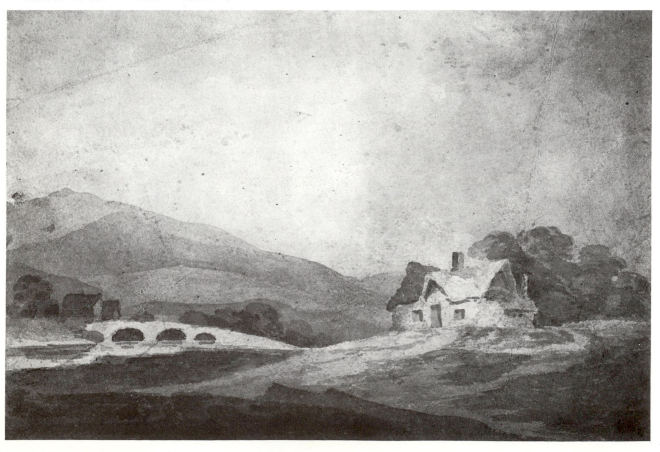

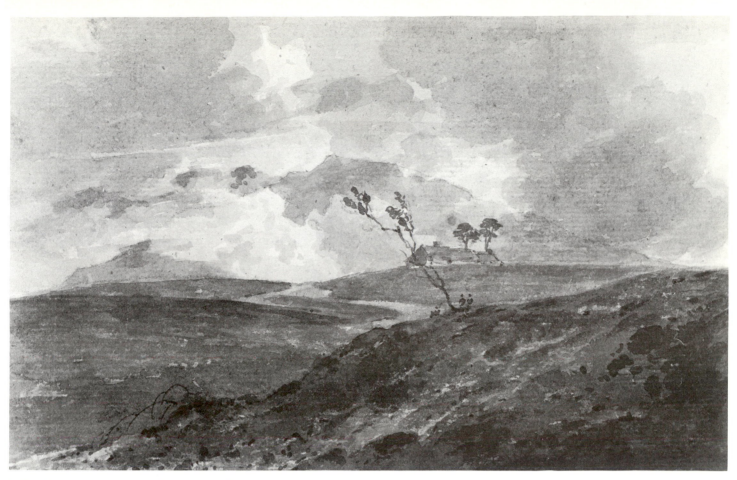

145. *Mountainous Landscape*. Collection Mr. J. F. Wordsworth, London.

146. *Dolgelley, North Wales*. City of Norwich Museums, Norwich.

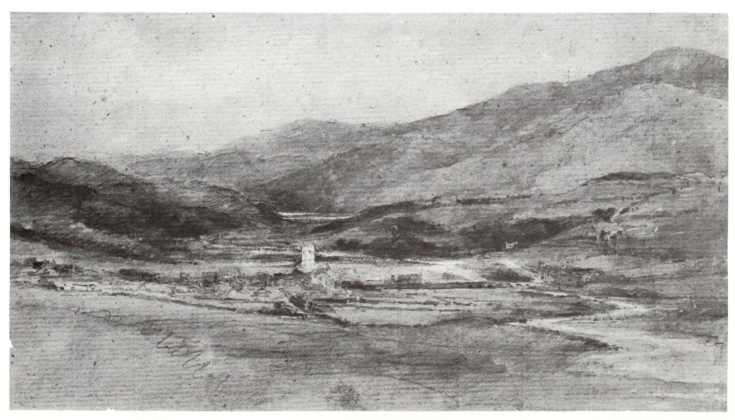

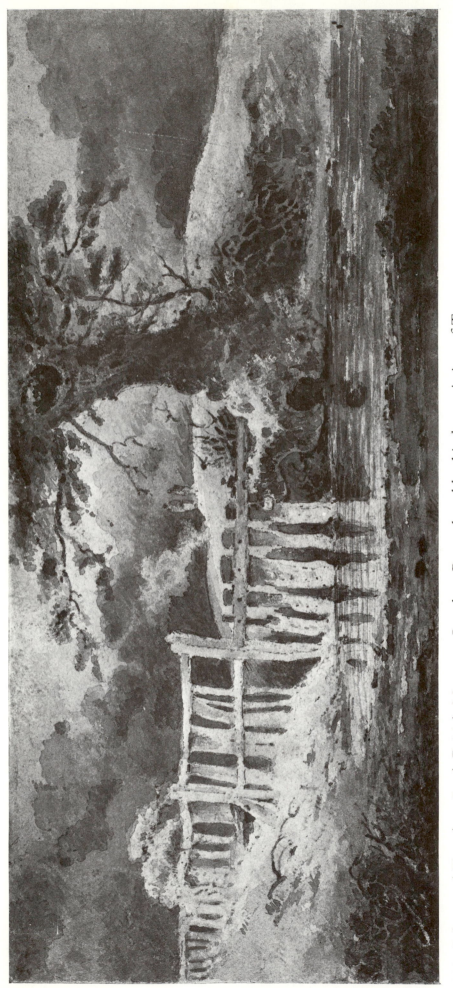

147. *Palings and Trees by a Pond*. British Museum, London. Reproduced by kind permission of Trustees of the British Museum.

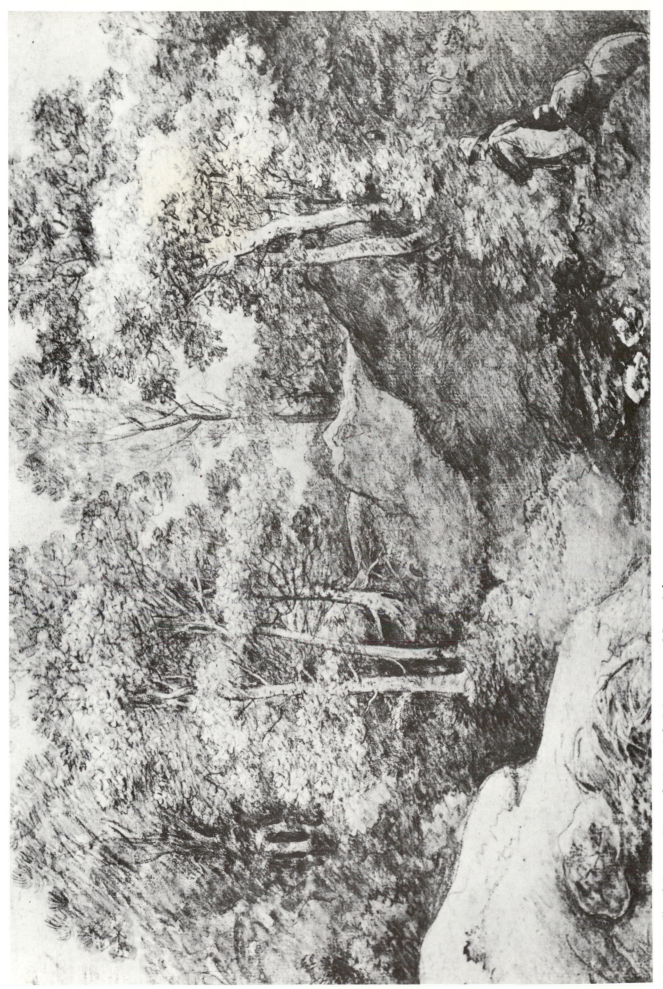

148. *Woodland Scene*. City of Norwich Museums, Norwich.

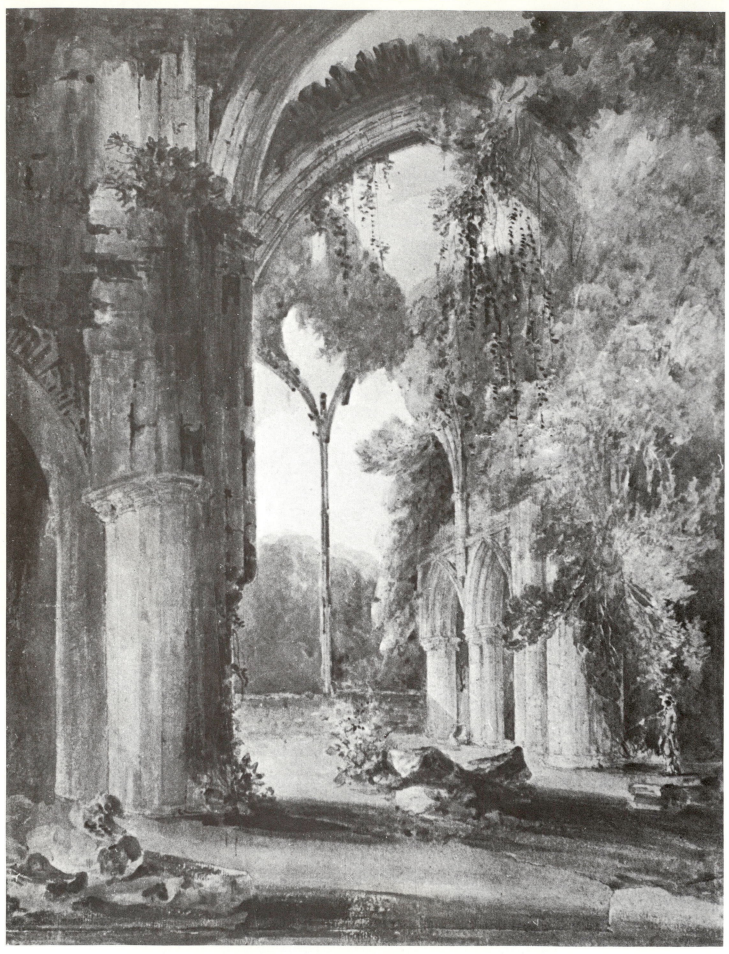

149. *Tintern Abbey*. City of Norwich Museums, Norwich.

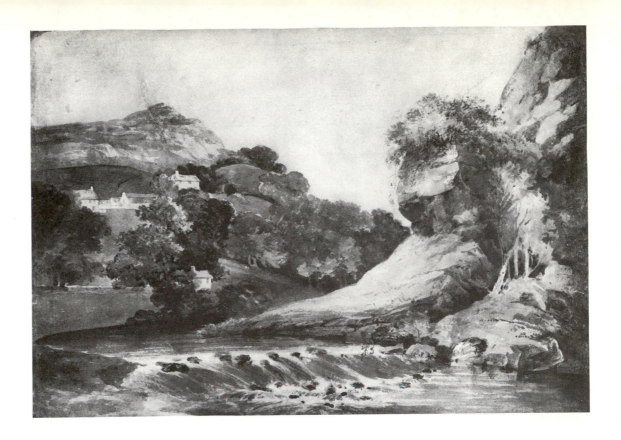

150. (top) *River and Rocks*. City of Norwich Museums, Norwich.

151. (bottom) *Interior of Caister Castle, Norfolk*. Custody of the Royal Exchange Assurance Company, Ipswich.

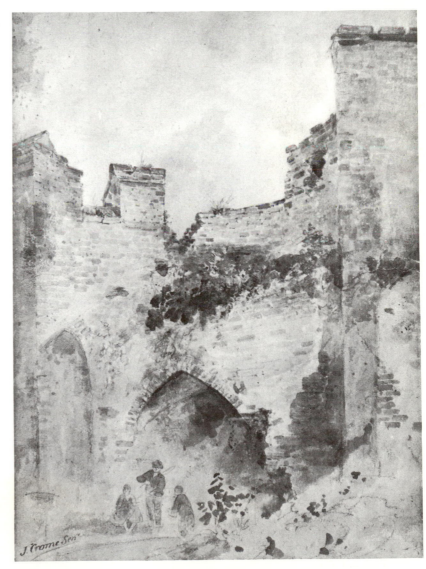

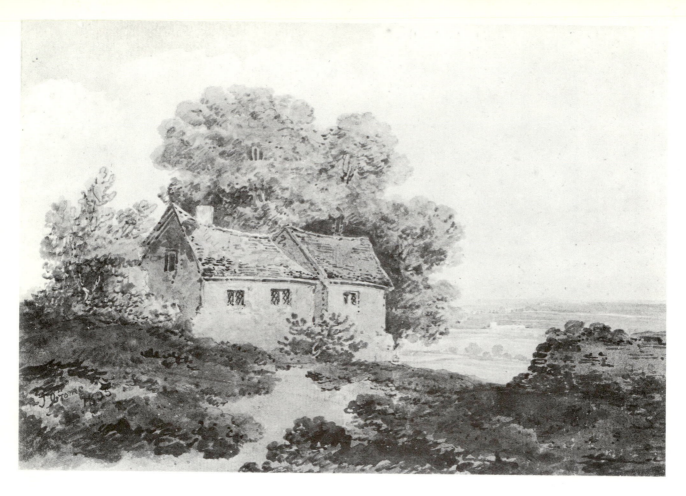

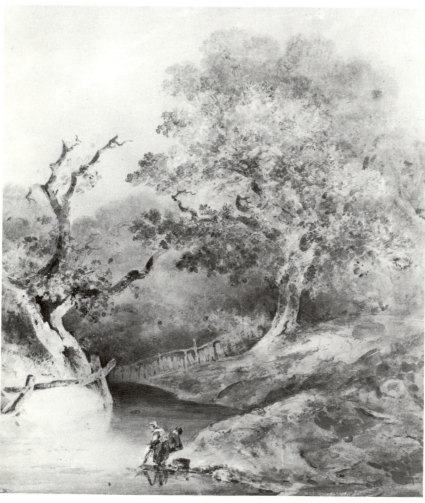

152. (top) *Cottage in the Trees*. Henry E. Huntington Library and Art Gallery, San Marino, California.
153. (bottom) *Wooded Landscape with Stream and Figures*. Collection Mr. E. P. Hansell, Cromer, Norfolk.

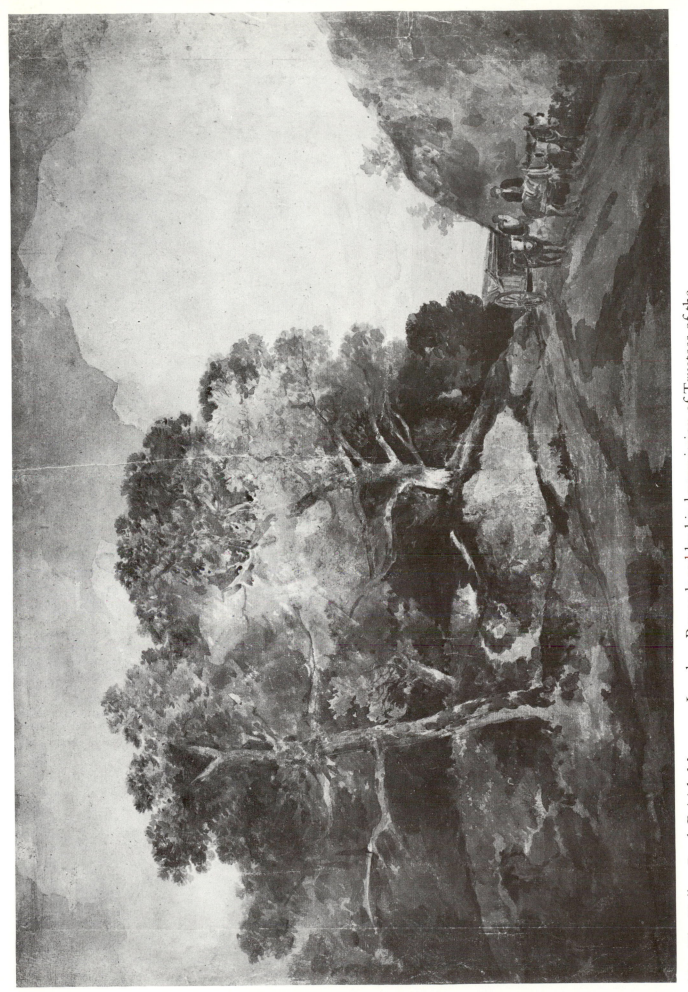

154. *The Hollow Road.* British Museum, London. Reproduced by kind permission of Trustees of the British Museum.

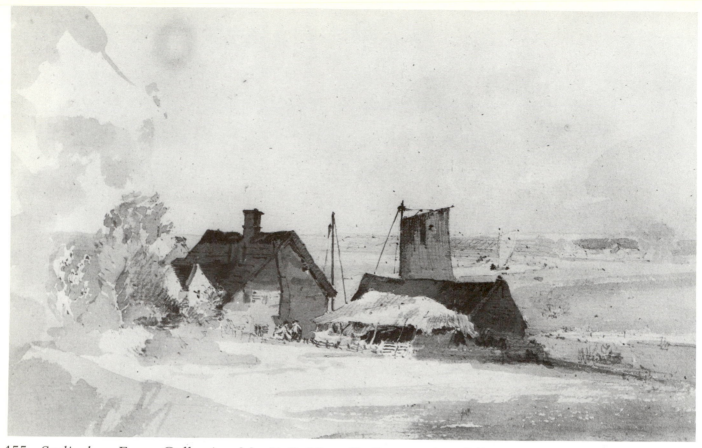

155. *Surlingham Ferry*. Collection Mr. E. P. Hansell, Cromer, Norfolk.

156. *Trees between St. Martin's Gate and Hellesdon*. British Museum, London. Reproduced by kind permission of Trustees of the British Museum.

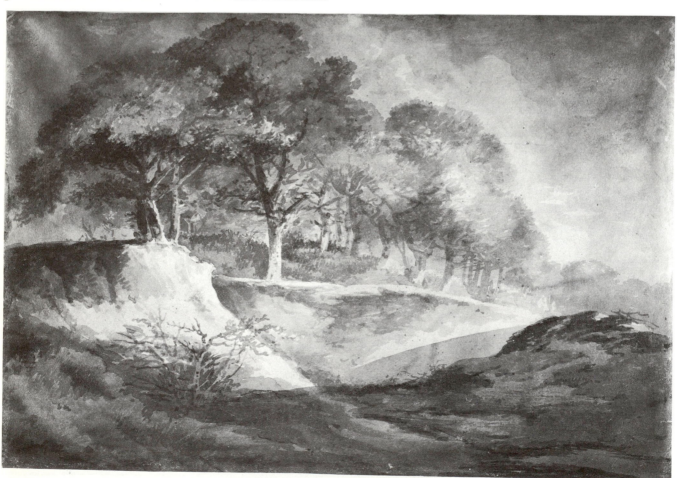

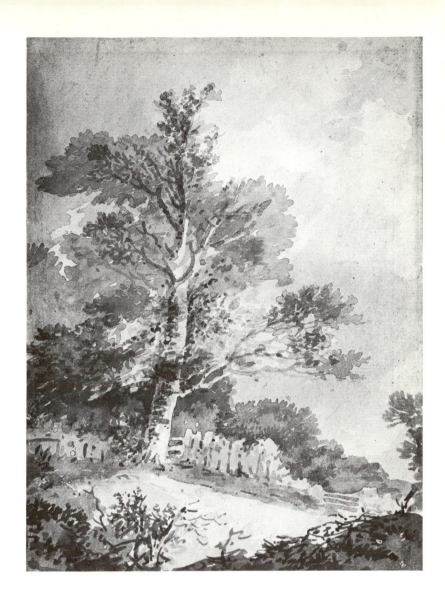

157. (top) *Trees and Palings*. British Museum, London. Reproduced by kind permission of Trustees of the British Museum.

158. (bottom) *Shed and Tree*. British Museum, London. Reproduced by kind permission of Trustees of the British Museum.

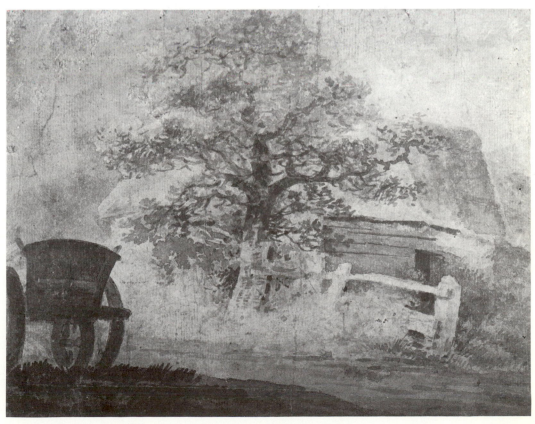

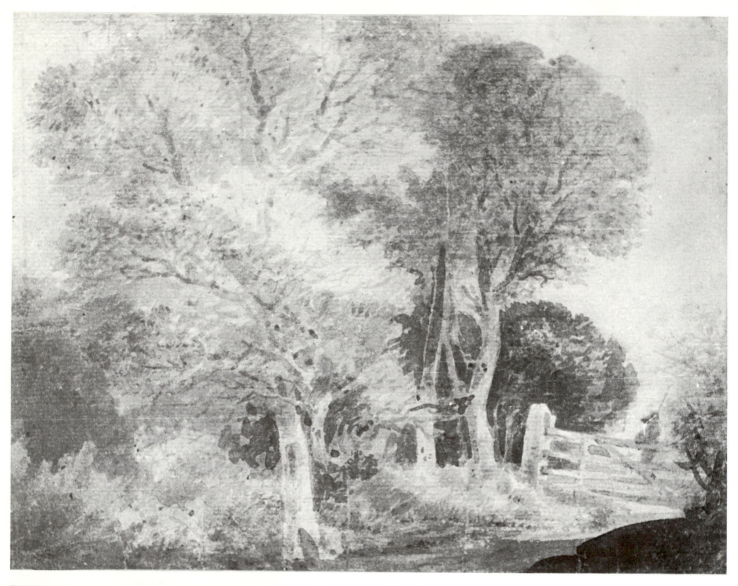

159. (top) *Woodland Scene with Gate*. Collection Sir Edmund Bacon, Bart., Raveningham Hall, Norfolk.
160. (bottom left) *Farm Buildings*. City of Norwich Museums, Norwich.
161. (bottom right) *Maltings on the Wensum*. City of Norwich Museums, Norwich.

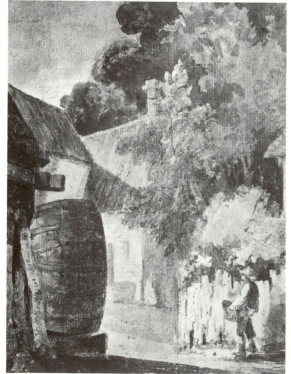

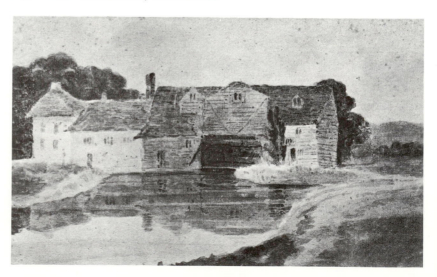

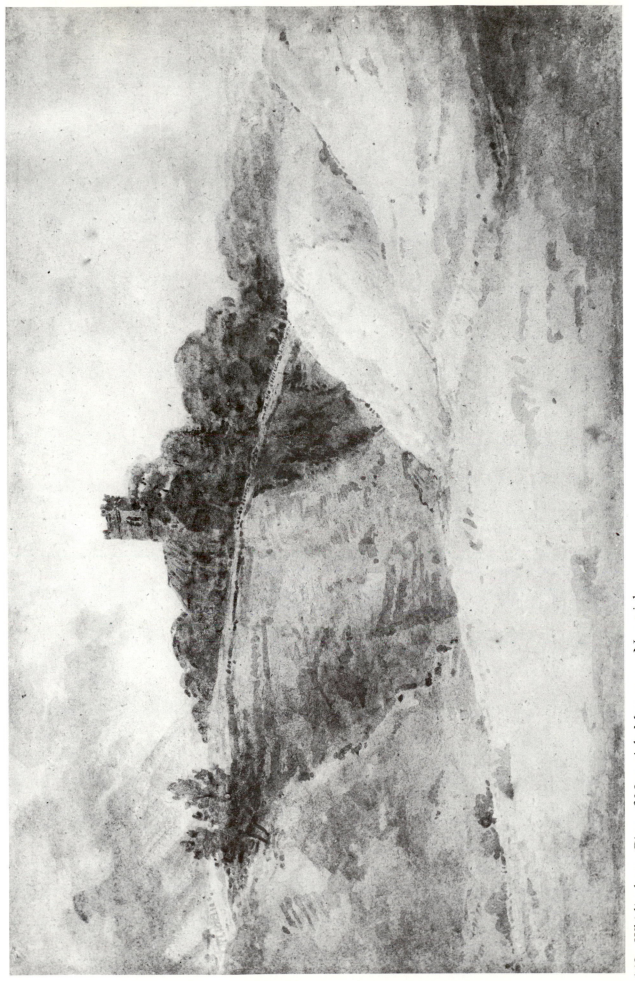

162. *Whitlingham.* City of Norwich Museums, Norwich.

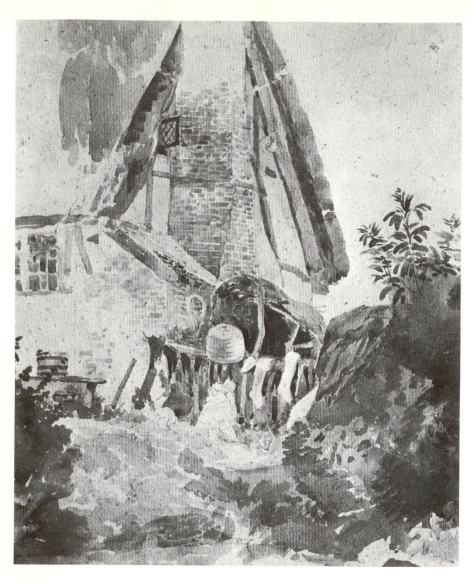

163. (top) *Cottage Gable in Ruins*.
City of Norwich Museums,
Norwich.
164. (bottom) *Waiting for the Ferry*.
British Museum, London.
Reproduced by kind permission of
Trustees of the British Museum.

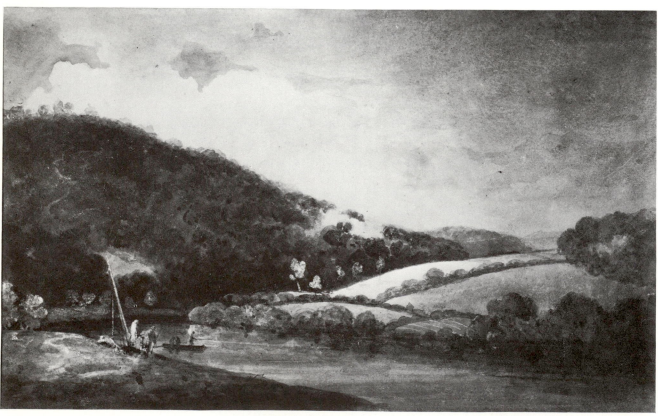

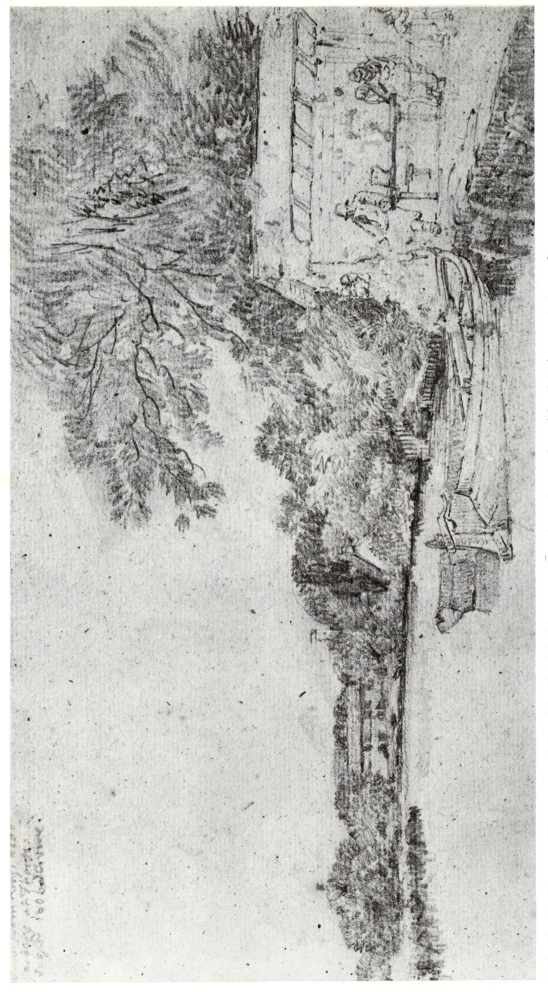

165. *On the River at Thorpe, near Norwich.* British Museum, London. Reproduced by kind permission of Trustees of the British Museum.

119

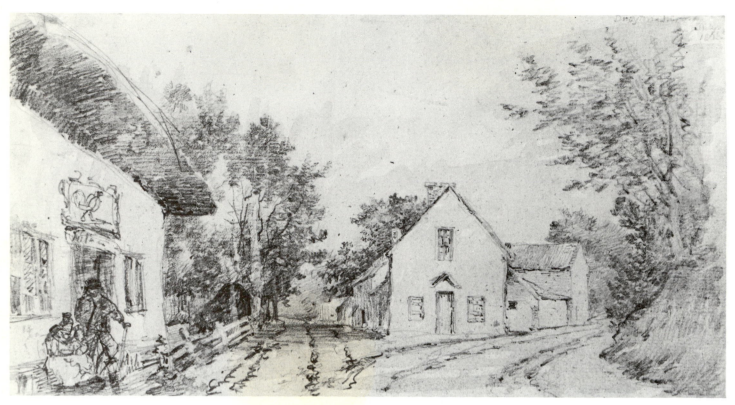

166. *A View of Drayton, near Norwich.* Fitzwilliam Museum, Cambridge.

167. *A Woodman's Shed.* Collection Mr. F. Grunfeld, London.

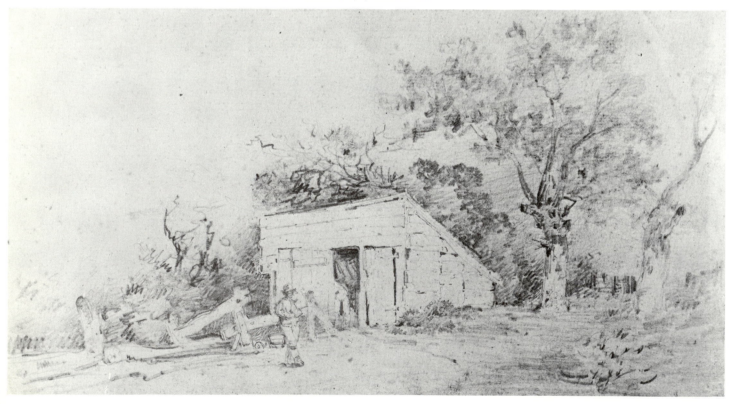

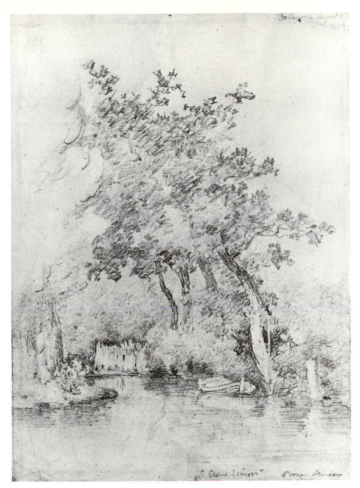

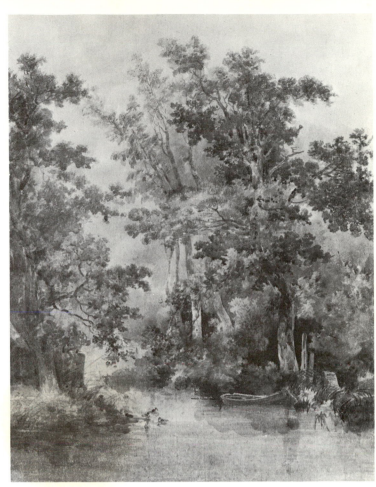

168. *Trees over a Stream*. City of Norwich
Museum, Norwich.

169. *River Scene*. Collection the Honorable Lady
Courtauld, Umtali, Rhodesia.

170. *Gabled End of a House*. Collection Mr. R. S. Aiken, London.

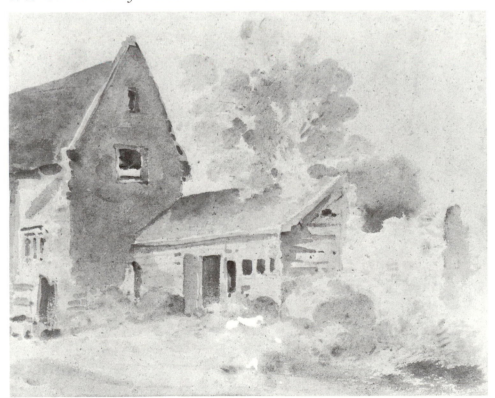

171. *Back River, Norwich.* City of Norwich Museums, Norwich.

172. *Thatched Cottage.* City of Norwich Museums, Norwich.

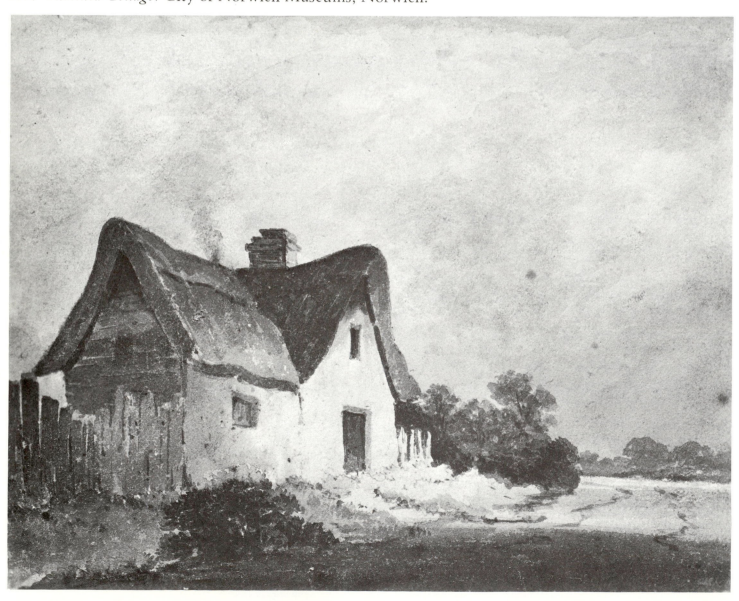

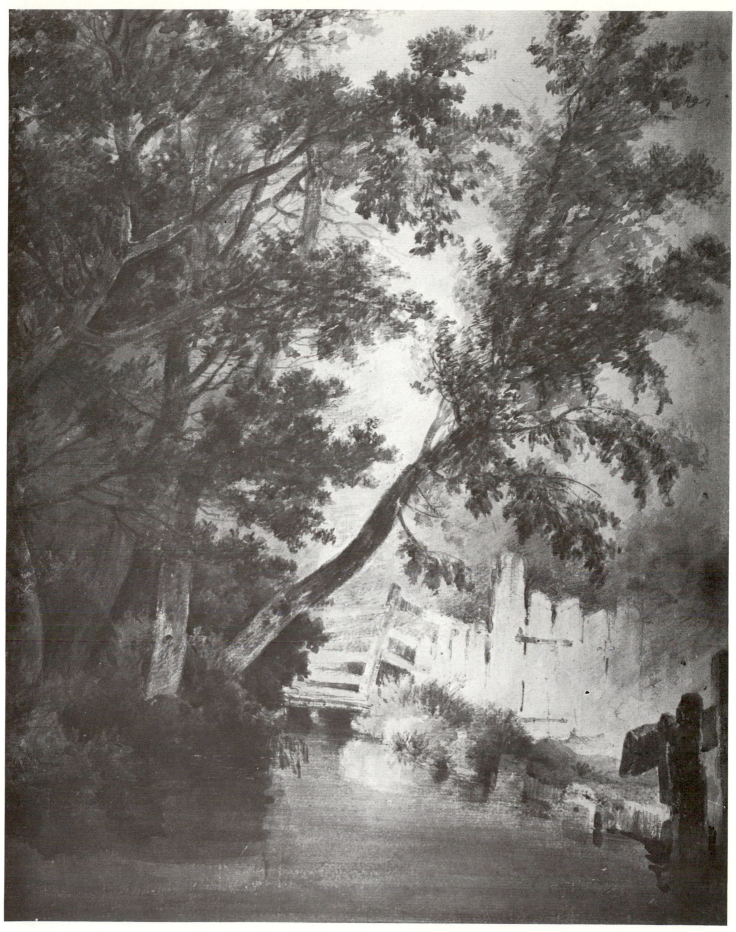

173. *Near Caister*. British Museum, London. Reproduced by kind permission of Trustees of the British Museum.

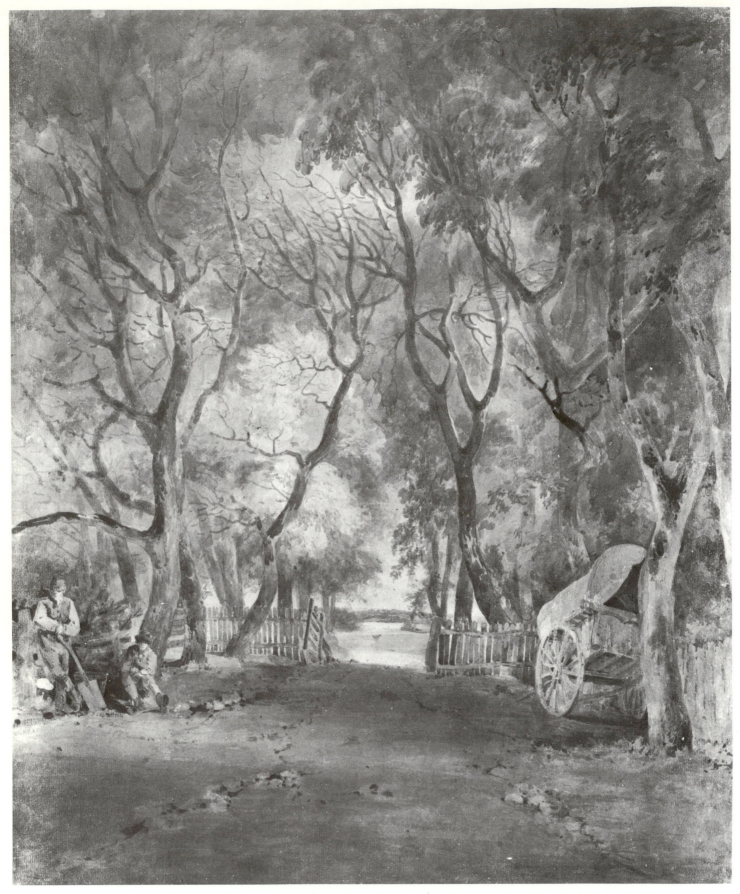

174. *An Entrance to Earlham Park, near Norwich*. Yale Center for British Art, Paul Mellon Collection, New Haven, Connecticut.

175. *The Blacksmith's Shop, Hingham.* City of Norwich Museums, Norwich.

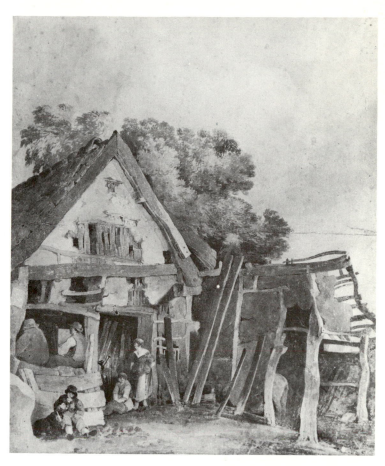

176. *The Blacksmith's Shop, Hingham.* Museum and Art Gallery, Doncaster.

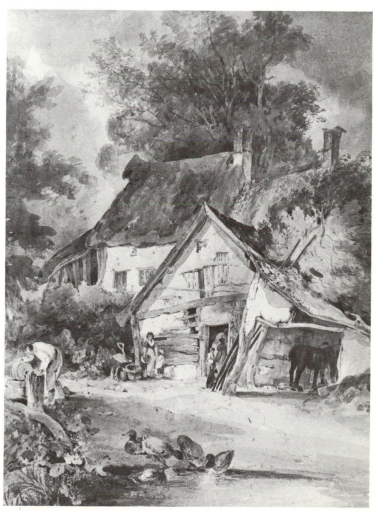

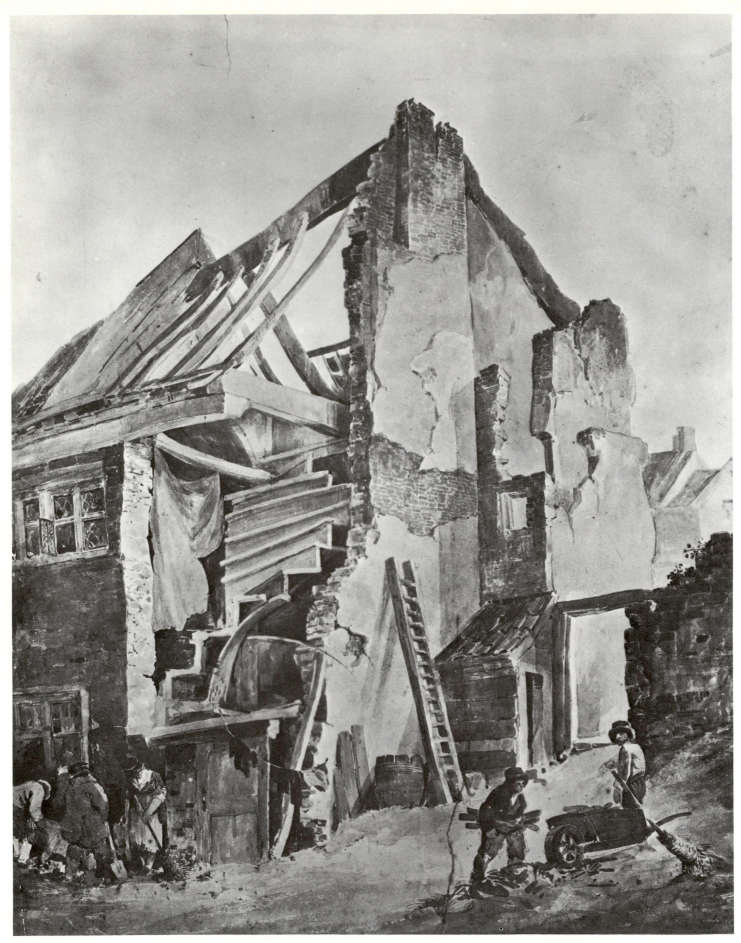

177. *Old Houses at Norwich*. Victoria and Albert Museum (Crown copyright), London.

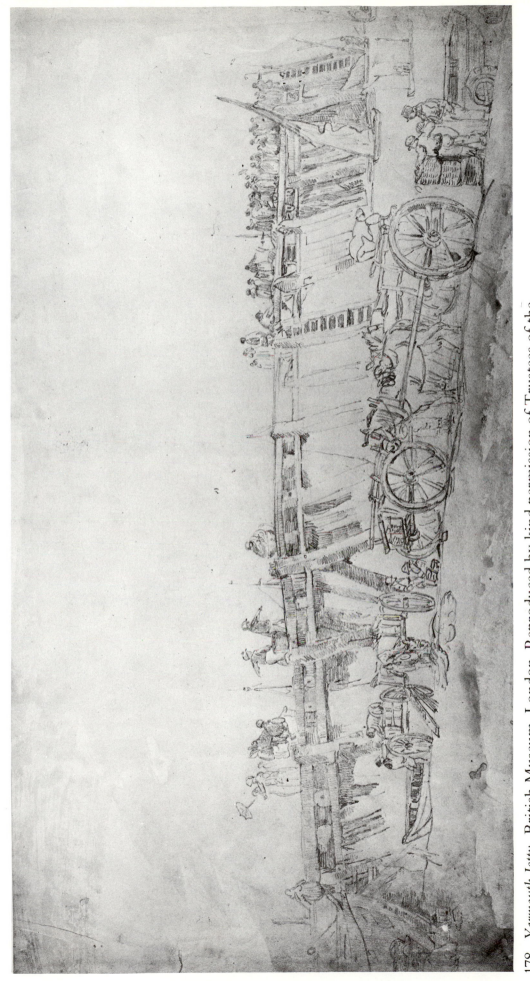

178. *Yarmouth Jetty*. British Museum, London. Reproduced by kind permission of Trustees of the British Museum.

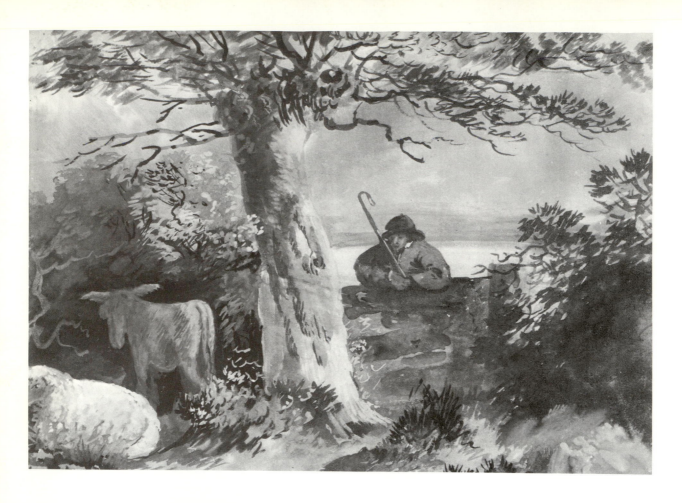

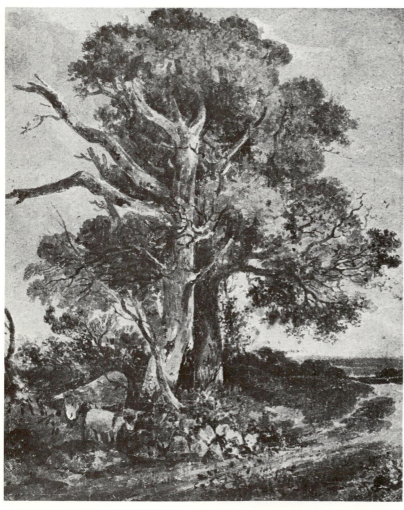

179. (top) *The Shephard*. Collection Mr. Norman Baker, Colchester, Essex.
180. (bottom) *By the Roadside*. Whitworth Art Gallery, University of Manchester, Manchester.

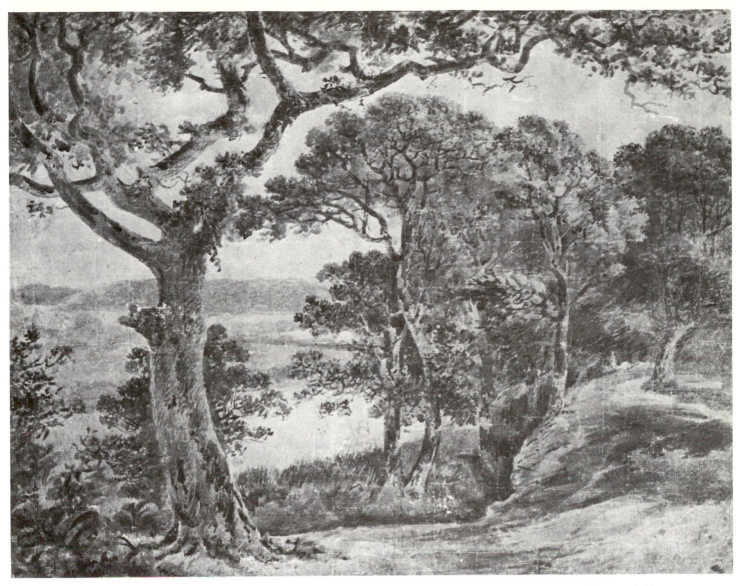

181. *River through the Trees*. Collection Sir Edmund Bacon, Bart., Raveningham Hall, Norfolk.

182. *Landscape with Boy Fishing*. Metropolitan Museum of Art (The Robert Lehman Collection), New York.

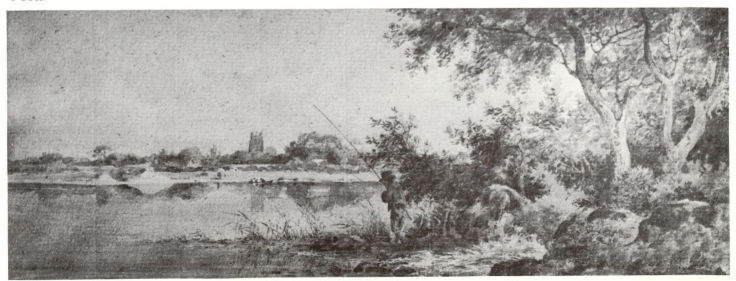

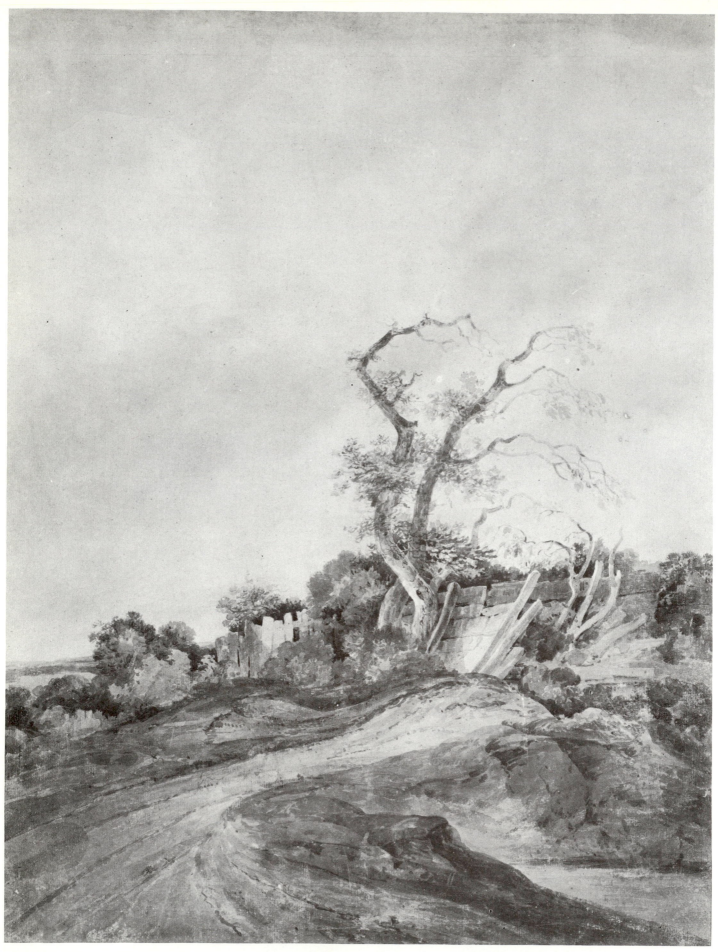

183. *The Blasted Oak*. Collection Sir Edmund Bacon, Bart., Raveningham Hall, Norfolk.

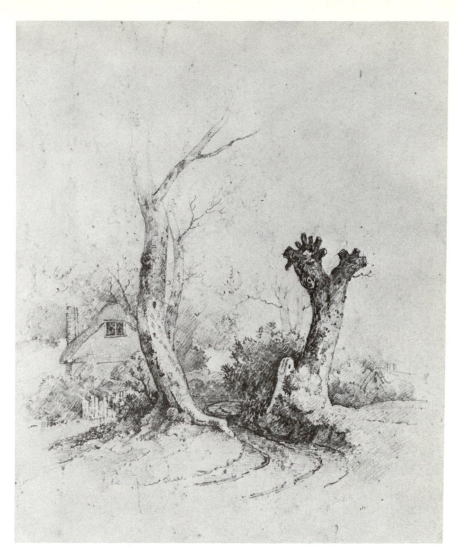

184. (top) *Study of Trees.* Collection
Mr. Frederick L. Wilder, Woodford
Green, Essex.
185. (bottom) *View of the Thames at
Battersea.* Whitworth Art Gallery,
University of Manchester, Manchester.

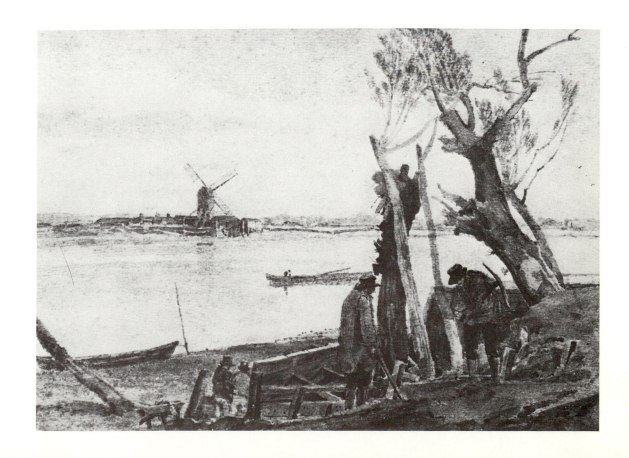

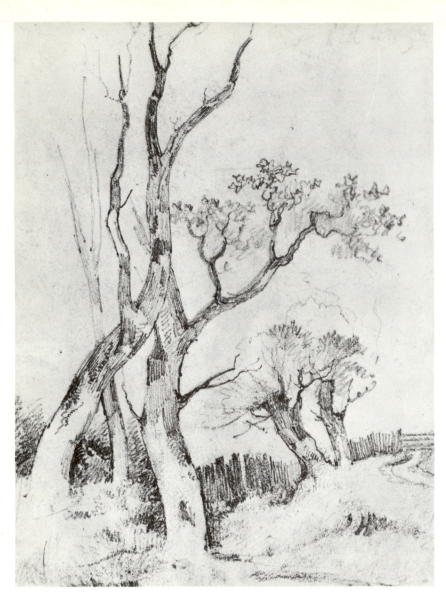

186. (top) *The Blasted Oaks*. City of Norwich Museums, Norwich.
187. (bottom) *Group of Trees overhanging a Pool*. City of Norwich Museums, Norwich.

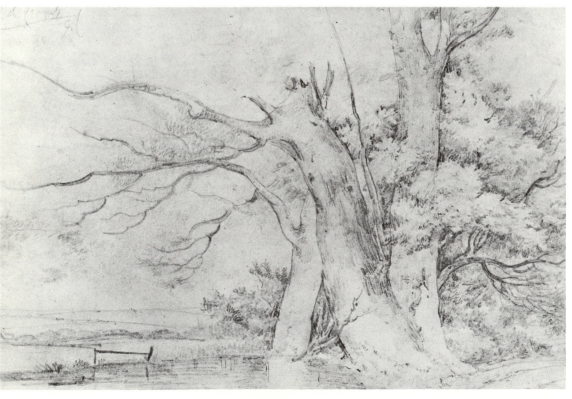

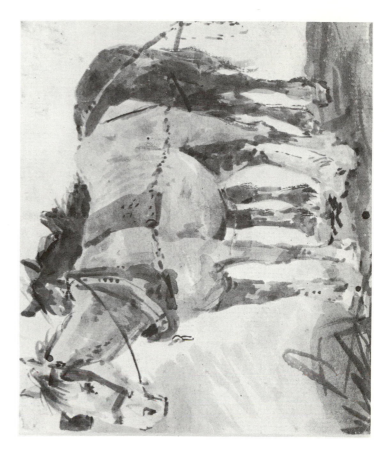

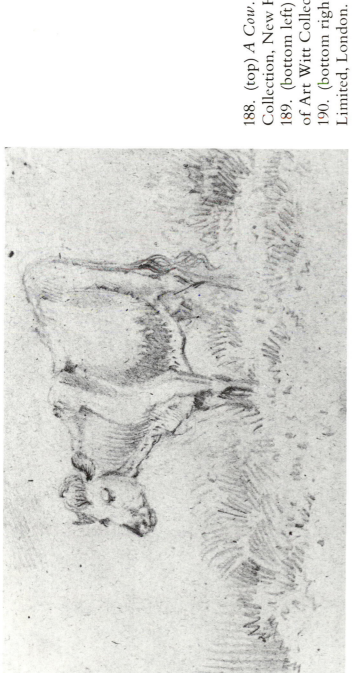

188. (top) *A Cow*. Yale Center for British Art, Paul Mellon Collection, New Haven, Connecticut.
189. (bottom left) *Sketch of Three Pigs*. Courtauld Institute of Art Witt Collection, London.
190. (bottom right) *Two Cart Horses*. Manning Galleries, Limited, London.

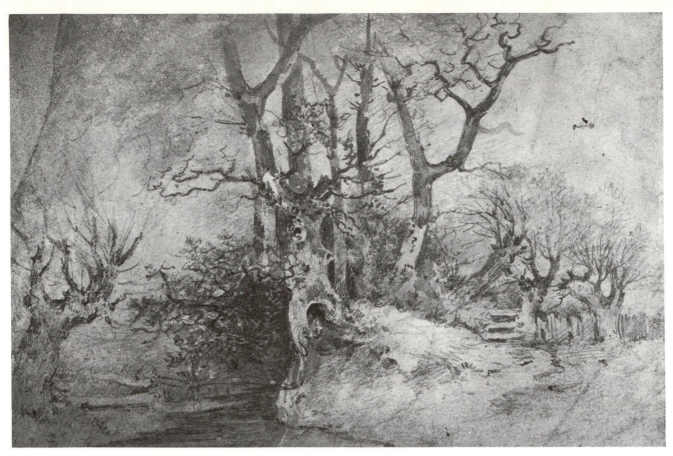

191. *Trees on a Stream*. British Museum, London. Reproduced by kind permission of Trustees of the British Museum.

192. *The Gnarled Oak*. Collection of Sir Edmun Bacon, Bart., Raveningham Hall, Norfolk.

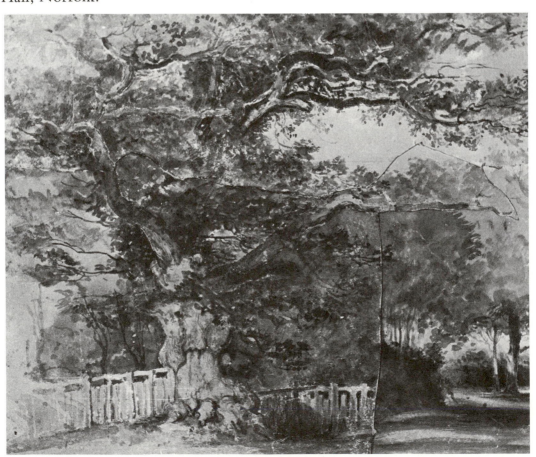

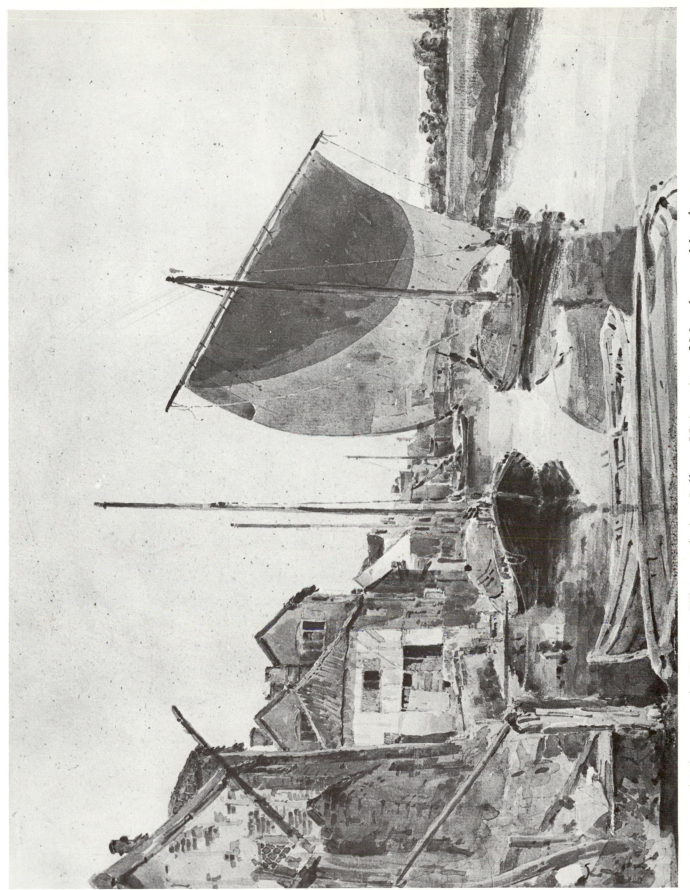

193. *Houses and Wherries on the Wensum.* Whitworth Art Gallery, University of Manchester, Manchester.

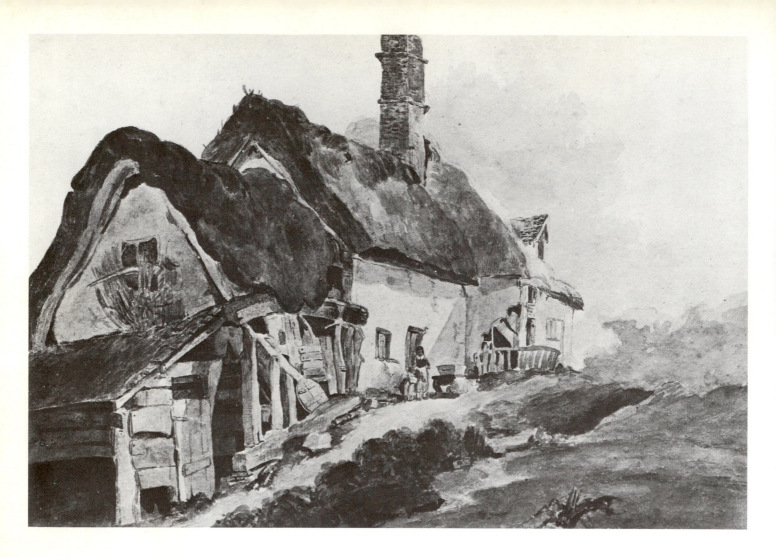

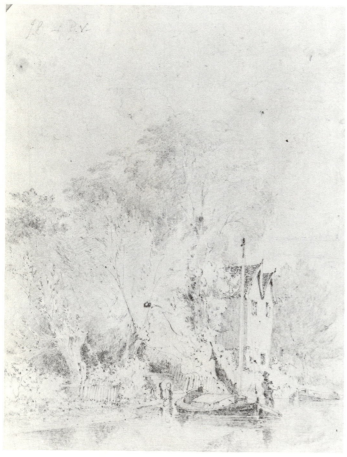

194. (top) *Thatched Buildings with Figures.* City of Norwich Museums, Norwich.

195. (bottom) *Willow Tree near Mr. Weston's House.* Yale Center for British Art, Paul Mellon Collection, New Haven, Connecticut.

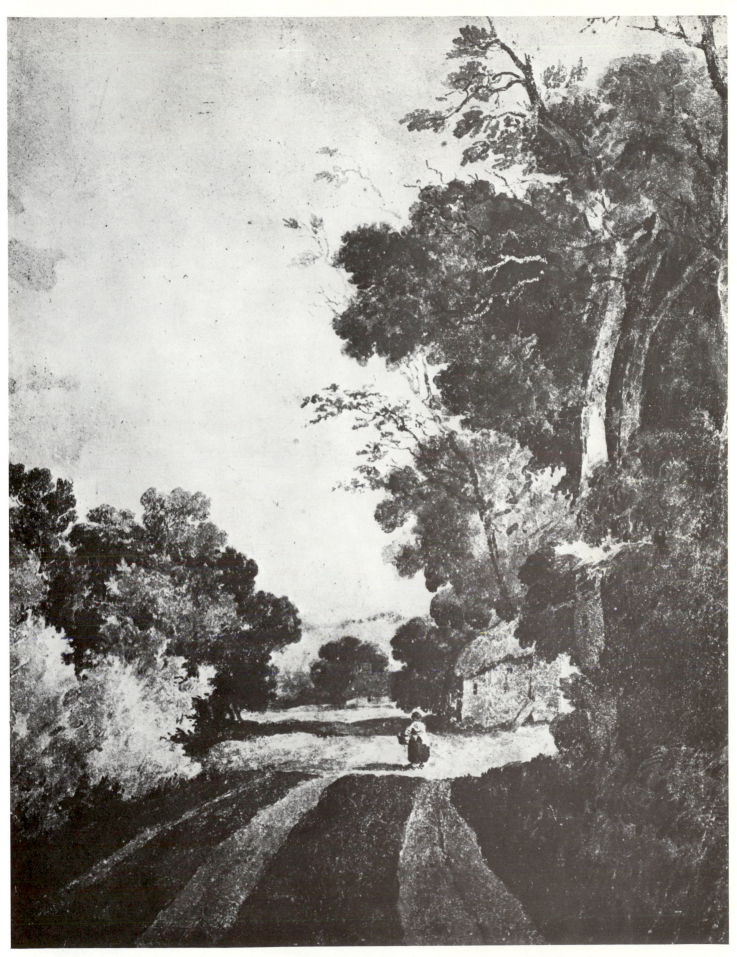

196. *Landscape with Cottages*. Victoria and Albert Museum (Crown copyright), London.

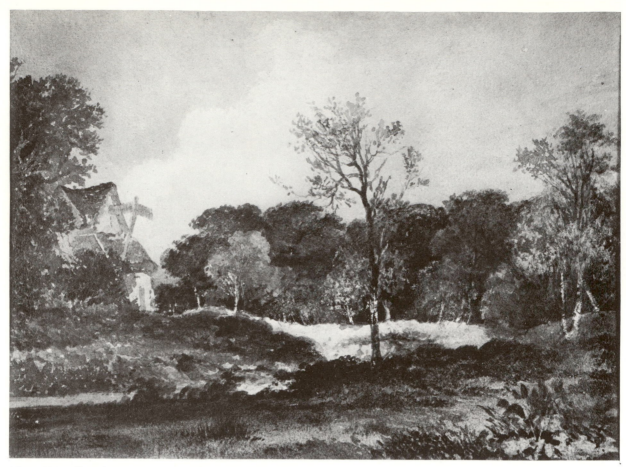

197. *Woodland Scene, Dunham, Norfolk.* British Museum, London. Reproduced by kind permission of Trustees of the British Museum.

198. *Hedgerow with Grindstone and Stile.* Christchurch Mansion, Ipswich. Reproduced by kind permission of Ipswich Museums Committee.

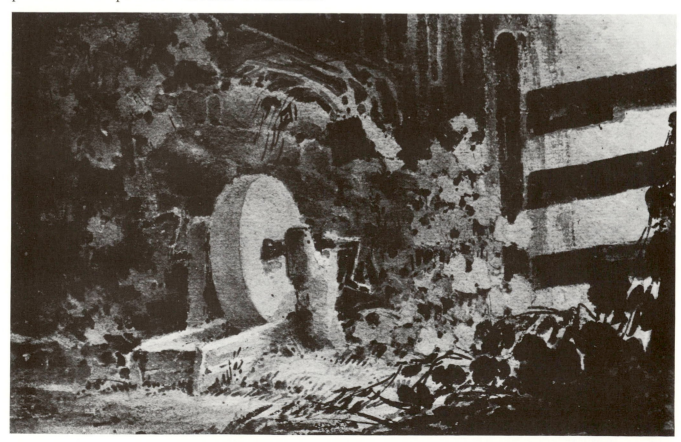

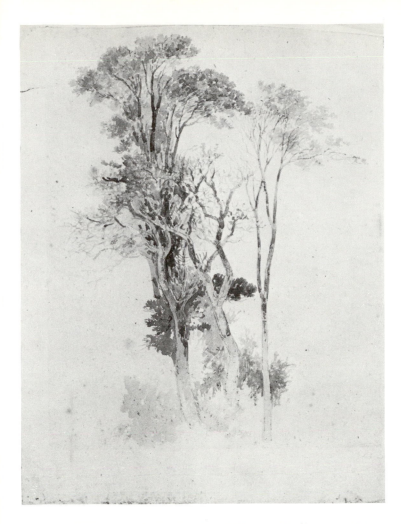

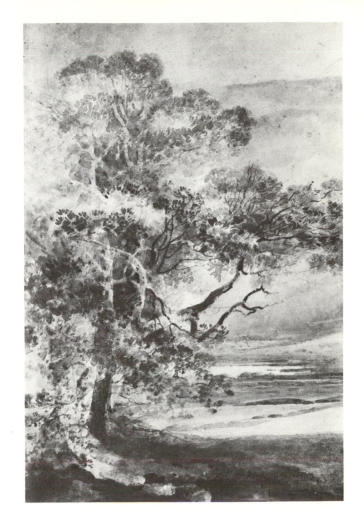

199. (top left) *Study of Trees*. Collection Mr. Frederick L. Wilder, Woodford Green, Essex.
200. (top right) *Study of Trees*. City Museum and Art Gallery, Birmingham.
201. (bottom) *Trees by a Pond*. Yale University Art Gallery, New Haven, Connecticut.

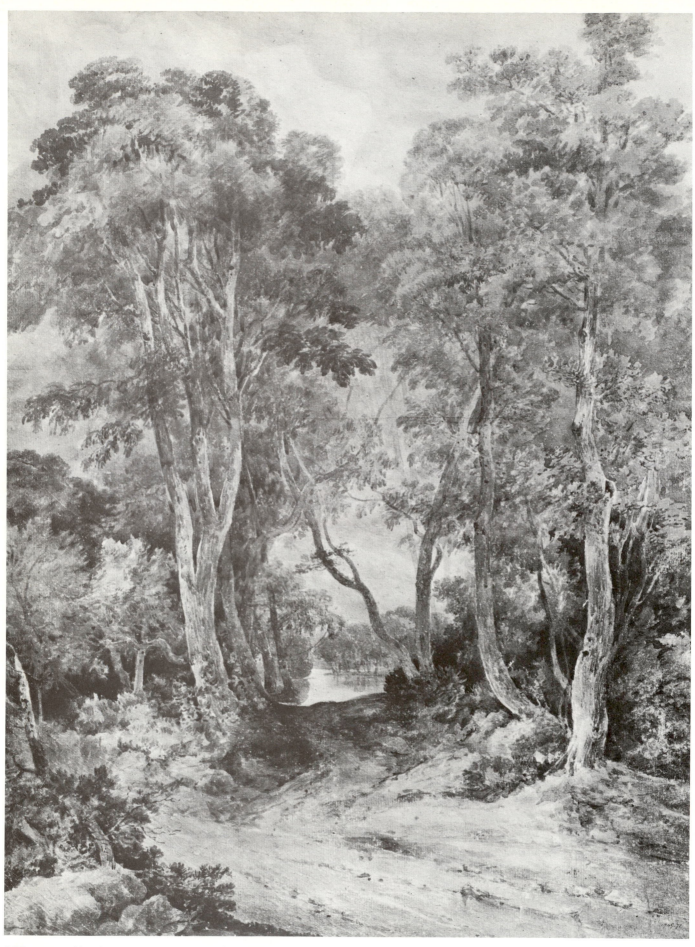

202. *Woodland Scene*. Victoria and Albert Museum (Crown copyright), London.

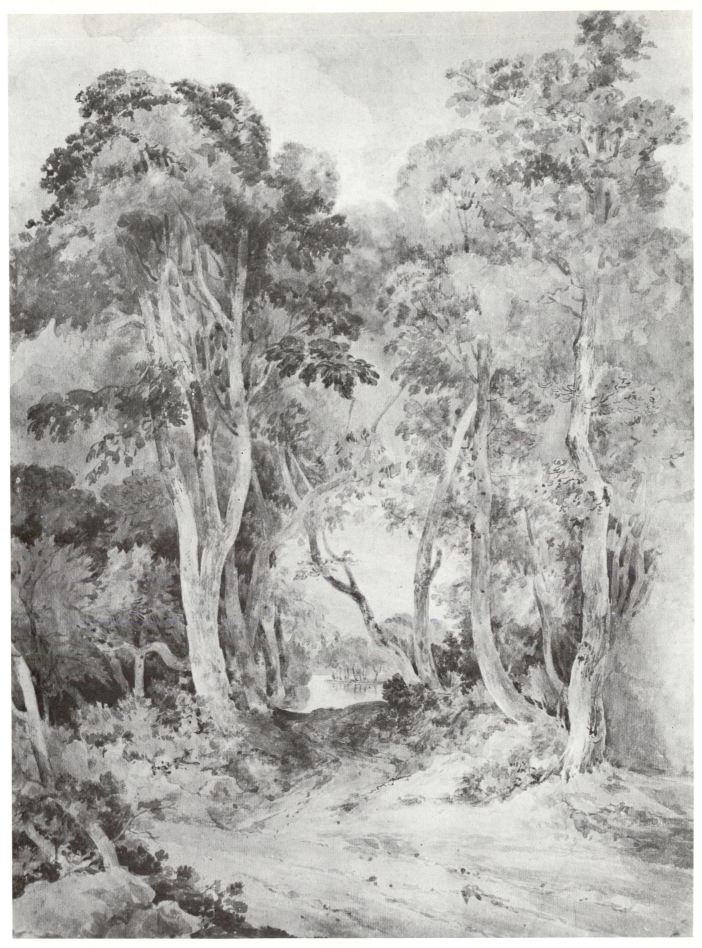

203. *Lane Scene near Norwich*. City of Norwich Museums, Norwich.

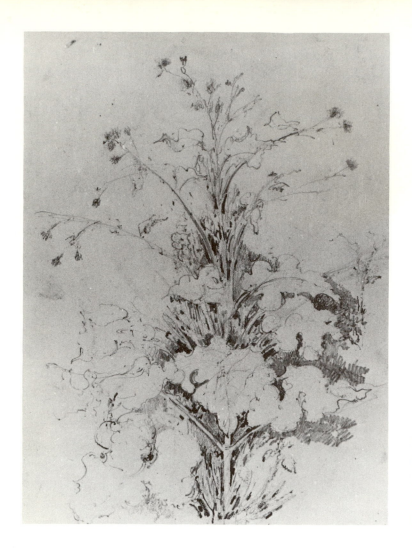

204. (top) *Plant Study: a Burdock.* Courtauld Institute of Art, Witt Collection, London.
205. (bottom) *Study of a Pollard.* Christchurch Mansion, Ipswich. Reproduced by kind permission of Ipswich Museums Committee.

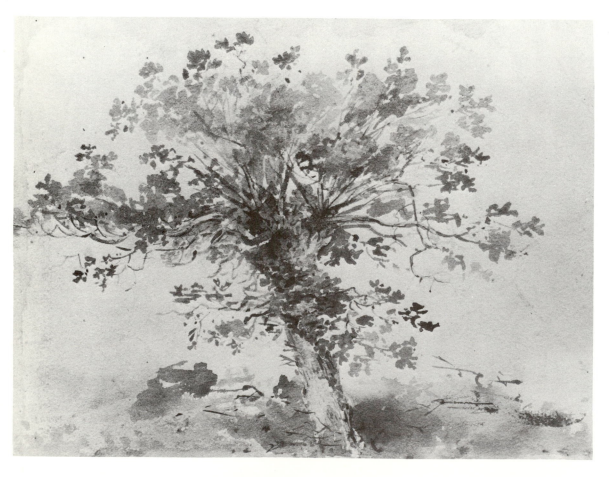

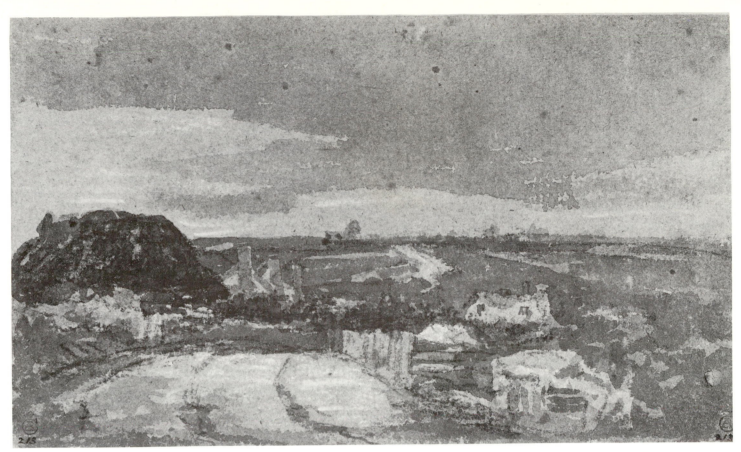

206. *Near Magdalen Gate, Norwich.* Victoria and Albert Museum (Crown copyright), London.

207. *King Street, Norwich.* Victoria and Albert Museum (Crown copyright), London.

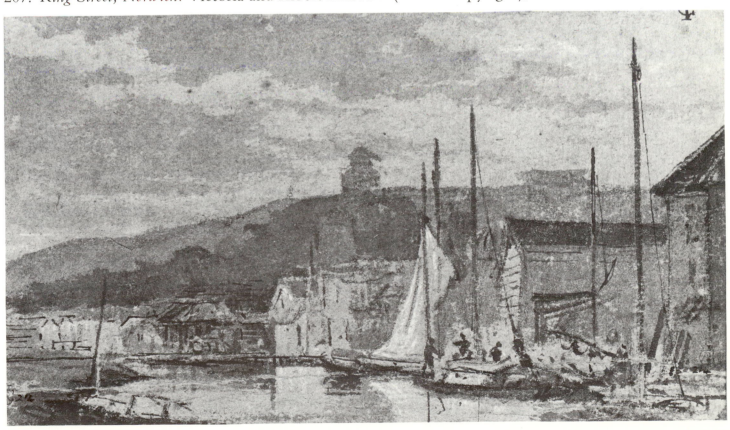

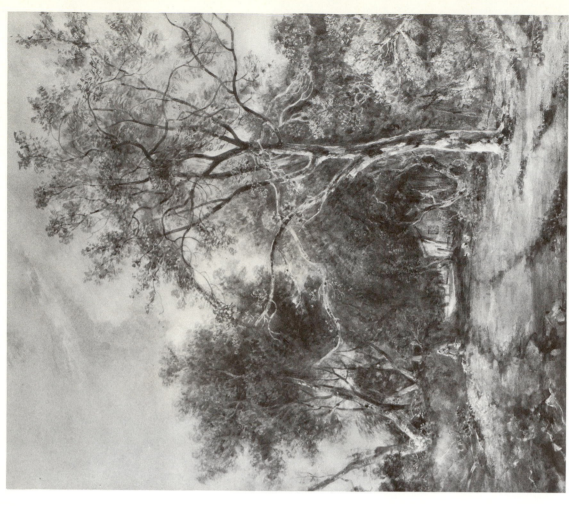

209. *The Glade Cottage.* Collection the Right Honorable Viscount Mackintosh of Halifax, Barford, Norfolk.

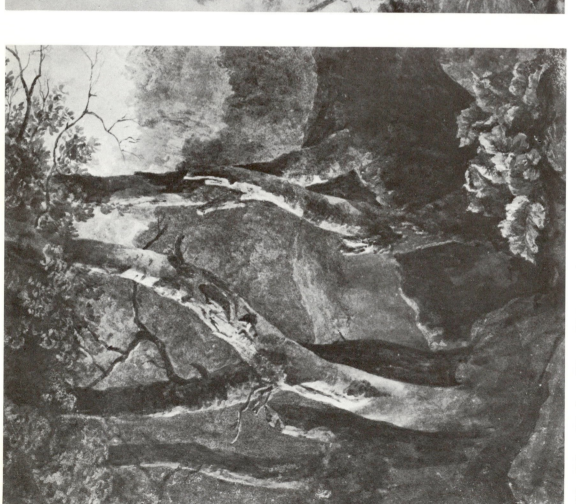

208. *Silver Birches.* City of Norwich Museums, Norwich.

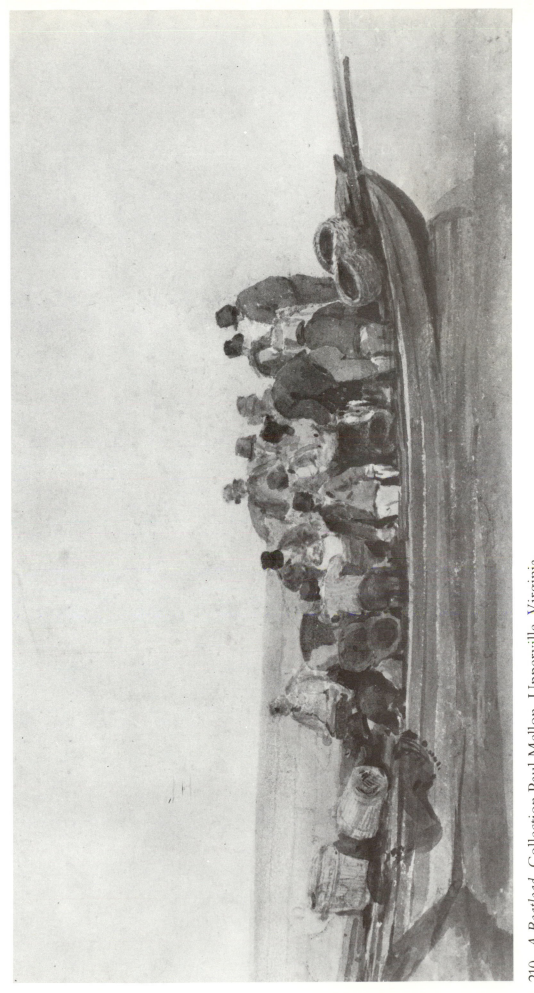

210. *A Boatload.* Collection Paul Mellon, Upperville, Virginia.

145

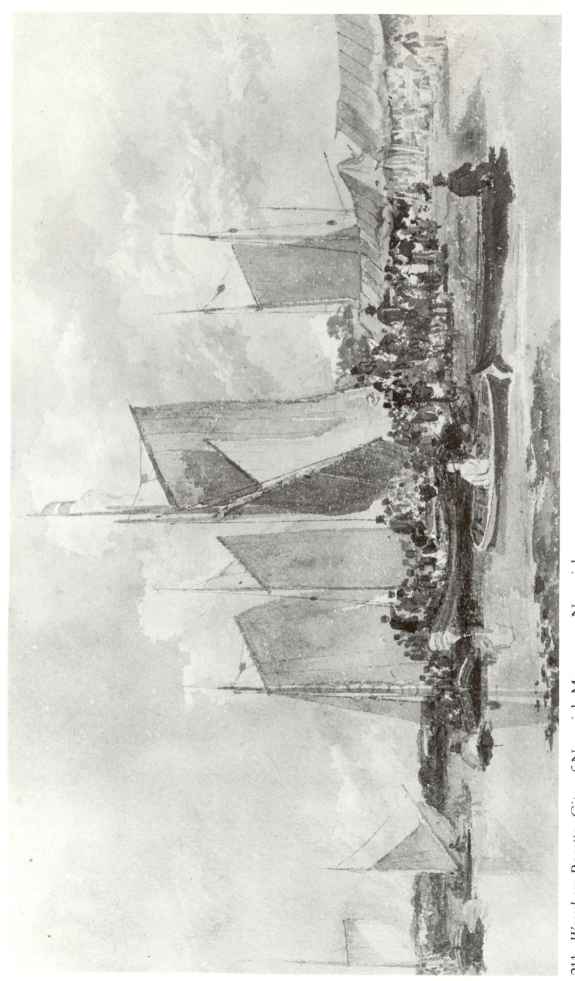

211. *Wroxham Regatta*. City of Norwich Museums, Norwich.

146

THE ETCHINGS

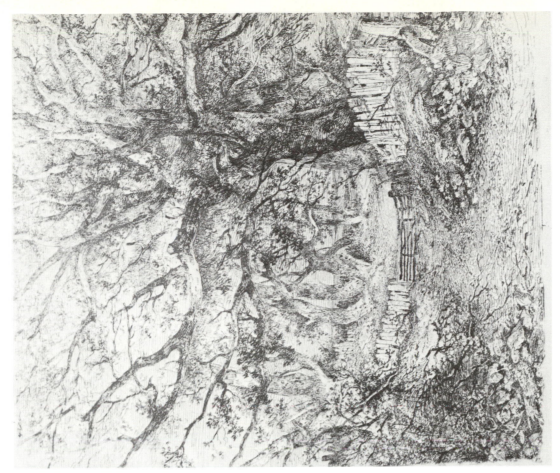

213. *Road Scene, Trowse Hall (near Norwich)*. Third state

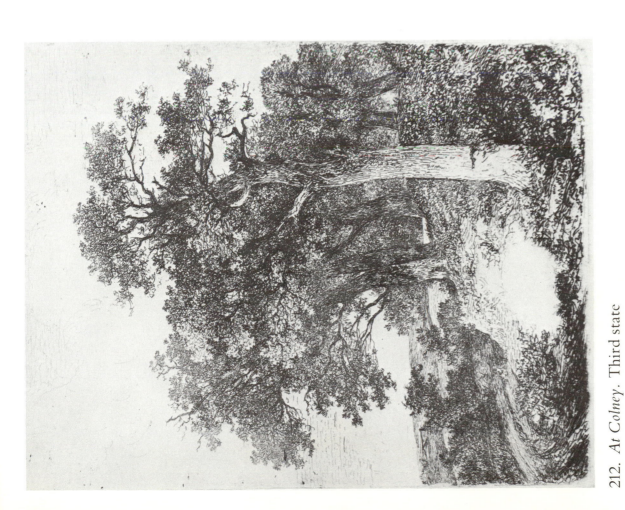

212. *At Colney*. Third state

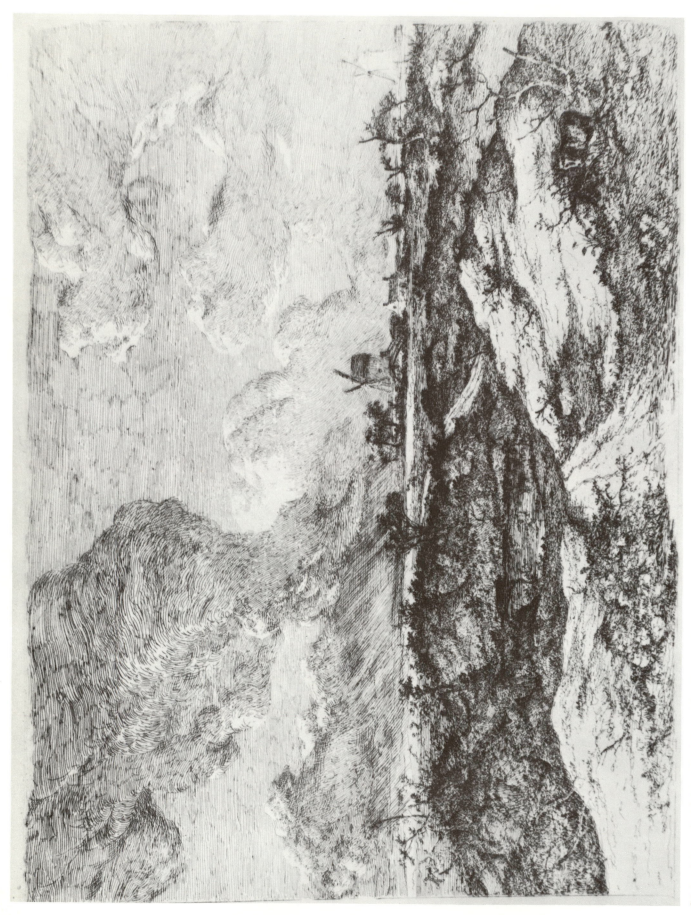

214. *Mousehold Heath, Norwich.* Second state

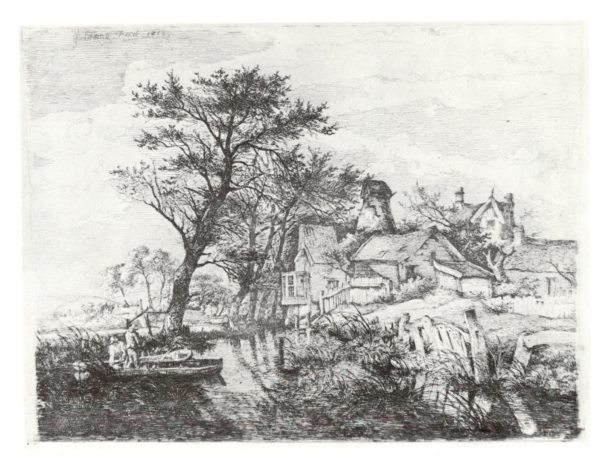

215. *Back of the New Mills.* Second state

216. *Front of the New Mills, Norwich.* Second state

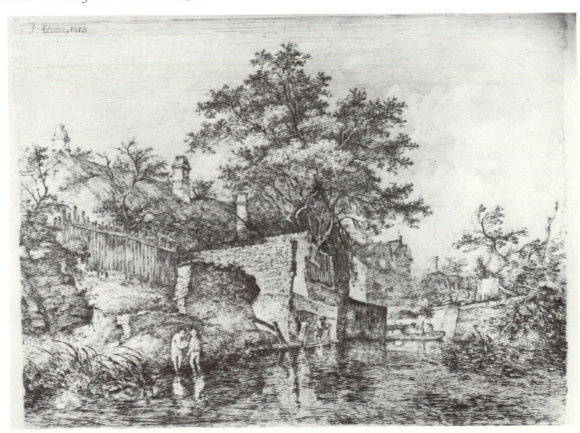

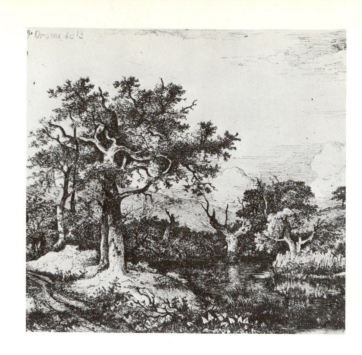

217. (top left) *Gravel Pits, Marlingford.*
Second state
218. (top right) *Deepham, near Hingham.*
Fourth state
219. (bottom) *Footbridge at Cringleford.*
Second state

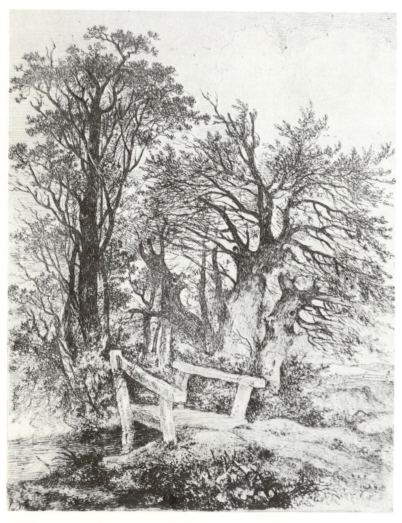

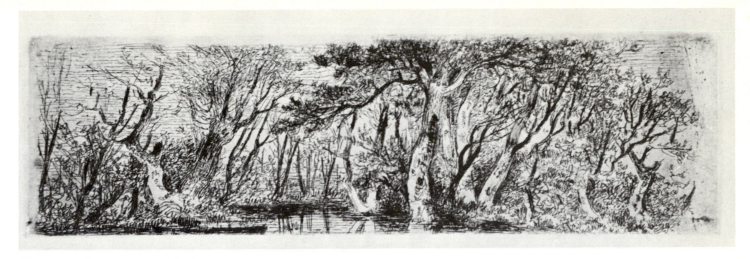

220. *At Woodrising*. Third state

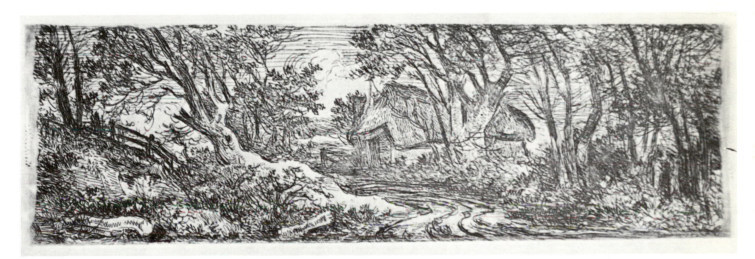

221. *Rustic Road with Thatched Barns*. First state

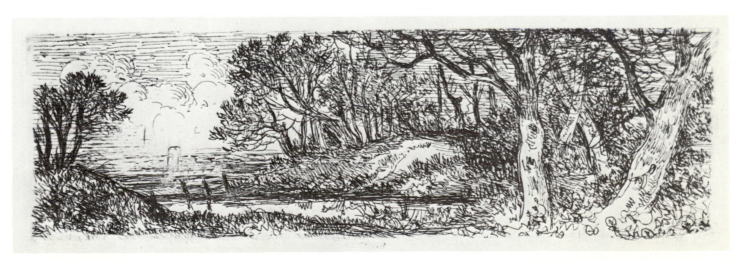

222. *At Scoutton*. Second state

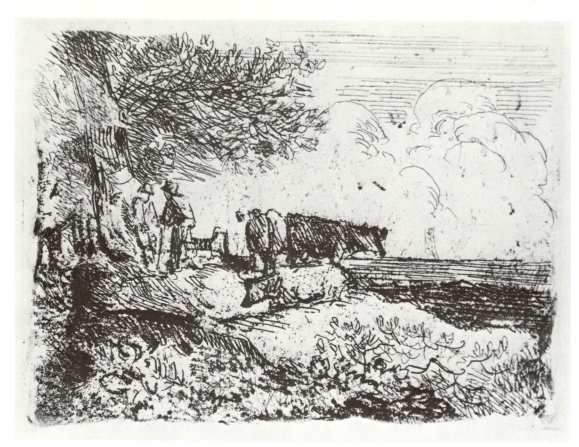

223. *A Composition: Men and Cows.* First state

224. *At Bawburgh.* Second state

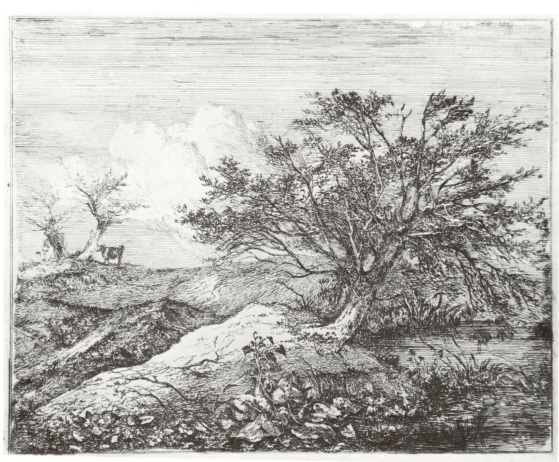

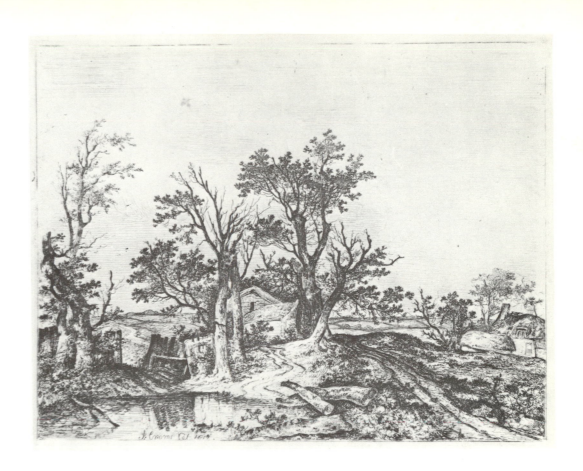

225. (top) *At Hackford.* Fourth state
226. (bottom) *Back of the Mills.*
Second state

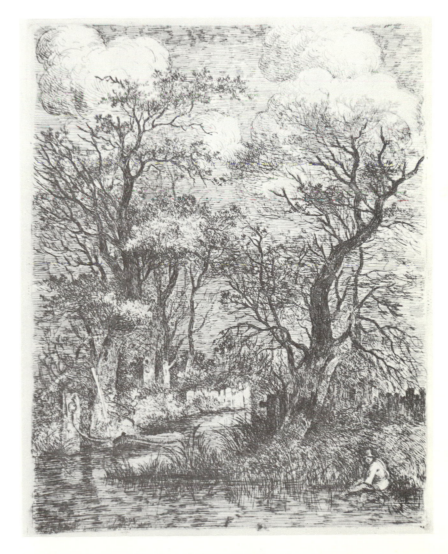

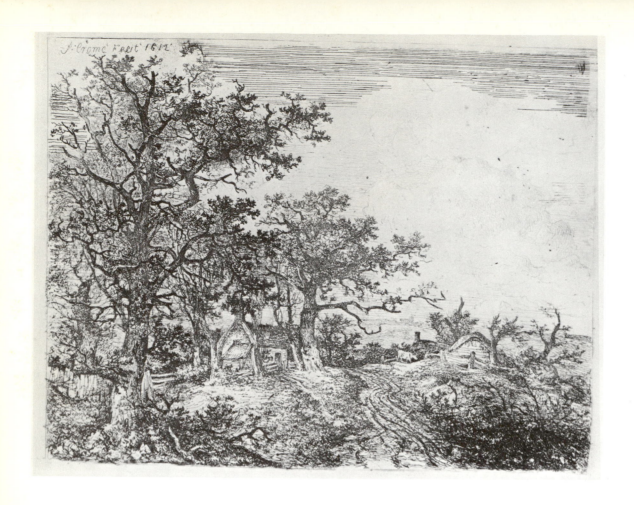

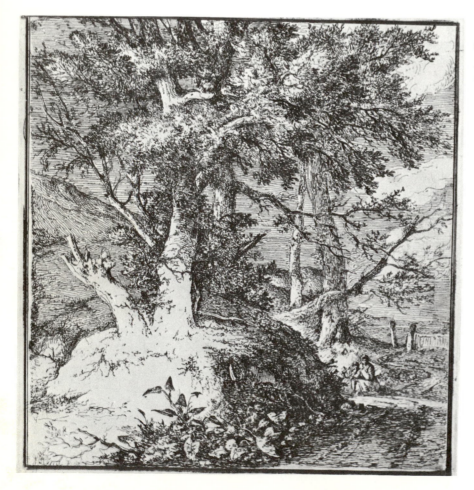

227. (top) *The Hall Moor Road near Hingham.* Third state
228. (bottom) *A Composition.* Second state

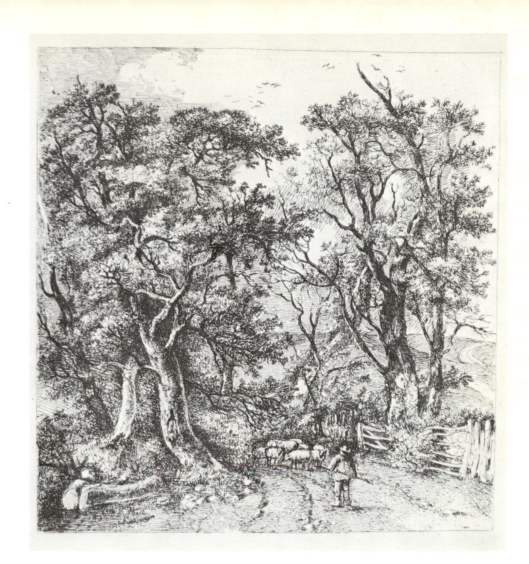

229. (top) *Road Scene,
Hethersett*. First state
230. (bottom) *Road by Park
Palings*. First state

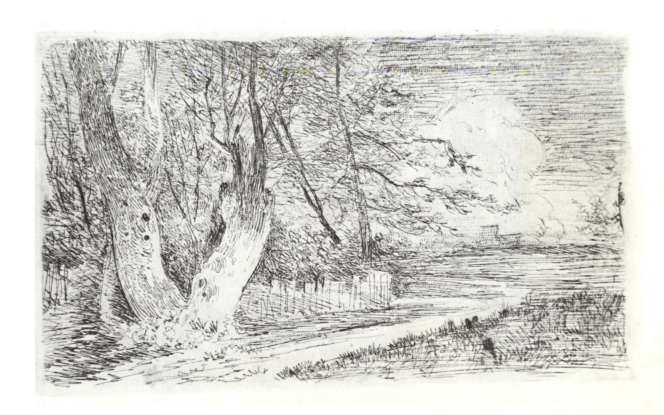

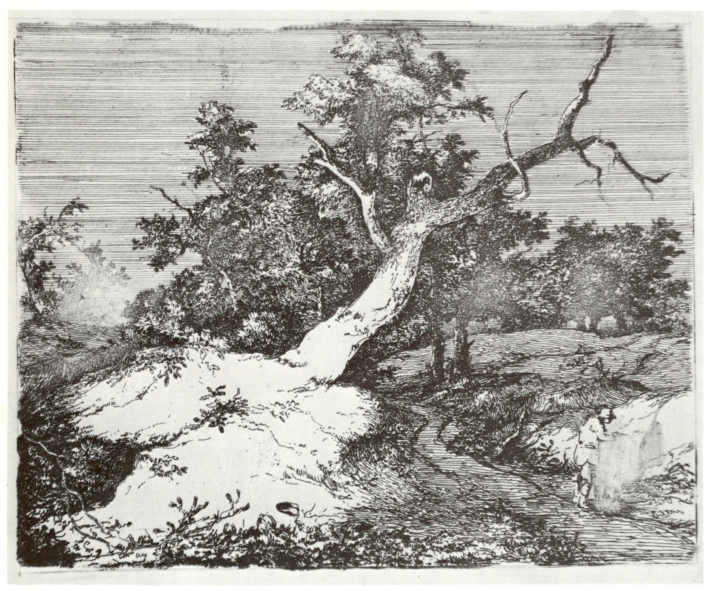

231. *Road by Blasted Oak.* Second state

following page:
232. *Composition: Sandy Road through Woodland.* Second state

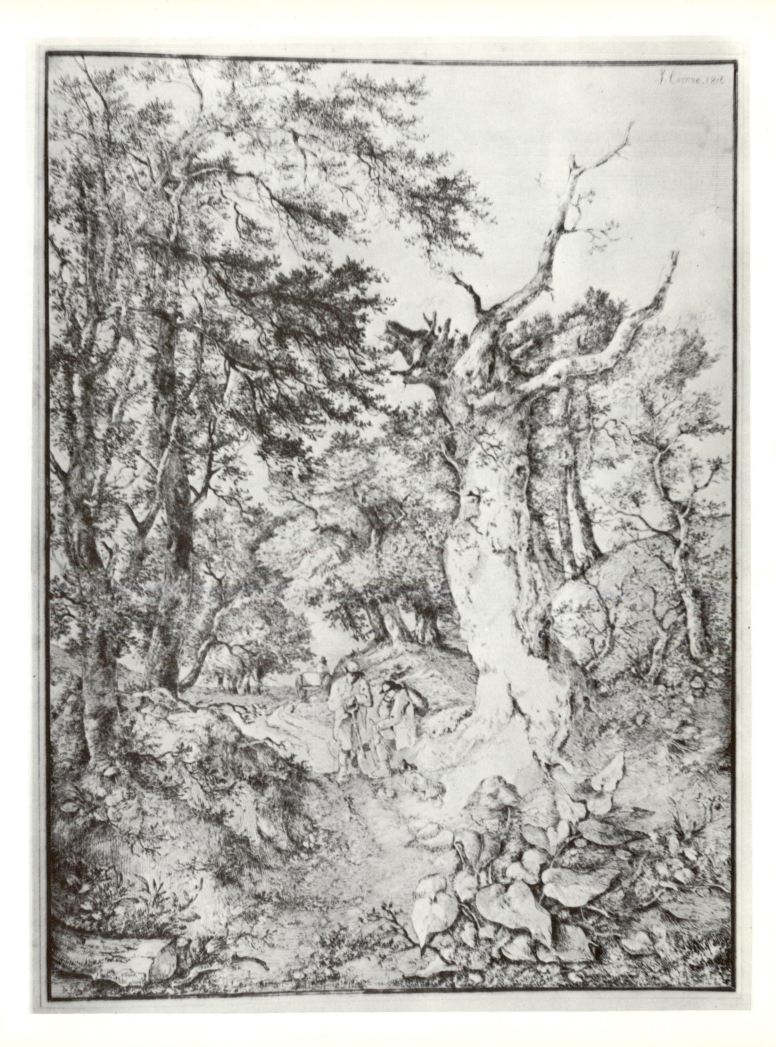

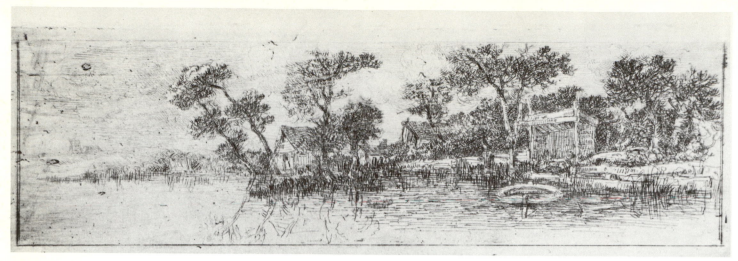

233. *At Heigham.* First state

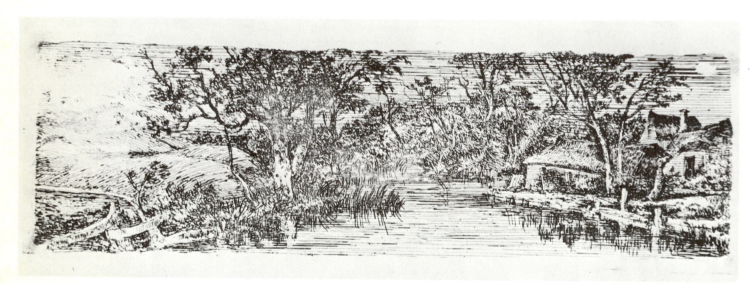

234. *Farm Buildings by a Pool.* First state

235. *Landscape with Wooden Bridge and a Horseman.* Only state

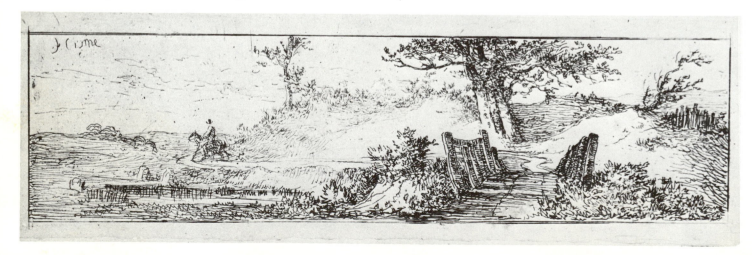

THE SOFT-GROUND ETCHINGS

236. Untitled and unpublished.

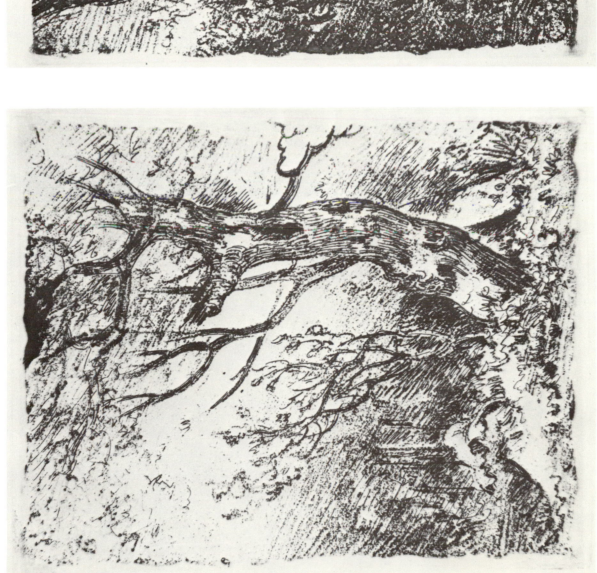

238. *Waggon Wheels, Tree Trunk and Beams.* Only state

237. *Tree Trunk and Bushes.* Only state

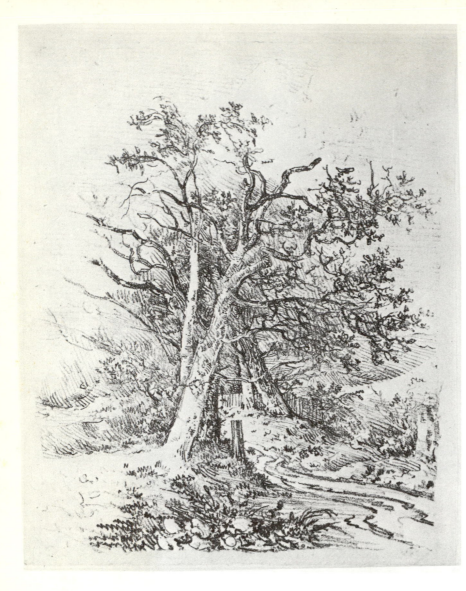

239. (top) *Tree Trunks and Lane.*
Only state
240. (bottom) *Hoveton St. Peter.*
Only state

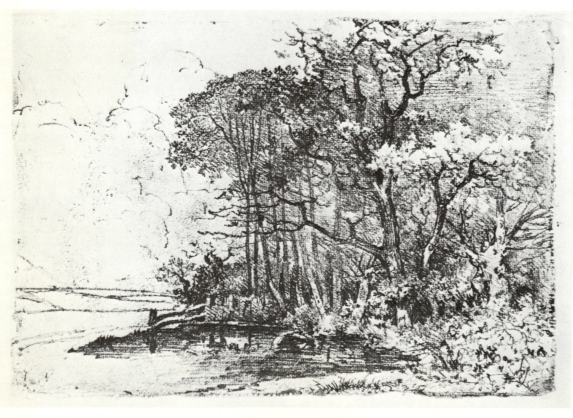

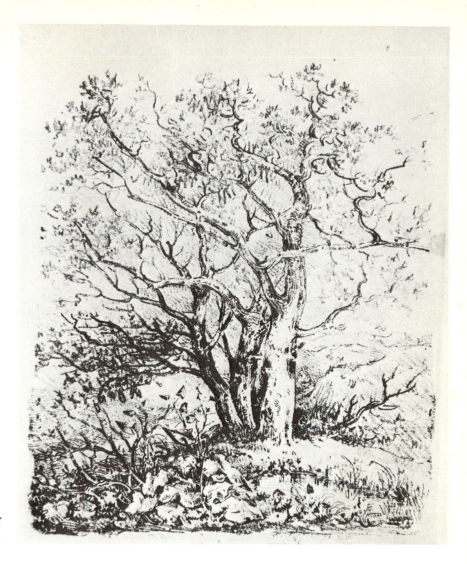

241. (top) *Three Trees*. Only state
242. (bottom) *Colney*. Only state

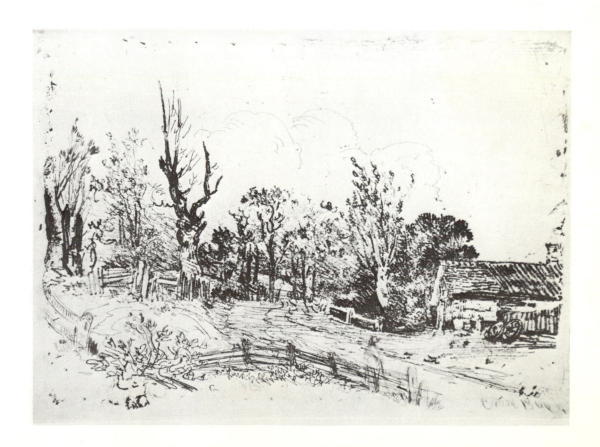

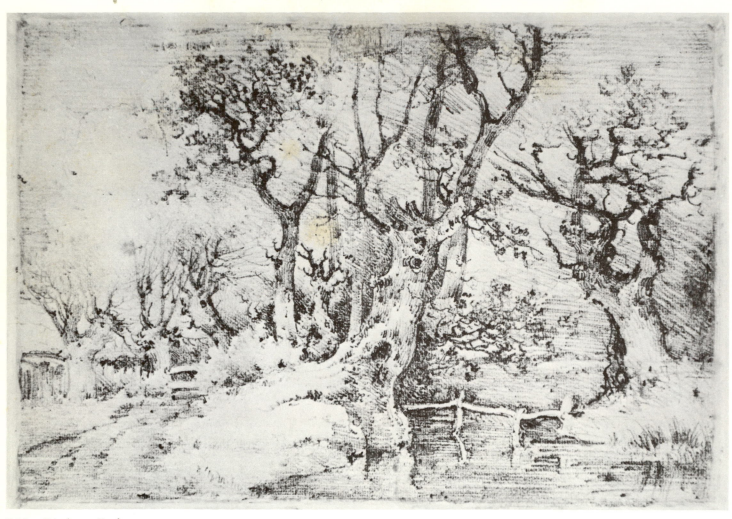

243. *Bixley*. Only state